Robin Derrick is creative director of British *Vogue*. An art director and photographer, he started work in 1982 on *i-D* magazine before graduating from St Martin's School of Art, London, in 1984. The art director of *The Face*, Italian *Elle*, French *Glamour* and *Arena*, he was also a founder of Studio Box, the fashion-oriented design studio based in Paris and Milan. In 1999 he was the creative director responsible for the launch of Russian *Vogue*.

Robin Muir is a writer and curator and former picture editor of *British Vogue* and the *Sunday Telegraph Magazine*. He writes regularly on photography and contemporary art for the *Independent* in London, and occasionally for *Vogue* and *The World of Interiors*. He is the archivist of the Terence Donovan Archive and a contributor to the *New Dictionary of National Biography*. He has published five books and curated exhibitions for the National Portrait Gallery, the Victoria and Albert Museum, the Museum of London and the Yale Center for British Art.

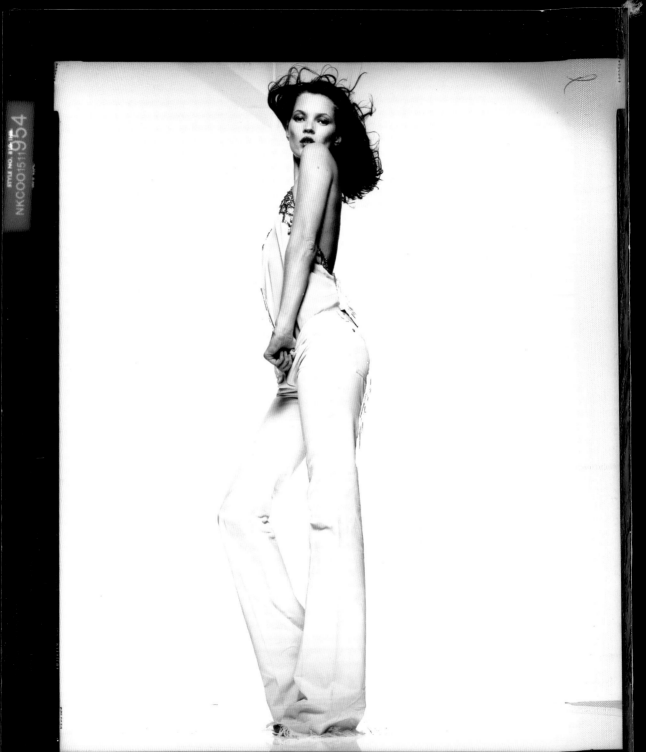

UNSEEN VOGUE

THE SECRET HISTORY OF FASHION PHOTOGRAPHY

EDITED BY ROBIN DERRICK AND ROBIN MUIR

A Little, Brown Book

First published in Great Britain in 2002 by Little, Brown
This paperback edition published in 2004 by Little, Brown
Reprinted 2005
Copyright © 2002 The Condé Nast Publications Ltd
VOGUE Regd. TM is owned by The Condé Nast Publications Limited and is used under
licence from it. All rights reserved.

The right of Robin Derrick and Robin Muir to be identified as authors of this work has
been asserted by them in accordance with the Copyright, Designs and Patents Act 1988.

Designed by Robin Derrick in Line and Gill Sans.

A CIP catalogue for this book is available from the British Library.

ISBN 0-316-72766-0

Colour origination by Radstock Reproductions.
Printed and bound in China.

Little, Brown
An imprint of Time Warner Book Group UK
Brettenham House
Lancaster Place
London WC2E 7EN

www.twbg.co.uk

The following photographs are © The Condé Nast Publications Ltd:
pages 10–11, 14–31, 41, 44–53, 56–65, 67–73, 78–84, 86–100, 104–113, 116–147,
150–253, 266–275, 292–7, 300–1, 307–9, 314–21, 333–345, 348–9.

Pages 42–3, © 1946 The Condé Nast Publications Inc.
Page 66, © 1950 The Condé Nast Publications Inc.
Pages 76–7, © 1951 The Condé Nast Publications Inc.
Page 85, © 1952 The Condé Nast Publications Inc.
Page 101, © 1956 The Condé Nast Publications Inc.
Pages 148–9, © 1967 The Condé Nast Publications Inc.

Pages 32–9, courtesy of Lee Miller Archive.

Page 52, courtesy of Pam Makin.

Page 55, courtesy of Norman Parkinson Ltd/Fiona Cowan.
Pages 74–5, courtesy of Norman Parkinson Ltd/Fiona Cowan.
Pages 102–3, courtesy of Norman Parkinson Ltd/Fiona Cowan.

Pages 114–5, courtesy of William Klein.

frontispiece
NICK KNIGHT
KATE MOSS, 2000
Contact print from a 10 × 8in negative, showing initial retouching marks.
Clothes, by Stella McCartney for Chloé.

CONTENTS

FOREWORD by ALEXANDRA SHULMAN

Every day, in hundreds of different ways, the staff of *Vogue* are involved in the production and collation of the photographs which will make up the magazine. In an average issue there are over 400 images: fashion shoots, still lifes, portraits, paparazzi shots. Looking at *Unseen Vogue* as the magazine's editor, I know that each picture not only tells a story but masks an even better one.

Unseen Vogue is a pictorial history of the magazine, bound together by many of these untold tales. The images it includes are not simply images from *Vogue* shoots, but pictures that testify to the labyrinth of labour that must be negotiated from conception to publication. In every contact sheet there are 100 decisions; in every crop there is concerned debate.

A photograph commissioned by *Vogue* is rarely a simple matter. First, there are the numerous personalities involved – personalities which, as this book vividly demonstrates, are often far from easy-going. Then there is the idea, the concept, the vision which each of those personalities brings to the shoot. There are practicalities such as budgets, locations, equipment, timing. And then, just when you might have thought you'd got the picture, you cross the horizon to find emerging a whole other vista, which includes editing the shoot – the stage at which many of the images in *Unseen Vogue* were rejected for publication – the layout, the cropping, the retouching and the printing.

Images from earlier issues of *Vogue* were produced in a way both very similar to and very different from how we work now. As an editor, seeing the inclusion of so many contact sheets on these pages, I experienced a tremendous nostalgia for those times when such bounty regularly made its way into the art room. Indeed, huge numbers of contact sheets or vast packages of transparencies were the way that a photographer's work was presented to the magazine until the late 1980s. The longing I feel for those days is, of course, the longing for control. Nowadays, increasingly, photographers present two, possibly three, images from the acres of film that they have shot, reducing the degree to which

the editor can manipulate the visual subtleties of the magazine.

Take, as an example, the 1950 Cecil Beaton shoot of Maxime de la Falaise (pages 62–3). She poses for Beaton in an unadorned room, the only props a screen, a chair, an improbably huge window and a mirror – incidentally, still the most common props of choice. The bareness of the room acts as a foil to her outfit – a black-and-white striped taffeta fishtail dress by Paquin and a gloriously weighty pair of earrings which drop into the curve of her collarbone when she sits.

In some of the shots she also wears a fur stole; in others her shoulders are bare. In the 20 small images on the page, how many attitudes are evoked. We see her stoleless, photographed from the back, self-aware as she adjusts her own image in the mirror. In another – this time a full-length image – she is seated, the drama of the gown vying with the beauty of the model for leading role. Maxime stares not at us, but through the window – at what? one wonders. With the addition of the stole comes a transience, as if she is en route to a party or a premiere. The image has a lighter feel, she seems less a prisoner of her mannered beauty. Which should be used in the magazine?

In taking this decision, the editor or art director is considering not only that particular shot but the story in total and, ultimately, the magazine as a whole. If there is another story, containing another picture of a seated goddess in a striped dress, then that might tip the balance against that similar image's being used, in favour of a shot that focuses more on the head and torso. The images that are unpublished, the 'overs', are for this reason often as compelling, occasionally even more so, than the finally published choice.

Historically, *Vogue* has had a close relationship, during any given decade, with a relatively small number of photographers. Hoyningen-Huene, Cecil Beaton, Clifford Coffin, John Rawlings, Norman Parkinson, Guy Bourdin, Snowdon and, more

recently, Patrick Demarchelier, Peter Lindbergh, Bruce Weber, Juergen Teller, Nick Knight and Mario Testino.

During research for *Unseen Vogue* not only photographs but also some pertinent correspondence was unearthed in the *Vogue* Library. The inclusion of the memoranda between these photographers and the editorial team demonstrates both how interdependent the relationship between the two often was, and also how little has changed over nearly a century.

From 1955, a marvellous memo from the then editor, Audrey Withers, to Cecil Beaton begins, 'Dear Cecil, I have unpleasant news for you. We have been forced to kill every picture which you took recently for our April Lead. We all found these pictures unpublishable, since they did not in any way embody or put over the theme of our What To Wear With What feature.' Beaton, instead of photographing the carefully chosen accessories that the team had brought to him, had made his own choices, which contradicted the designated *Vogue* message. 'The upshot was that these pictures, instead of being object lessons in how an outfit should be put together and accessorised, appeared in fact far less well accessorised than most normal fashion features,' continues Withers. This particular shoot, of which the rather dull contact prints are shown accompanying the letter (pages 95–7), was for Withers the culmination of several years of unsatisfactory sittings. Beaton seemed to be going out on what she regarded as an increasingly unsteady limb. 'If you have reached the point of feeling that our fashion features no longer hold your interest, I think it will be better for both of us if we cease to offer them to you,' was her desperate conclusion.

Reading this gem along with Beaton's also previously unpublished reply, which offered a variety of excuses for his behaviour, including lack of communication between him and a sickly *Vogue* staff, I felt a complete familiarity, indeed affinity, with Miss Withers – even though the exchange was over

50 years old. The only real difference is that nowadays we would never dare offer a photographer a job as unimaginatively titled as 'What To Wear With What'. Instead, the kind of instructive, reader-friendly story which might show you clearly how to put a look together, will be enticingly sold as something like 'Lauren Hutton Chic', or 'Montmartre '68' or even, as I remember with a recent story on classic coats and black trousers, 'The Danger of Black'.

Reading *Unseen Vogue* from the vantage point of editor, the question that returns again and again is, what would I have done had I been faced with those pictures on my desk? In this collection there are some images that I fervently hope I would have had the foresight to publish – even though at the time they would have seemed unsettlingly avant-garde. There are, too, variations of a published image that I'm not sure I would have published at all.

Vogue's success has always been the product of the tension between the creative and the practical; the dreamworld and the reality; the inspiration and the bottom line. How often a wonderful image has resulted from the magazine pulling one way – with the clothes it demands be included, and the model it insists be used – and the photographer tugging with all his or her might in another direction. It is one of the fascinations of *Unseen Vogue* that this tug of war is ubiquitous in its pages, chronicled both in the images and the captions.

Take for instance one of the unpublished Clifford Coffin shoots 'Jewel – Evening dresses' (pages 92–3). Here, the rigidly formal evening dress and the models styled with immaculate chignons and masked in perfect make-up, are photographed in soft focus. Their perfection blurred at times into an evocative smudge, enchanting ghosts at the ball. Part of Coffin's final sitting for *Vogue*, the pictures were judged too experimental and killed. How I hope that it would have been different had I been making that decision. But who knows what the untold story

was that time? Certainly that set of pictures, lacking any clarity, was unlikely to sell the work of those couturiers off the page. Yet with its central vibrant bruise of fuchsia, contrasted with the ethereal silhouettes, it conveys a certain elegance and era. Its blur foreshadows one of Nick Knight's shoots of the 1990s – seen here as snaps in the fashion director's daybook – featuring Amber Valletta and Shalom Harlow (pages 282–3) as similarly ectoplasmic beauties in ballgowns on a Bahamian beach.

In contrast, some of the Guy Bourdin beauty shots (pages 152–3) – porcine thighs on which sit a baby's legs; a grossly distorted back topped by a miniature head in the guise of beauty pictures – are uncompromisingly difficult and I fear that had these landed on my desk, they might easily have been greeted with an impatient glance and the comment that they had nothing to do with skincare or beauty, or some such Philistine observation. It is occasionally the photographer's fate to be subject to the whimsy of individual prejudice.

Throughout the book there are images specifically designated for the cover, which for some reason or another never made it to the promised land of the newsstand. Covers are the packaging of the magazine and have to sell to the reader as well as convey the content of the issue – roles which may not necessarily be complementary. Interestingly, in almost all instances, I found it easy to see why the rejected covers were deemed unsuitable. A 1956 image of a girl garlanded with an ugly tangle of Christmas lights, muddled in with tinsel, diamanté *and* a sparkler (page 105), looks more like a bad advertisement for a haberdashery department than a *Vogue* cover. The Just Jaeckin of Twiggy, complete with pinprick pupils and the sinister red light of the darkroom (page 147), is similarly unappealing.

Less clear to me now is my own decision not to use the Regan Cameron cover try of Stella Tennant – a classic English beauty, simply portrayed in a classic black poloneck (pages 300–1). At the time, Stella had dark black hair and that, combined with

the dense dark clothes, seemed to me to make it a slightly drabber version of the immensely successful image, several years earlier, of the radiantly blonde Princess of Wales photographed almost identically. I chose to leave it to languish.

It is when reviewing my own decisions, stripped of the refining perspective of distance, that I find it harder to judge whether a picture was wrongly relegated. There are fewer rejects from the past 10 years than in the magazine's earlier years, purely because, as previously mentioned, there was a smaller choice to start with. Each of those pictures carries with it the baggage of memory – the moment when I first examined them; the discussions with the fashion editor or the art director – sometimes, even, our exact words.

I wish now we had used Terry Richardson's Couture image of Helle, her mouth brutally gagged by the metal Messieurs sign on a Parisian brasserie door (page 319). And the David Sims photograph of Emma Balfour, which successfully mixed the tail end of grunge with a *Vogue*-ish glamour (pages 272–3). However, I can't say I regret losing the Nick Knight image of Kylie Bax seemingly electrocuted by light (page 322), or the highly eccentric Paolo Roversi images from a shoot entitled 'Wild and Wonderful' – a gaunt woman in expensively theatrical layers of tat (pages 298–9). The nonsensical introduction to the published story ran, 'Mainstream fashion is all about pared-down classics, but there's still room for invention.' Where was I when that was written?

It's been my privilege to have occupied the editor's chair at *Vogue* for a decade – a slim chapter in the history of the magazine. What this book demonstrates so vividly is that *Vogue* has commissioned much of the very best fashion photography in the world over the past century. We must ensure that in the future, when *Unseen Vogue 2* is compiled, we have left later generations as extraordinary a legacy as we have inherited.

Alexandra Shulman is editor of British Vogue.

THE CINDERELLA SYNDROME by ROBIN DERRICK

Fashion photography has long struggled to be taken seriously. In the past, even some of its most important practitioners have dismissed their pictures, considering their portraiture or documentary pictures to be their 'real' work. For them, fashion photography may have been simply a lucrative sideline or a means of social access. For most of the twentieth century, few photographers regarded it as their 'main event', creatively speaking. Even at the height of 'supermodel-dom' in the late 1980s and early 1990s, a period when the fashion photographer's star had definitely risen, many fashion photographers, on appointments to show their work to the art director, would accompany their published 'tear-sheet' portfolio with a more 'serious' black-and-white album of 'personal' work – landscapes, trees, truck stops and so on, and, usually, a nude. They thus attempted to align their work with the more 'noble' photographic ambitions of, say, Walker Evans, Edward Weston or Bill Brandt. It is no surprise then that the genre has suffered from a Cinderella syndrome; the poor but pretty sister of real photography, fashion photography has been undermined as a serious artistic medium by its superficiality, prettiness and obvious appeal. The contrivance and commercial nature of many of the pictures has discredited them both as art and as historical record.

Accurately recorded within the medium, of course, is the history of fashion: the decline of the great couture houses and the parallel rise of the designer. The Norman Parkinson picture of 1948 for a London Collections sitting (page 54) shows an outfit by Worth – creator of one of the first great fashion houses and, in 1856, the first couturier to 'sign' his dresses. Three more generations of Worths ran the business until the Paris salon –

closed during World War II – was sold in 1946. Worth of London remained at 50 Grosvenor Street, where lack of competition after the war allowed it to survive – selling made-to-measure clothing – until 1954, when the name was sold to a scent manufacturer. Perhaps the exclusion of that dress from Vogue's Collections sitting was symptomatic of its creator's decline.

The first picture in Unseen Vogue (pages 14–5) shows Chanel outfits worn by the Marquise de Paris and others – clearly a group of very aristocratic Frenchwomen; the last, Angela Lindvall – a modern, languid American beauty from Lee's Summit, Missouri – wearing Gucci. Such is the trajectory of Vogue magazine – and fashion itself. Once the exclusive territory of the elite, fashion is now a part of an international culture that, in the developed world, touches most areas of our lives.

Changes in women's fashion obviously reflect changes in society and convention, whether it is a matter of not having to wear a corset, or the licence to wear a shorter skirt. Fashion photography offers a distilled image of these changes in attitudes and tastes. Here are documented the different degrees of acceptable undress and the evolving body language – authoritative, passive, aggressive or sexually provocative. The pictures' situations and styling have been created deliberately to heighten the mood or to provide some social context or narrative. It is not only the photographer, however, who is distilling the moment; the designers' clothes are also intended for one season only and, in their own way, are also 'moments in time'. Thus develops a synthesis that captures a mood in a very precise manner.

Yves Saint Laurent became head designer at Dior in 1957 and, after he was invalided out of national service, he created his own label in 1962. A look at the pictures of the Yves Saint Laurent outfits in this book offers an insight into the symbiosis of fashion and fashion photography: David Bailey's provocative pictures of Marie Helvin on his bed in 1974 (page 205), Guy Bourdin's foreboding pictures of a YSL suit in 1975 (page 215) – with his instructions to print them with a 'twilight ambience' – and his sexually charged pictures of Yves Saint Laurent chiffon dresses in 1977 (pages 220–1). Nick Knight stripped back his lighting to one bare flash bulb to create his raw image of 2001 (page 346–7), only this time the designer directing the fashion house was Tom Ford. These pictures complete a cycle, showing both the chic sexuality of the designer's art and the shared dark, erotic vision of the different photographers.

Unlike the 'worthier' photographic endeavours of portraiture or reportage, fashion photography makes no attempt to be truthful or timeless. On the contrary, it strives for an idealised image and one which is intrinsically of the moment and therefore ephemeral. These are images infused with the preoccupations and desires of their time.

The Clifford Coffin pictures taken in Grosvenor Square in 1947 (pages 50–1) say more about postwar Britain than many contemporary reportage pictures of bombed London. In these pictures a woman in a ball gown stands in the ruins of a grand town house. The war is over, the end of the British Empire is at hand, the country faces huge debt, which it will take decades to repay. Amid the rubble, the model wears the new season's fashions, with a mixture of optimism, ignorance and

an anachronistic air of self-importance. This picture was not intended to be an arch comment on postwar Britain; rather it was taken by a man of his times trying simply to capture the character of the season. His record is therefore an authentic document of the spirit of the age.

Such pictures trap in amber fleeting concerns and obsessions and encapsulate mood more accurately, or at least honestly, than might more studied observation. This quality of fashion photography is well recognised. Indeed some fashion pictures have so effectively absorbed the *Zeitgeist* that they have become icons of their period: a couple sitting on the end of a diving board, taken by Hoyningen-Huene in 1930; the back of a woman wearing a loosely fastened corset, by Horst, 1939; Helmut Newton's picture of a slim woman dressed in an Yves Saint Laurent tuxedo on a dark street in 1975; Twiggy on a monkey bike, by Ronald Traeger in 1967. These pictures have become a kind of visual shorthand for particular eras, and are now familiar through repeated use; they are not included in this book. Television documentaries on the 1960s always contain a fashion shot of girls in sci-fi Courrèges jumpsuits or white sunglasses; for a survey of the 1950s, similarly, there will be a tight-waisted full skirt and a fin-backed car.

Since the history of fashion photography has not until recently been considered a serious area for study, it has inevitably been haphazard. Not only, compared to other types of photography, does the form carry the stigma of frivolity and superficiality, but the published record is lamentably incomplete. Once fashion pictures have been published in a magazine, they are indexed and referenced. The photographer may subsequently receive syndication requests for their published work – the same images may be reproduced again and again – but their unpublished pictures remain unseen. What's more, picture researchers working on new books rarely bother to trawl through vintage magazines, restricting their searches instead to existing collections of fashion photography. These are mostly monographs produced by photographers, their agents or their estates in an effort to sell or perpetuate their work, so they scarcely constitute a full resource for an even-handed evaluation of the genre. Largely as a result of the way pictures have been used or recorded, therefore, the history of fashion photography has been reduced to some 200 famous – and now hackneyed – images.

Unseen Vogue, while it cannot be totally objective or comprehensive, looks at the history of fashion photography through the microcosm of *Vogue* – particularly British *Vogue* and its unpublished archive, which offers the chance to retell those stories, to question icons and re-evaluate unused images. It is interesting to recognise how our preoccupations have changed, but maybe more so to see the extent to which they remain unaltered.

For me, as the current creative director of British *Vogue*, who commissions the photography each month, this book has represented an extraordinary journey through the many thousands of unpublished pictures in the vaults. I recognise the frustrations, the brave attempts, the crushed gems and simple cockups that constitute this mass of work. I acknowledge the effort that went into each picture, and I take this opportunity to salute those whose work I have had the honour to pick over.

Robin Derrick is the creative director of British Vogue.

'WHEN I DIE, I WANT TO GO TO VOGUE' by ROBIN MUIR

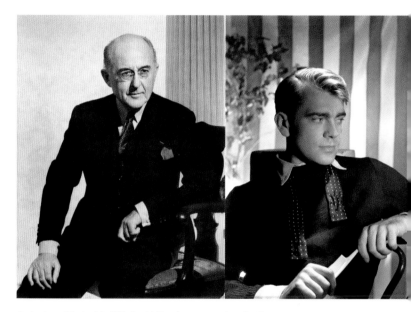

At the time of his death in 1942, Condé Nast, the owner of the magazine publishing house that still bears his name, oversaw a stable of a dozen or so magazines (one of them in abeyance: French *Vogue* suspended itself for the duration of the German occupation). His obituary in British *Vogue* related that 'to the publishing world, he was one of the few who have always originated, never copied. He lifted fashion drawing from the level of hackwork to that of an art. He was the inspirer of a new taste in photography…' It might have added that he oversaw the development of the modern magazine layout and fostered the art of modern typography; it might also have recorded that almost every famous photographer of the quarter century before his death had either started with The Condé Nast Publications or worked for them early in his or her career. Had Argentinian *Vogue* still been in existence (it ran 1924–6), or the Havana-based Spanish *Vogue* (1918–1923, revived successfully in 1988 but from Madrid), or the first German *Vogue* (a lamentably short early life 1928–9, but revived in 1979), or the original *Vanity Fair*, which ran for 23 years until amalgamated with American *Vogue* in 1936, no doubt they too would have eulogised their

proprietor. For Nast was truly a modern publisher. Having sniffed a trend in the air, in whatever aspect of contemporary life, he never shrank from taking the risk of originating a magazine to feed, and feed on, that trend. He might then, with equal composure, have admitted its failure and closed it, rather than keep it going purely for the sake of appearances. The original German *Vogue*, incidentally, lost Nast around $300,000, which included the cost of a Christmas promotion, on a scale which was startling even for the Weimar years – 55,000 cocktail shakers, filled with mixed martinis, were sent out to newsstand distributors.

The obituaries which appeared in both his *Vogues* were accompanied by the same portrait (*above left*) by Horst. The choice of valedictory picture is significant and reveals more about the man and, by association, the spirit of his stable of magazines than might have any alternative. During his life (1873–1942), though he largely shied away from the camera, he was known as a gregarious man (he entertained, for example, on a colossal scale) and there would have been other photographs with which to commemorate him. In Horst's portrait,

below, from opposite left
Condé Nast by Horst, 1932; Horst, 1930s (unaccredited);
Cecil Beaton's photographs, 1942 (detail from a self
portrait); George 'Dadie' Rylands as the Duchess of Malfi by
Cecil Beaton, 1924; Lee Miller by Georges Lepape, 1927.

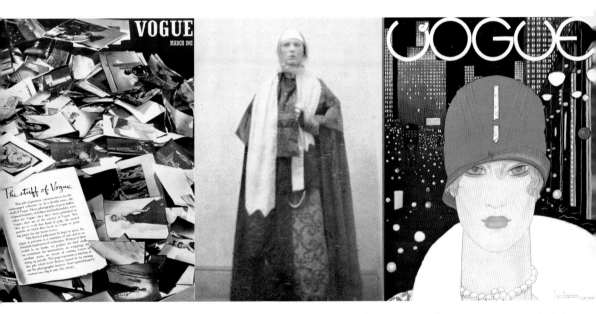

Nast certainly looks every inch the publishing magnate – straight-backed with pince-nez, starched cuffs and a pocket-handkerchief; patrician certainly, but reserved or sensitive enough not to meet the gaze of Horst's lens.

The use of this picture represented a final irony. Horst (*opposite right*), born a German in 1906, is known as one of *Vogue*'s great photographers. Indeed very little of his 60-year career was spent away from The Condé Nast Publications. But Nast himself effectively killed that career stone dead in its infancy.

In 1932, Horst, who had been in New York photographing for *Vogue* for some time (hired by Nast himself at $60 a week), was summoned to Nast's office. There, laid out on two mahogany tables, was six months' work – Horst's entire output for the magazine, published and unpublished. Balancing his pince-nez on the end of his nose, Nast gave the photographer the benefit of his advice and criticism – two hours' worth – much of which, Horst recalled, was valid. However, when the young photographer made an effort to defend

his work, he was cut short by the proprietor: 'If you can't make a picture out of this dirty ashtray,' barked Nast, pointing at the table, 'a picture that could be hung in a museum, then you are no photographer. I realise of course that you are not Edward Steichen…' Horst started to reply along the lines of: 'If I didn't think I could one day be as good as Steichen…' but Nast, already bristling, exploded into a rage, the severity of which, Horst heard later, was unique in *Vogue*'s history. Horst found himself fired.

So, at 26, Horst was all but destroyed. He had little alternative but to return to Europe – until two years later, when Nast welcomed him back. Surely it would not have escaped either man barely a decade later, that one of the last pictures Horst took before this showdown – possibly *the* last picture was adopted as the definitive portrait of Condé Nast, and was finally used as a tribute to him by *Vogue* – the cornerstone of his empire.

This story illustrates the way magazines and their favourite sons and daughters fall in and out of favour with each other: they compromise; they

break free of one another; they come running back. And each is occasionally prompted by necessity to forgive. As the last line of Nast's obituary in American *Vogue* put it: 'His door, like his heart, was always open.'

Norman Parkinson, one of British *Vogue*'s most celebrated contributors, was certainly one of those who experienced that tolerance. In the late 1940s, as he recounted in his memoirs, he 'meticulously embarked upon a course of behaviour of which I am not proud…' Having earmarked a transparency, from four choices, of a Victor Stiebel dress he expected *Vogue* to run full page, he enquired of the art director, John Parsons, which he would use. Parsons did not select Parkinson's chosen frame but another. The photographer then took the art director's favourite, held it up to the light and ripped it into pieces as small as his teeth would render. That accomplished, he walked back to the *Vogue* Studio. Later, he received a telephone call. Parkinson recalled the brief conversation: 'When you have finished, would you please go to see Mr Yoxall?' (Harry Yoxall was then *Vogue*'s managing director.) 'I knocked nervously on Harry's door and

stood before him for the expected admonishment. "Parkinson, you have done a very bad thing; you have shocked your good friends and you have no right to offend them so. However, the damage is done; please don't do it again. You have made a serious mistake, your behaviour is unforgivable, but please understand I cannot afford to employ people who *don't* make mistakes.'" Mr Nast and Mr Yoxall knew much about magazines and a thing or two about human nature besides.

We hope that this compilation of unpublished photographs from the archive of British *Vogue* will reveal something about the ties that bind magazine and photographer. Sometimes – many times probably since its inception in 1916 – the ties are pulled taut and begin to snap. Many of the photographs you see on these pages are taken from 'killed' sittings. This means, in *Vogue* parlance, that not a single exposure from the story, though commissioned for a particular issue of the magazine, was ever used in it. The photographer's expenses would have been covered, his negatives or transparencies paid for; but they were then bundled together and deposited in the *Vogue* Library to grow old in Manila envelopes. Photographers do not enjoy being 'killed', which is unsurprising, since the term, a convenience for the magazine, is close enough to 'failure', 'not-quite-right', 'past it', 'execrable', 'laughable' or even 'he/she'll never work for us again.' In his autobiography, writing of photographers, Harry Yoxall recorded, '[they] suffer morbid suspicions of their colleagues. They claim their techniques are plagiarised and demand personal assistants restricted to their private use, so that their "secrets" cannot leak through to other photographers. But the results of their work will be passing through the hands of the art and fashion departments in a day, will be revealed on the editor's board in a week and be published to the world in a month…'

Maybe, through this book, some of those overstretched lines can be slackened and repaired, wires uncrossed and ancient grievances laid to rest, for among the hundreds of thousands of unpublished pictures stored in the *Vogue* Library, many of those 'killed' so long ago – and not so long ago – are self-evidently brilliant, and worthy of the life initially denied them. *Vogue* editors don't cast aside sittings or pictures wilfully. With the benefit of hindsight, it is clear that many were killed not because they weren't good enough or the

composition and execution poor, but because the fashion was too obscure, the styling too inventive, the camera technique too pioneering. Maybe, for a combination of these reasons, they were just too far ahead of their times. If there wasn't enough room for them in August, perhaps they were held over for September then forgotten until October when, as the new Collections issue approached, their moment was lost. In some cases 'killed' has become 'obliterated without trace', so there are several outstanding images here for which we had nothing to guide us as to authorship – they remain anonymous.

For all the pictures that were published there are, of course, all the other exposures and setups from that sitting that were not used and were relegated to the bags marked 'overs', 'out-takes', 'rejects' or 'variants'. So you may half-recognise some of these unpublished photographs. Moreover, although Nast and his successors mostly allowed each *Vogue* to be autonomous, in the early years of colour printing, British *Vogue* was reliant on 'lifts' from its American sister. This means that it borrowed colour plates of published pictures to complement home-generated material. This was useful – if not indispensable – during the war years, when any *Vogue* photographer who was able was involved in the war effort. This policy stretched into the postwar era and, for 'International Collections' issues, up to the 1960s. It was thought expedient before then for one photographer, nominated by American *Vogue*, to cover the Paris Collections and for the results to be distributed to all three *Vogues*. There are a few examples here of such photographs which, although accepted by British *Vogue*, were not finally used.

In a handful of cases we have stretched our criteria to include photographs-never-before-published-in-this-form. In other words, they *did* run in the magazine but were cropped (only part of the full image appeared), used only as small insets, or otherwise published in a barely recognisable format. These are presented here as the photographer originally submitted them. This applies particularly to the work of Lee Miller, *Vogue*'s war correspondent (an unlikely role on a fashion magazine) and a true heroine of her era. That era included the 1930s when she was an occasional model for *Vogue*, having been discovered by Condé Nast himself. (She had stepped off the kerb of a Manhattan sidewalk directly into the path of an oncoming car, but was pulled back to safety by a

passer-by… Condé Nast.) Miller relentlessly sent back dozens and dozens of rolls of films from whatever front on which she found herself – she was invariably there before anyone else. Despite the constraints, *Vogue* never missed an issue during the war years but, struggling with wartime paper restrictions – its wartime issues were a quarter of its peacetime size – it could not publish all Miller's work, despite its popularity. Often her reportage ran at a size only slightly larger than postage stamps, and even then it was cropped in a way that displeased her.

In fact British *Vogue* owed its genesis to the previous world war. Nast bought *Vogue* in the United States in 1909 (it had existed since 1892 as a weekly for Manhattan socialites) and until the Great War it sold well through agents in Europe. It sold well in Britain, too – 3,000 to 4,000 copies by the time that war broke out; four times that number by 1916. However, the same year saw an intensification of submarine warfare and the merchant fleet inevitably concentrated on essential cargoes, leaving *Vogue* stranded in the American docks. With commendable courage and foresight, Nast started up British *Vogue*, his first overseas venture. The inaugural issue came out on September 15, 1916, and cost one shilling (5 pence).

During the Second World War, paper was in such short supply that a prospective subscriber to *Vogue* had to wait until an existing one died. The magazine decided to set an example to its rivals, the consequence of which explains why the bulk of this book starts at around 1946. The frontispiece to the issue of March 1942 (a cropped version of the photograph on page 19) showed a mound of photographic prints captioned as follows: 'This pile of pictures – treasure trove for the wastepaper collector – is, in a double sense, the stuff of *Vogue*. These photographs of great ladies, of great beauties, of fashion and fashionables, were taken for *Vogue*; they have been published in *Vogue*; they are of the essence of *Vogue*. Now they go to swell that flood of pulp, the merest particle of which flows back to *Vogue* as printing paper for our future issues…' With that, *Vogue* urged its readers to turn out their own 'squirrel-hoards'.

And so the whole lot went – *Vogue*'s rich tapestry from its birth in 1916 through to the 1940s, hundreds of priceless masterpieces, all the Steichens and de Meyers, all the Horsts and, bar

one or two, Hoyningen-Huenes, all the drawings by Dalí, Bérard and Tchelitchew… pulped. There were, as you will see, some escapees from the purge, but they are few. One, a vintage print by Hoyningen-Huene of de Meyer (page 17) is among the most exquisite photographs the *Vogue* Library holds. While the published photograph of the March 1942 frontispiece showed only Cecil Beaton's clear-out, other staff photographers' archives followed suit. In fact not all of Beaton's oeuvre was lost; he lodged some contact sheets and rough prints alongside his negatives, which the *Vogue* Library has stored since the 1930s.

Of all *Vogue* discoveries – for the magazine and for British culture in the twentieth century – Cecil Beaton is by far the most significant. 'I was an undergraduate when my first contribution appeared in *Vogue*,' he remembered years later. 'It was a slightly out-of-focus snapshot of the eponymous lead in Webster's *Duchess of Malfi* (played by the distinguished English don Mr George ['Dadie'] Rylands), standing in the subaqueous light outside the men's lavatory of the ADC Theatre in Cambridge.' So began his prolific career for the magazine – as a fashion photographer, portraitist, illustrator and caricaturist, writer and taste arbiter and, for most of a 54-year association, an indispensable contributor. Few careers illustrate the magazine's capacity for indulgence better than Beaton's.

In 1938 an incident occurred which hung over Beaton and Nast as much as the 'Steichen' affair hung over the proprietor and Horst. It concerned an inscription on an illustration by Beaton for a society piece in *Vogue*. Barely discernible without a magnifying glass, but most definitely there, was the caption: 'Mr R. Andrew's Ball at the El Morocco brought out all the damn kikes [Jews] in town.' A storm raged, fanned by Walter Winchell's *New York Daily Mirror* column. Accusations of anti-Semitism would not die down and, as his words were scarcely defensible, Beaton did not try very hard to defuse the tension. He was hauled out of his box at the New York Opera and summoned to Nast's apartment, where his resignation was sought: 'I could not mind more if I were losing my own son,' Nast said regretfully. The following day with *Vogue*'s switchboard jammed, he withdrew 130,000 copies of his magazine, thereby losing a considerable amount of money. As major advertisers prepared a boycott, Nast asked Beaton to leave town. 'You

plunged me, as a publisher,' wrote Nast, 'into a political and racial situation completely out of character with *Vogue* and entirely at variance with, and distasteful to, my own feelings.' It had serious repercussions for Beaton: articles were axed, photographs killed and in London he was told he would not now be designing the costumes for Orson Welles's *Henry IV*. Beaton assumed – wrongly – that he would still be free to photograph for British *Vogue*. Even though Nast allowed him back after three years, the affair haunted Beaton throughout the war years and beyond, and he found he was especially unwelcome in Hollywood. It was only in the late 1950s that he began to work again with any regularity for American *Vogue*. But finally Beaton was forgiven.

Beaton sowed the seeds of his decline with British *Vogue* in 1954, as an exchange of letters on pages 94 to 97 shows. But the magazine could not quite let him go nor vice versa, and he was a contributor (an increasingly infrequent one) until his death in 1980. Beaton's relationship with *Vogue* was always a little fragile. Yoxall records: 'Perhaps my most exacting task was the periodic renewal of his [Beaton's] contract. Conditions were readily agreed but when we reached the indelicate question of payment, Cecil would start a mysterious mental dance, with approach and recoil, like some hieratic pavane… Even my annual paper-buying expeditions to Aberdeenshire were simple in comparison.'

In spite of the hiatus from 1916 to 1946, the Library of British *Vogue* still holds, unquestionably, Europe's finest archive of twentieth-century fashion photographs. (This might have been the boast of French *Vogue*, but years ago, during some redecoration, so the story goes, the whole archive went out on to the Place du Palais Bourbon in bin bags to be liberated by passers-by.)

All the great names are represented there, some more fully than others: Horst and Cecil Beaton in the 1930s, William Klein, Norman Parkinson and Irving Penn in the postwar years, David Bailey and Helmut Newton after that, and, right up to the present day, Nick Knight, Corinne Day and Juergen Teller. There are a father and son too: Bob Richardson, the legendary and wayward photographer of the 1960s and 1970s, has been joined by his less wayward but equally provocative son, Terry. There are some names you might not expect: Brassaï (of *Paris After Dark* fame); John

Deakin, recorder of 1950s Soho, friend of Bacon and Freud, and now recognised as a giant of British portrait photography; Robert Doisneau, exuberant chronicler of postwar Parisian life; Henri Cartier-Bresson; grim Bill Brandt; and, of course, Lee Miller, among the first to enter the Dachau death camp. *Vogue* still keeps several of her typescripts (see page 38). There are forgotten geniuses too, such as Clifford Coffin, who reduced fashion editors to exasperation and models to tears decades before it became commonplace, and his colleague and rival Henry Clarke, who is surely overdue for recognition.

So it should come as no surprise that the *Vogue* Library over the years has been a magnet for costume designers, fashion and photography historians, fashion designers, fledgling art directors, biographers and photographers. It is still not fully explored; who knows what might one day come spilling out of a drawer or a long-forgotten box? It is now a resource solely for The Condé Nast Publications and only in special circumstances can you get through the doors. Gone then are the days of Julie Christie wandering in to research costumes for a film, or Philip Treacy to find inspiration for a hat, or of Terence Donovan dropping by on slow days at his studio across the road.

Until the late 1970s, the *Vogue* Library was barely run like a library at all. It took the pioneering efforts of its first titular head, Bunny Cantor, to make it more user-friendly. A very elegant woman, Bunny cheerfully admitted that she knew nothing about anything, nor could she recognise anyone apart from the Royal Family. Years after she had retired, pictures would be retrieved from the oddest places. Jacqueline Kennedy, for example, was filed as 'Mrs Hyannis-Port' (which, for a time, she quite probably was). Bunny could, however, recite the names of the top fashion mannequins of the 1950s and 1960s, for she had been one herself – much more useful, in this context, than recognising the wives of dead American presidents.

Although most of the contents of the *Vogue* Library are, and will remain, inaccessible to all but a few, we hope that this book will give a glimpse of that treasure and the illusive world which it encapsulates; a world whose glamour is neatly implied by a title once suggested for his (unwritten) autobiography to David Bailey, one of its most significant creators: 'When I Die, I Want to Go to *Vogue*.'

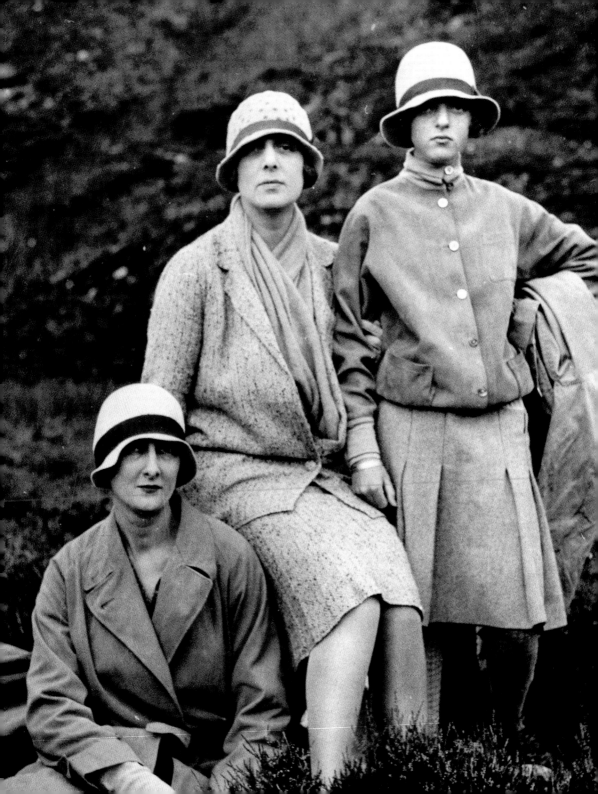

PHOTOGRAPHER UNKNOWN
THE MARQUISE DE PARIS, BARONNE EDOUARD DE ROTHSCHILD AND MADEMOISELLE DE ROTHSCHILD, LATE 1920s

The earliest extant photograph in the *Vogue* Archives, this dates from the era before modelling was considered a legitimate profession. In the guise of society pictures, however, such photographs could be captioned to include suitable descriptions of the clothes. The caption on the reverse of the image reads in French: 'Taking a few minutes' respite after a challenging climb, the Marquise de Paris wearing a grey waterproof, a grey felt hat with dark trim, the Baronne Edouard de Rothschild wearing a loose-cut suit by Chanel with matching scarf, and Mademoiselle de Rothschild'. In the early years of *Vogue* (and the infancy of magazine photography), material was shared between the various editions of *Vogue*, much of it travelling across the Atlantic from the founding publication American *Vogue*. This image was probably lent by the French edition (established in 1921); it was never published, and has remained in British *Vogue*'s possession ever since.

following pages

GEORGE HOYNINGEN-HUENE
BARON ADOLPHE DE MEYER, 1932

A portrait of the fashion photographer Adolphe de Meyer. To Cecil Beaton, de Meyer was the 'Debussy of the camera' and he was much influenced by de Meyer's extravagant style. Beaton's shooting through gauzes and latticework and judicious displays of lilies has its origins in de Meyer's arrangements for *Vogue*. Now recognised as the first professional fashion photographer, de Meyer was put under contract to *Vogue* in 1914. Created a Baron of Saxony around 1901, he was married, so rumour had it, to the illegitimate daughter of Edward VII or Wilhelm II, last Kaiser of Germany. By the time of this portrait, de Meyer's best work was behind him. He was working for more money but with less enthusiasm for *Vogue*'s rival *Harper's Bazaar*. On the reverse of this print is the name 'Agha' indicating, perhaps, that it was approved for publication by Dr Mehmed F. Agha, the monocled art director of American and French *Vogues* from 1928 to 1943, a founding father of modern magazine design. Also legible is the name 'Brunhoff'. This was the editor of French *Vogue*, Michel de Brunhoff, brother of Jean the creator of *Barbar the Elephant*. His discerning eye proved itself time and again, not least for turning down for *Vogue* a young illustrator, Christian Dior, on the grounds of poor draughtsmanship, recommending instead that he explore an obvious flair for fashion design. As de Meyer's soft-focus style slipped out of fashion and his career spiralled downwards, into his shoes stepped, among others, Hoyningen-Huene, who took this portrait. A displaced Baltic baron with a barely controllable temper, and a leading figure in the new genre of fashion photography, he too suffered a crash in his career not long afterwards. During lunch with *Vogue*, something was said about the terms of his contract, prompting the irascible Huene to upend the table – and the half-finished meal – over his companion. This happened to be Dr Agha. Huene's contract was not renewed and he joined de Meyer at *Harper's Bazaar*. This allowed his protégé Horst, already a rising star, to assume a place of prominence at French *Vogue*.

DE MEYER, Baron

PHOTOGRAPHER HOYNINGEN-HUENÉ

DATE February 20, 1932

WHERE Vogue Studio, Paris

SUBJECT Baron de Meyer

MODEL

DATE OF ISSUE

de Brunhoff / Agha #116

$1⁰⁰
9977

4873

16

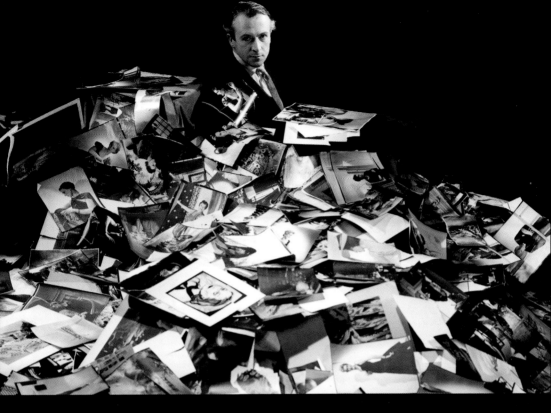

above

CECIL BEATON
SELF PORTRAIT 1942

As a response to the war effort, *Vogue* pulped its entire archive of photographic prints. Cecil Beaton relished taking a lead in this and was photographed sitting amid a pile of his prints destined for recycling. A few, like the Hoyningen-Huene portrait on the previous page, escaped the purge. The magazine's public spiritedness did not, fortunately, extend to the negatives it held. These photographs and those on the following six pages have been exhumed from a filing cabinet of negatives.

opposite

CECIL BEATON
MARLENE DIETRICH, 1936

Beaton photographed Dietrich in New York in 1935, producing the 'Merry Widow' profile portrait, which is now among his most famous pictures. Like so many photographers before and after him, in Dietrich he found his match. There was little she did not know about photographic printing, let alone lighting and composition. 'Please take a look at the left hand,' she instructed Beaton, poring over the finished enlargements. 'The line you put there is clear to see, but it is done in pencil and the rest of the hand that we wanted cut is still there.' Note the halo down Dietrich's right-hand side, indicating that retouching was carried out on the negative, rather than on the finished print. Beaton had included her in a list of the 'six most beautiful women in motion pictures', earning himself the dubious accolade of 'bravest man in Hollywood'. They became friends and the actress a frequent sitter. Surely he was not the first to exclaim, as he recalled much later, 'What cheekbones! What a forehead!' But he probably was the first to dare write in *Vogue*, some six years before this portrait was taken, 'Dietrich… is a few pounds overweight.' He took this in London, and on the same day photographed the actress Vivien Leigh for the first time

following pages (left)

CECIL BEATON
PRINCESS KARAM OF KAPURTHALA, 1936

Frequently in demand as a *Vogue* model, not least by Beaton, Princess Karam was much admired in *Vogue* for the exotic looks of 'our dark flower'. Although she is simply scaling a ladder here, there was not much that the Princess would refuse to do. At Lady Mendl's 'circus party', just before the war, fellow guests pondered the absence of an elephant or two. 'These elephants,' reported *Vogue*, 'caused more speculation and gossip than any beautiful woman… The true story is that Princess Karam Kapurthala (sic), the only person who knew how ladies should ride elephants, tried one out, with her hotel bed mattress strapped to its back. The circus elephant was not educated in Indian elegance and trod down half the circus in protestation.'

following pages (right)

CECIL BEATON
VIVIEN LEIGH, 1936

Vivien Leigh was one of Britain's most distinguished stage and screen actresses, whose considerable achievements are frequently overshadowed by her stormy marriage to Laurence Olivier and her fragile mental health. She appeared often in *Vogue* and Beaton photographed her many times. He worked on the set and costumes for Alexander Korda's *Anna Karenina* (1948), in which Leigh took the title role, on her husband's production of Sheridan's *School for Scandal* (1949) and on Noël Coward's production of a Feydeau farce, *Look after Lulu* (1959), in which she also starred. Leigh was particularly sensitive about her hands. When she complained that a pair of gloves Beaton gave her to wear were too small, he observed that it wasn't that they were too small but that her hands were too large. 'The remark,' according to Beaton's biographer, Hugo Vickers, 'was not forgotten.' Her evening dress in chartreuse green is by Victor Stiebel

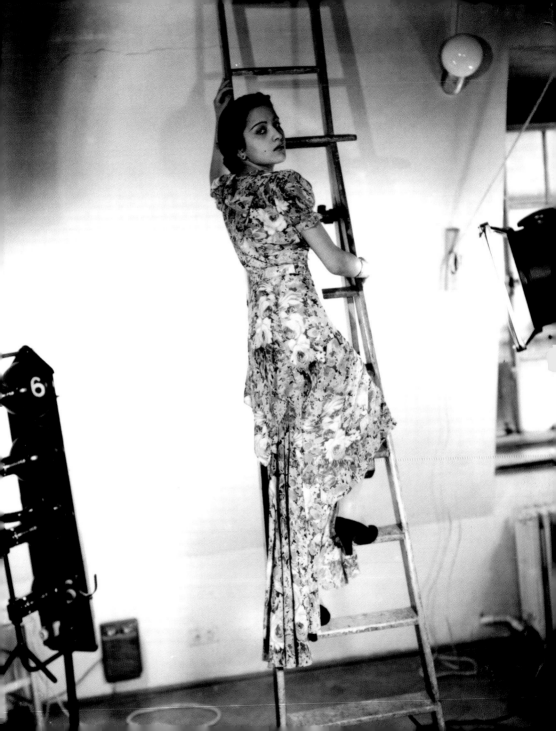

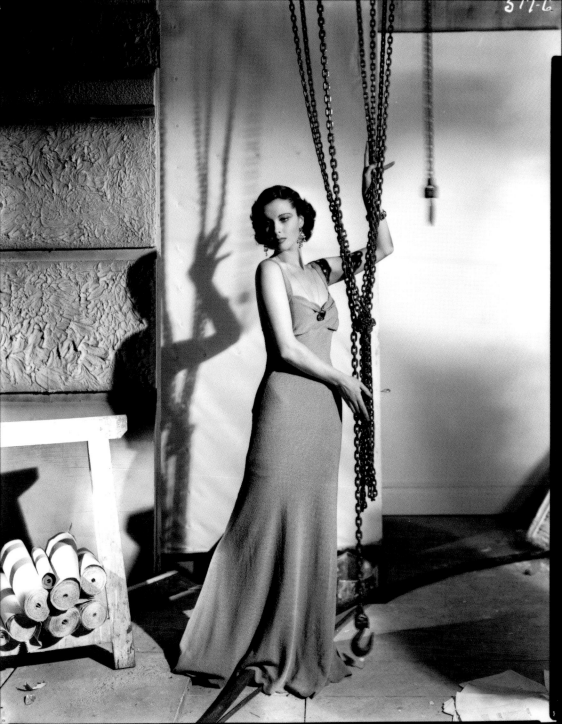

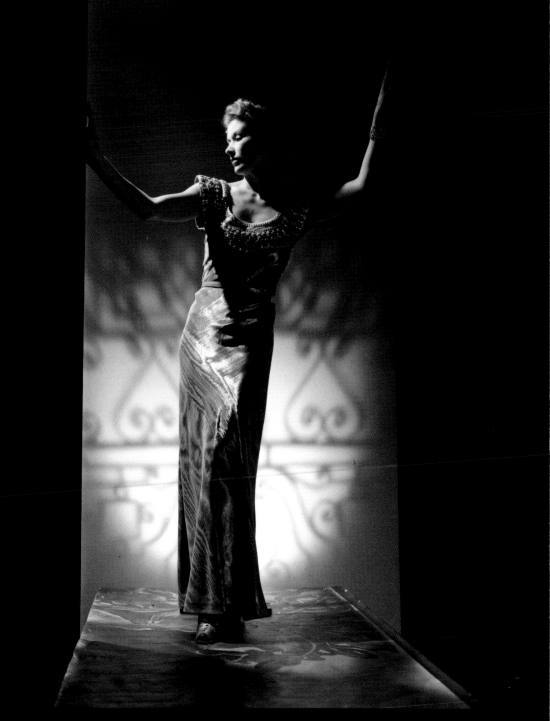

JOHN RAWLINGS
LISA FONSSAGRIVES, 1939

John Rawlings was a pioneer of the 'American Look'
of the late 1950s – 'a visual can-do-ism', according to
his biographer Kohle Yohannan, 'that American
women could immediately relate to.' Early in his
career, Rawlings was sent to British Vogue to oversee
its fledgling studio operation as the magazine lacked
enough home-grown talent to carry out all the
assignments for its pages. As an international fashion
centre of the 1930s, London lacked the glamour of
Paris or even of New York, but Yohannan's assertion
that, by accepting a posting there, Rawlings was being
'promoted to night watch on the Siberian front' was
an overstatement. As Rawlings would later remark,
'The day I left for London was the luckiest day of my
life…' and he lasted five years there. The Swedish
model Lisa Fonssagrives is best known for her
collaborations for Vogue with Irving Penn, her second
husband. They met in 1947 and married in London in
Chelsea Register Office, 'sandwiched between
portrait sittings of T. S. Eliot and a fishmonger',
recalled Penn. From 1936 to the early 1950s, the
decades before models became actresses or
restaurateurs or chat-show hostesses, the face of Lisa
Fonssagrives was one of the most recognisable icons
of contemporary beauty in America. She was, among
other things, the face of Tressemé oil shampoo tint
and had 'That Diamond Look' for Kramer Jewelry.
She appeared on the cover of Time magazine, the
first model to do so, named above the headline, 'Do
Illusions Sell Refrigerators?' She was so prolific in the
fashion pages of Vogue and Harper's Bazaar that her
face, it was said, was as recognisable as the Mona
Lisa's to three decades of magazine readers.

following pages (left)
CECIL BEATON
VALERIE HOBSON, 1941

The British actress had recently made *Unpublished Story*, in which she
played a young reporter covering the dangerous days of the Battle of
Britain. Beaton photographed her for an article 'Fashion in War Films',
against an appropriately war-scarred background; the *Vogue* Studio had
recently been damaged by fire.

following pages (right)
CECIL BEATON
VOLUNTEER NURSES, c.1942

Beaton's wartime photo-essays from around the world are well known
and considered no less interesting because he never came under enemy
fire. To compensate for their lack of immediacy, he became ever more
inventive with form and composition. By the end of the war he had
published eight books of his war photographs. He did not neglect the
domestic front, and for *Vogue* he ensured that the efforts of those left at
home did not go unsung. This shot illustrates the approach that Beaton
took to photography in the war years: pared down and free from the
baroque artifice of much of his previous fashion work. Still a little
mannered, it is nevertheless appropriate to the spirit of the times and the
services *Vogue's* readers were expected to volunteer.

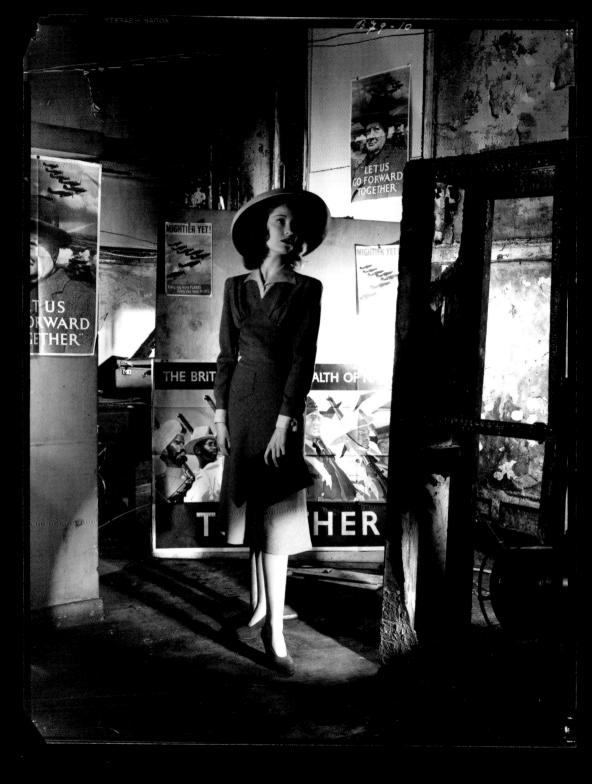

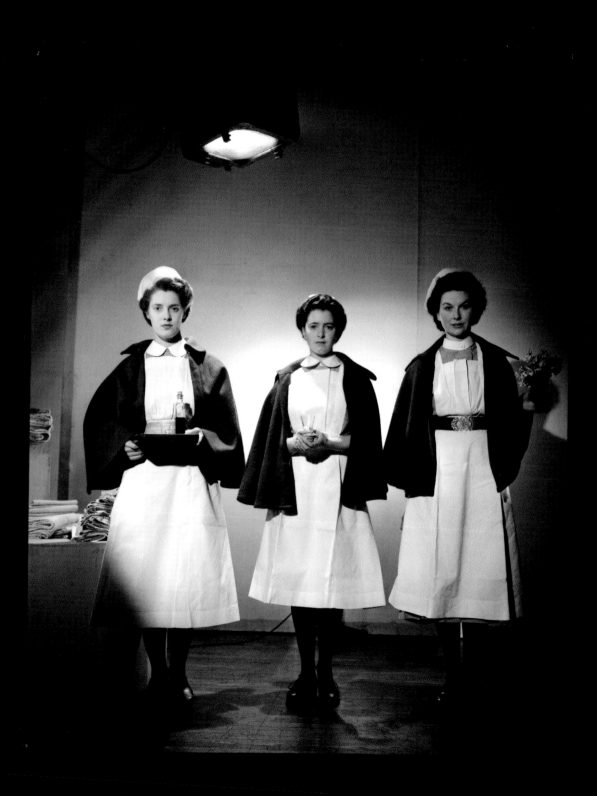

ELFER
SUMMER FASHION, c.1943
For a while, *Vogue* reacted to the war years with displays of optimism, such as this and Beaton's photograph on the following page, that denied the carnage of war in favour of a sunny English idyll. The rayon crêpe dress (*left*) is by Spectator Sport, the woollen one (*right*) by Bery.

CECIL BEATON
LAND-GIRL FASHION, c.1940
Pictures taken at harvest time in the Home Counties.
It is possible that the girls Beaton used were models,
but more likely that they were simply young local
people. If the date is correct, the wholesome industry
that these photographs portray belies less peaceable
activity elsewhere – the Battle of Britain raged
from August until October of 1940.

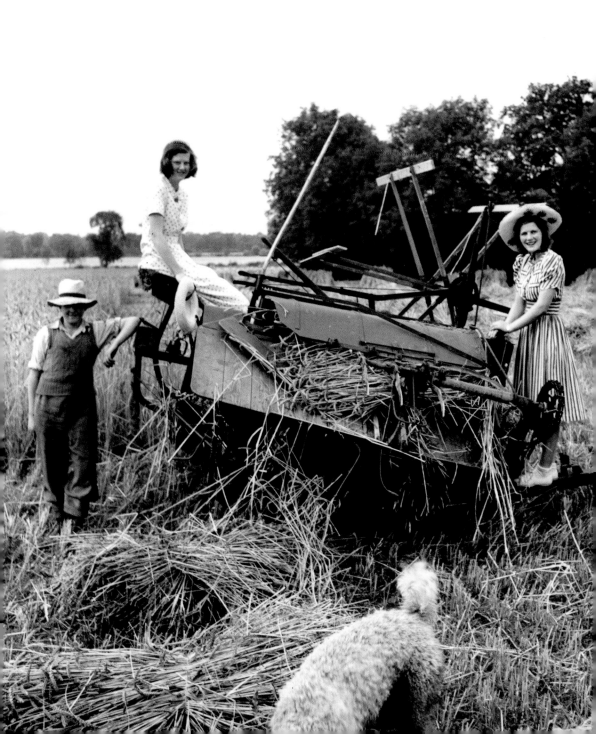

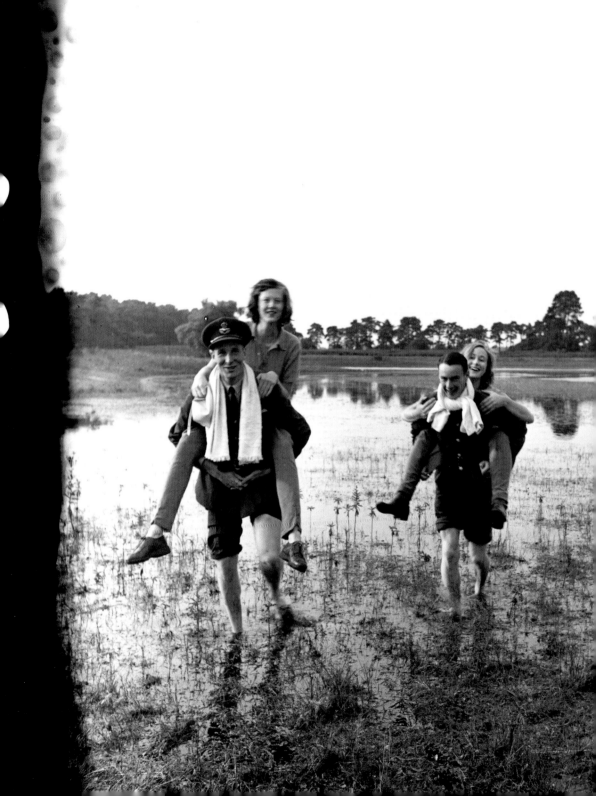

CECIL BEATON
LAND-GIRL FASHION, c.1940

This photograph, found at the end of a damaged roll of film, was taken during a break from the fashion sitting from which the pictures on the previous pages were part. The RAF pilots were probably from a nearby airbase. At the height of the Battle of Britain, the life expectancy of Spitfire pilots could be measured, it was said, in days, if not hours. Beaton was immensely moved by the fighter pilots and bomber crews he came across, their stoic resignation, flippant disregard for death and their light-hearted euphemisms for it: 'bought it', 'presumed lost', 'bumped off'. In one of his finest wartime pieces for *Vogue* – 'RAF Impressions' (1941) – he articulated the emotions that his subjects might not express for themselves for fear of 'letting the side down'. And he wrote this from the operations room of an airbase, perhaps not far from the flooded fields over which these young men had carried his models: '[Here] it is often possible to hear the fighter pilots talking from their radio set to another. "Look out on your right," you hear them say. "What's that to the left?" Always it produces a shiver down the spine and a dryness in the mouth of those that hear the cry "Tally Ho!" as the fighters dive to engage the enemy. It is not always easy to hear clearly and so messages are often repeated. "Raid successful, raid successful – losing height over the Alps, plane losing height over the Alps. Love and kisses, love and kisses." The heart must stop when the "ears" hear, "Bombs released on target. Am bailing out now over the sea. Good morning, brother…"'

LEE MILLER
THE LIBERATION OF PARIS, 1944

Lee Miller's dispatches from the front, both photographic and
textual, are astounding documents. Some originals of both still
exist at *Vogue*, the typed-up articles full of crossings-out and
addenda, for she often found it almost impossible to convey
adequately all she felt. This photograph and that on the
following page are taken from a set chronicling the liberation
of Paris. Miller had hitched a ride to get there on the very day
of deliverance. The deadpan tone of the caption (*above*) to
this photograph – evidently not supplied by Miller – was
designed to reassure readers that, with the arrival of the
Allies, life in the fashion capital of Europe would return swiftly
to normal. That it ignores the party of GIs in a jeep and the
flag of the Red Cross on the handlebars of the young Chilean
in the foreground may have irritated the photographer.
According to her son and biographer, Antony Penrose, 'Lee
was often dissatisfied with the text presented with her
pictures. She felt that the cloying pap produced by some of
the copywriters reduced the impact of her photographs and
compromised her ideals of honesty and accessibility.' These
pictures were accompanied by an article, written by Miller,
entitled 'Paris... Its Joy... Its Spirit... Its Privations'.

LEE MILLER
STILL LIFE IN THE STUDIO OF ROBERT PIGUET, 1944
For this still life, Lee Miller has positioned, amid the hats and
hatboxes of the milliner Paulette, her calling card – a biretta, with its
insignia denoting the wearer as a United States War Correspondent.
The war in Europe was far from over. The issue that saw these Paris
pictures also featured Miller's coverage of the siege of St Malo, where
napalm was used in action for the first time. *Vogue*'s Lee Miller was
the only photographer and reporter there.

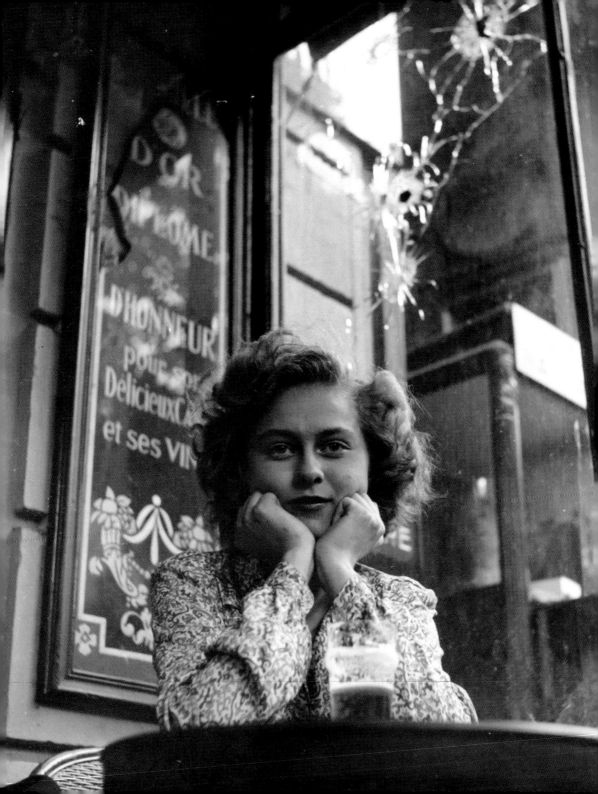

LEE MILLER
CHRISTIANE POIGNET, 1944
Published as a vignette in the magazine in November 1944, this is the full version. Mademoiselle Poignet was a law student. 'Paris had gone mad…' wrote Miller: 'Girls, bicycles, kisses and wine and, around the corner, sniping, a bursting grenade and a burning tank. The bullet holes in the windows were like jewels…' and just the kind of tableau that would have caught Miller's Surrealist eye. In 1929, she had left New York for Paris, resolving to meet the most exciting and inventive photographer then working there – Man Ray – to become not only his model but his pupil. She became both, and his lover, too. Though their partnership was stormy, it was for both a creatively fruitful one.

 OPEN ONLY IN DARK ROOM.

 UNDEVELOPED FILM
 CAPTIONS

one roll Rollei. Portraits of Jean Oberlé...suggested by Michel for
 spotlight or scrap book.

two xxx rolls Portraits Drue Tartiere. .. wife of film producer
 director Jacques Tartiere.. victim of German
 gestapo... formerly Drue Leyton, under contract to
 Fox films. She harbored and nursed dozens of Amer-
 ican and British and canadian pilots during the last
 year of preparation for landings and when the Yanks
 got to her house on August 26 th this year several
 came out of her attics to join forces. This story
 has been in the American press, extensively... notably
 Helen Kirkpatrick and Jeff Parsons.. look it up.

 Waited for pictures until she had got her new clothes
 as always very well dressed befor war. Hat by Suzy in
 out door pix. Buildings in background Quai d'orleans..
 fourth floor above parked truck is her flat. Inside
 pix in her flat... wearing Schiapperelli dinner dress.
 Dress is xxl black... Jacket is black and blue brocade..
 You'd better pretty her up, as otherwise my throat'll
 be cut. Interesting to America probably as she is
 likely to go there on lecture tour. She is employed
 here in liason work, French MOI. like she was until
 fall of France. Church is backside of Notre-dame.

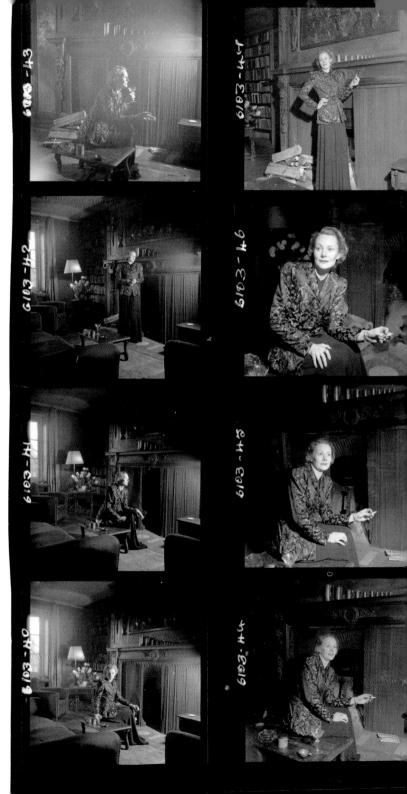

LEE MILLER
DRUE TARTIERE 1944

Lee Miller wrote these notes (opposite) to a profile of the former actress Drue Leyton from the Hôtel Scribe, Paris, the base for Allied war correspondents. She had reached it by hitching a ride from Rennes, where she had briefly been under house arrest for entering a combat zone without authorisation. At the Scribe, Miller had Room 412, the bathroom of which was her darkroom, and on a small table she placed her portable Baby Hermes typewriter. According to Antony Penrose, 'the room itself looked like the supply dump of an assault force. Weapons and equipment of every description overflowed from the wardrobe and drawers, cases of K rations were piled up against cases of Rouyer's cognac, and the whole lot buried under large cartons of flash bulbs.'

CLIFFORD COFFIN
'THE NEWS IS IN THE SHOES', 1946
For over a decade, in London, Paris and New York, Coffin produced some
of *Vogue's* most elegant fashion pictures. As well as covering the Couture
for the magazine in 1948 and 1954, he took one of the few photographs
of Christian Dior at his inaugural 'New Look' collection in 1947. He also
nurtured the careers of a generation of fashion models, including Wenda
Rogerson (Mrs Norman Parkinson), Barbara Goalen and Suzy Parker, and
discovered Elsa Martinelli, who worked with him as a model in Paris.
His lifestyle hastened an early retirement. As his workload escalated
(for his advertising work, at one point, he was the one of the world's
highest-paid photographers), his health deteriorated and he suffered bouts
of alcoholism and drug addiction. But his professionalism behind the lens
was never disputed.

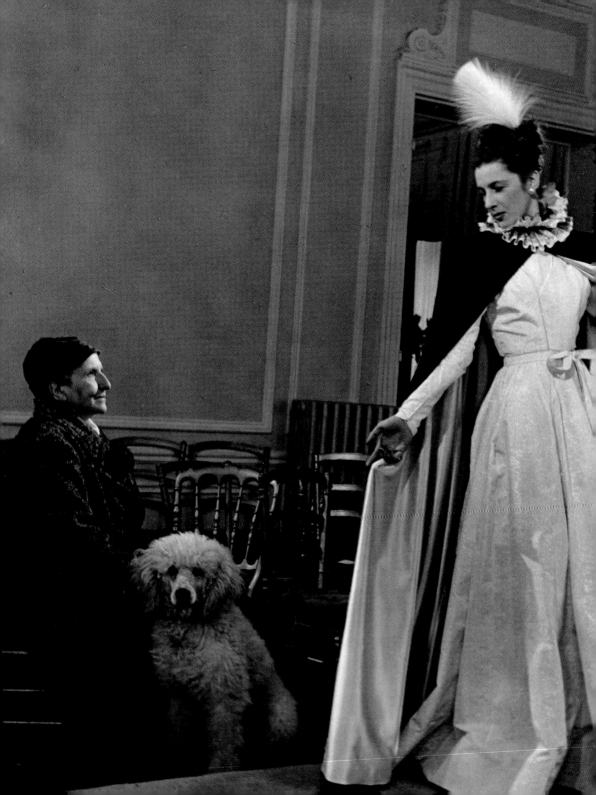

GERTRUDE STEIN AND FASHION

Pierre Balmain - Gertrude Stein is not exactly a fashion figure but she likes a fashion atmosphere. Here she is looking at the collection of Pierre Balmain - a slim mannequin showing a dramatic black taffeta evening cape that sweeps from shoulder to floor with a tiny white lace ruff tying around the neck. It is lined with white and worn over a white brocaded gown. A spout of white cross feathers shoot into the air.

HORST
GERTRUDE STEIN, 1946

As the original caption (*above*) suggests, the atelier of Pierre Balmain was an unlikely place to find the American writer Gertrude Stein. She had, however, become friendly with the couturier during the occupation of Paris (neither left the city and it was Stein's second world war lived out there). Horst also photographed her the following day in her apartment with its Jean-Michel Frank furniture, its paintings by Marie Laurençin and lampshades designed by Picasso, of whom she was an early champion. Her poodle was called Basket.

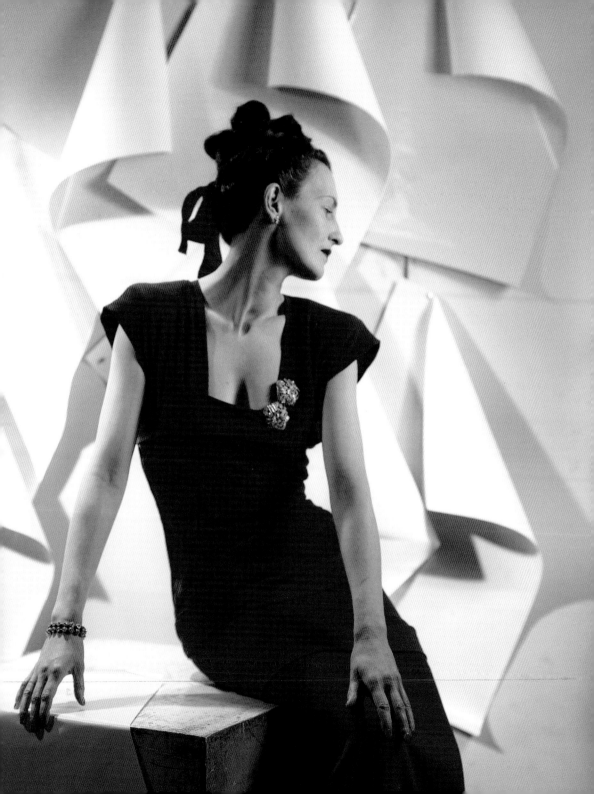

CLIFFORD COFFIN
DAY SUIT BY MARCUS, 1946
An American by birth, Coffin was 'on loan' to British *Vogue* from its
American sister publication to fill the shoes of British photographers
involved in the war effort. 'A thin, dark, nervous character', wrote *Vogue*
editor Ailsa Garland in her memoirs, 'he was, in his way a genius.' He
was enraptured by British life, its modes and manners, frequently using
circuses, pantomime sets and locations such as Stonehenge as
backdrops to fashion tableaux. His failure, however, to persuade the
Dean of Westminster to pose hand in hand with a model for him on
his way to evensong, led to an explosion of rage (from the
photographer and the cleric) for which *Vogue* was forced to
apologise formally. The incident appears, thinly disguised, in
Anne Scott-James's novel *In the Mink* (1952).

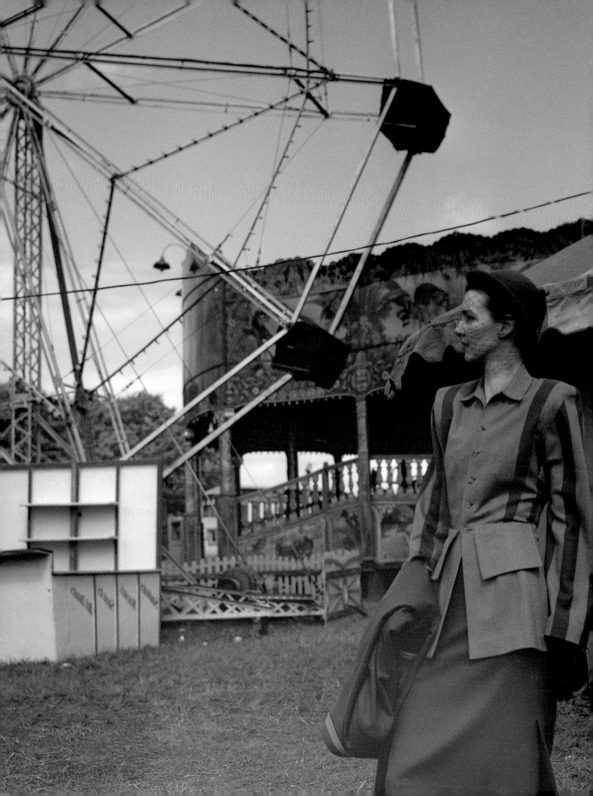

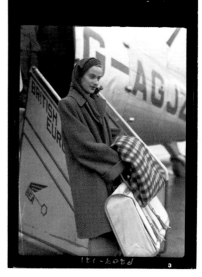

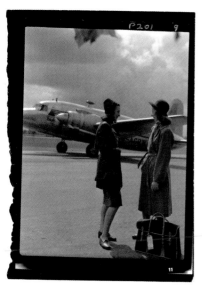

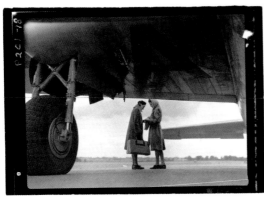

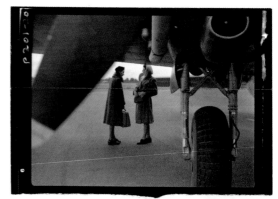

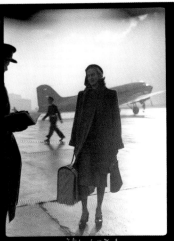

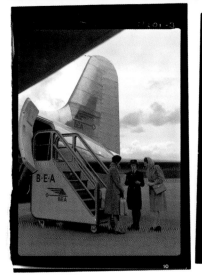

NORMAN PARKINSON
'WEEKEND IN BRUSSELS', 1947

'A Weekend Abroad – how nostalgic that sounds,' reflected *Vogue*. 'Now once again it is possible.' Even by 1947, two years after the conflict that reshaped the map of Continental Europe, many frontiers were still officially (and sometimes unofficially) closed. Travel for business, let alone pleasure, was difficult the closer to central Europe one chose to go. And financially extortionate in many cases, due to the spiralling inflation of recently occupied territories and those with trade balances to stabilise. Fashion travel, the backbone of the glossy magazine, gathered momentum, at least for British *Vogue* in the late 1950s and early 1960s, the age of jet travel. This trip to Brussels, undertaken by Norman Parkinson and a *Vogue* team a decade or so beforehand, was one of the earliest such trips and lasted 90 minutes in the air. *Vogue*'s 'take-off-and-land' wardrobe included a tomato topcoat to wear over an afternoon dress, a cinnamon stocking cap for warm ears at high altitudes and the staple air-travel accessory for years to come – a check rug.

following pages
CLIFFORD COFFIN
WENDA ROGERSON AND JOAN SEAGROVE, 1947

Fashion for a new era photographed in a bombed-out town house in Grosvenor Square, Mayfair. 'Ruins rise, and beauty has its second spring,' *Vogue* put it. 'The future holds equal hope and hazard, and the grace of a ball dress, bright against the rubble and brave in the encompassing dark, is a symbol of our gradual return to a certain serenity of life.' It was also a symbol of that characteristically English trait, most conspicuous in periods of hardship, stoicism – this time in the face of national bankruptcy, the imminent loss of an empire and, more pressingly for the ordinary *Vogue* reader, the aftermath of a ferocious winter. Among the clothes depicted are a pink faille dress by the Rahvis sisters, a black swing coat by Molyneux and a grey-and-white print dress by Peter Russell.

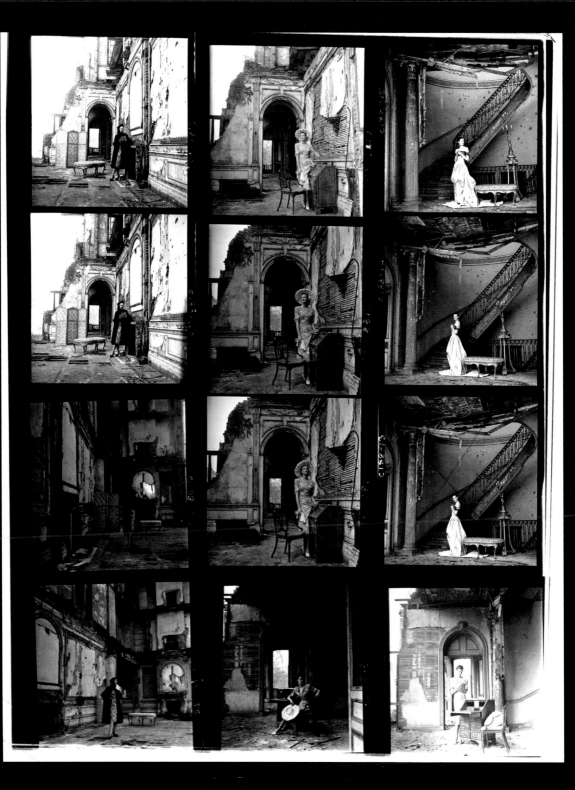

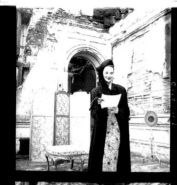
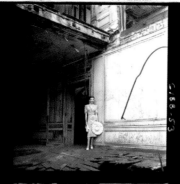
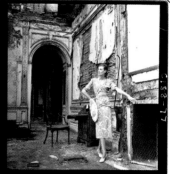
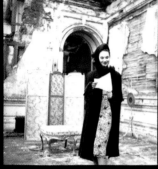
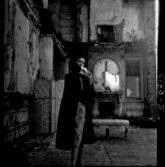
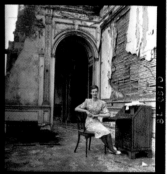
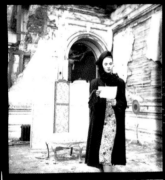
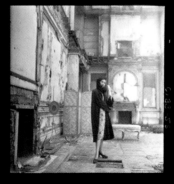
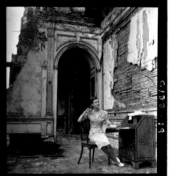
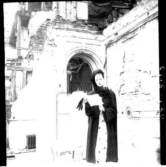
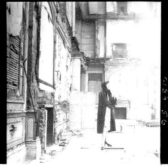
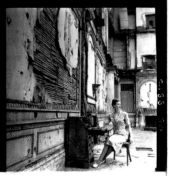

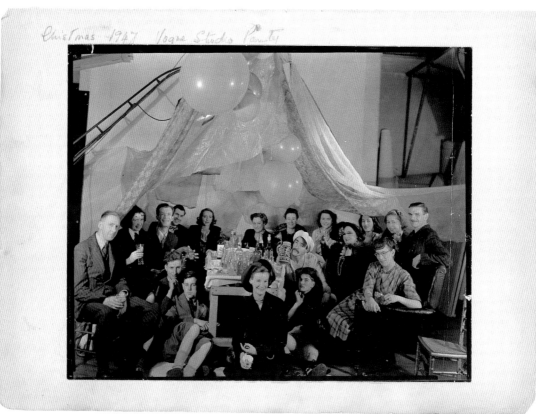

Christmas 1947 Vogue Studio Party

above

CLIFFORD COFFIN
VOGUE STUDIO'S CHRISTMAS PARTY, 1947

The *Vogue* Studio existed independently of the magazine in various locations in the West End, London: first in Rathbone Place, then Shaftesbury Avenue and finally in Vogue House, Hanover Square. It offered *Vogue* photographers a full back-up of assistants, printers, retouchers, appointment-makers and book-keepers and, for a commission, would find them advertising work. Like a fashionable restaurant juggling tables, the studio staff had to ensure that Cecil Beaton would not bump into Norman Parkinson, whom Beaton scorned for his lacklustre war record; that Parkinson would not come across Clifford Coffin, whose flamboyance he thought vulgar. No one wanted to meet John Deakin, a dandruff-flecked alcoholic. The studio's proximity to the pubs and drinking clubs of Soho would prove to be Deakin's undoing at *Vogue*, but ultimately his making as a portraitist. The members of the studio staff, arranged for this Christmas portrait, are *(from left to right)* Cyril Readjones, in-house photographer; Joan Morton, studio manager; Walter Crisham, a friend of Coffin; Ted Knowles, studio assistant; Robert St John Roper, a theatrical costumier; Vicomtesse Isobel d'Orthez, *Vogue*'s fashion editor; Sylvia Redding, head studio photographer; Pat Castle, the studio cleaner; a friend of Coffin (with tankard); Dickie Dunn, photographer's assistant; Pam Gosling, the youngest member of the studio office staff; Miss Rose, the retoucher; unknown; Hilda Cassell, head printer; Heather, a studio assistant; Jim Knight, assistant to Cassell. The guest of honour *(sitting centre)* is Wenda Rogerson. Some of the group reappear in Beaton's fashion photograph (opposite).

opposite

CECIL BEATON
BARBARA GOALEN, 1948

Beaton lamented the unsuitability of home-grown fashion models. Compared to their French and American counterparts, English girls possessed 'heavy legs, vast feet and thick wrists'. The situation perked up 'when Miss Barbara Goalen appeared as if from Cruft's' (a compliment, alluding to the similarity of her elegance and poise with that of a champion greyhound). Here she wears an embroidered velvet dress by Matilda Etches from the London Collections.

NORMAN PARKINSON
ANNE CHAMBERS, 1948

A photograph from the London Collections of 1948. The fragment of envelope that once contained it (*above*) tells us that the fashion editor was Vicomtesse Isobel d'Orthez. Her efforts and those of her predecessors and her immediate successor went largely unacknowledged in the pages of the magazine. Only in 1965 did the fashion editor join with any regularity the 'masthead' (the printed list of *Vogue* staff members found at the beginning of each issue). The fashion editor's position was itself vaguely drawn, especially in the early postwar years and before. In 1944 *Vogue* was unsure how to describe the Vicomtesse: 'She represents, rather than interprets, fashion,' it stated – the opposite of the modern fashion editor. During the war, when *Vogue*'s permanent staff numbered perhaps half-a-dozen, the fashion editor would be expected to supply her own copy for captions and credits, and to return the clothes and accessories she had called in. For a *Vogue* sitting in the days before hair stylists and make-up artists were *de rigueur*, she might also carry out their tasks too. Moreover, the Vicomtesse was occasionally called upon to be the model in her own pictures, by Clifford Coffin in particular. They vied to outdo each other in the extravagance of their vision. Though Parkinson suspected that 'Isobel d'Orthez knew as little about fashion as the editor [Audrey Withers], certainly much less about photography,' she was, by virtue of her personality ('lovable and memorable'), the earliest fashion editor at British *Vogue* to make a name for herself – despite the magazine's policy of anonymity. Bettina Ballard, a contemporary fashion editor at French and American *Vogues*, observed that, whatever fashion editing was, 'any editor who has never felt the thrill of translating fashion to paper through a photographer or artist hasn't really an notion for fashion editing at all.'

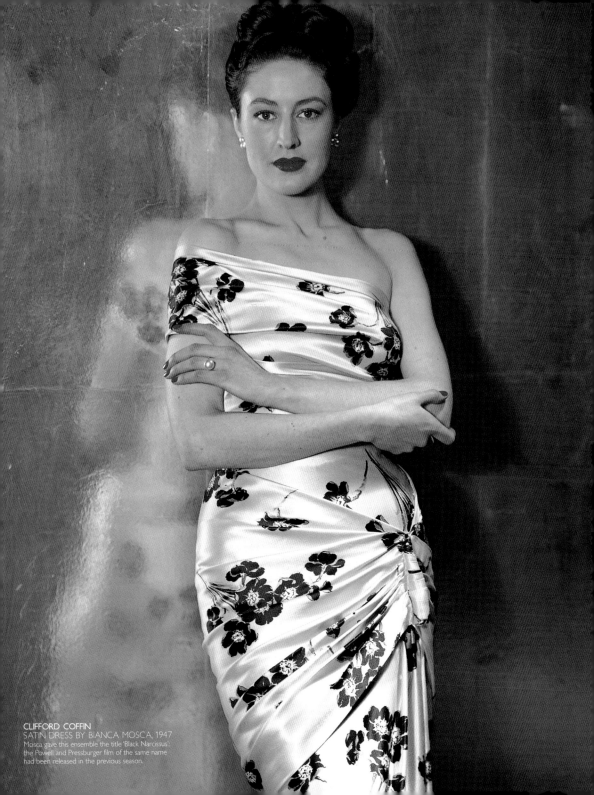

CECIL BEATON
HRH PRINCESS MARGARET, 1949

Beaton photographed the future Queen's sister on half-a-dozen occasions before she married Antony Armstrong-Jones (later the Earl of Snowdon), himself a *Vogue* photographer and one of whom Beaton was frequently jealous. This portrait was part of the official sitting to mark the Princess's nineteenth birthday. She wears a white tulle dress by Hartnell, embroidered with butterflies, which Beaton considered 'dull'. However, he found his sitter enchanting. 'She looked very pretty,' he recalled, 'and wore quite a lot of make-up. And the eyes are of a piercing blue – catlike and fierce, and so very pristine and youthful.' He added that the Princess 'likes dressing up, flirtations, going to nightclubs until all hours. Her "press" is rather scandalous…'

following pages

HORST
FASHION PHOTOGRAPHS, c.1949

Vogue took a dim view of models smoking in fashion photographs, a view best illustrated by editor-in-chief of all *Vogues* Edna Woolman Chase's admonition to Norman Parkinson: 'Smoking!' she exclaimed by cable. 'So tough! So unfeminine!' Though many succeeded in flouting the unwritten rule, perhaps these pictures fell foul of it. Most of Horst's long career (he died in 1999 aged 93) was spent in New York and Paris, though occasionally he undertook sittings for British *Vogue*, such as these, which never ran. In 1934, Horst photographed Noël Coward for his production *Conversation Piece*, and the same year covered the Paris Collections for the magazine. Several leading actresses, such as Vivien Leigh and Merle Oberon, also sat for him in London. Towards the end of his career, he was a frequent visitor to England and photographed, among others, the pop group Duran Duran and the lead singer's wife, the model Yasmin Le Bon (1986). Horst's companion and biographer Valentine Lawford wrote that Horst always 'felt out of his element in England', which may have had a little to do with rival *Vogue* photographer Cecil Beaton. In 1930 he visited Beaton at Ashcombe, his country house. There Horst, who was German and at that time spoke little English, was obliged to play charades, a feature of after-dinner entertainment at country-house weekends. He had to act out the word 'quaint' and threw his arms and legs around for an eternity until rescued by another guest. He suspected Beaton, who was paralysed with laughter, of arranging the incident and prolonging his agony.

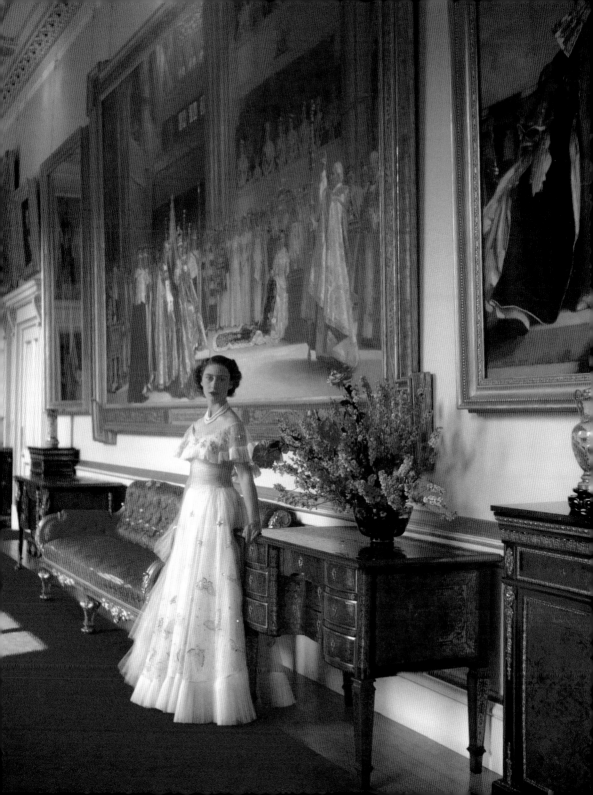

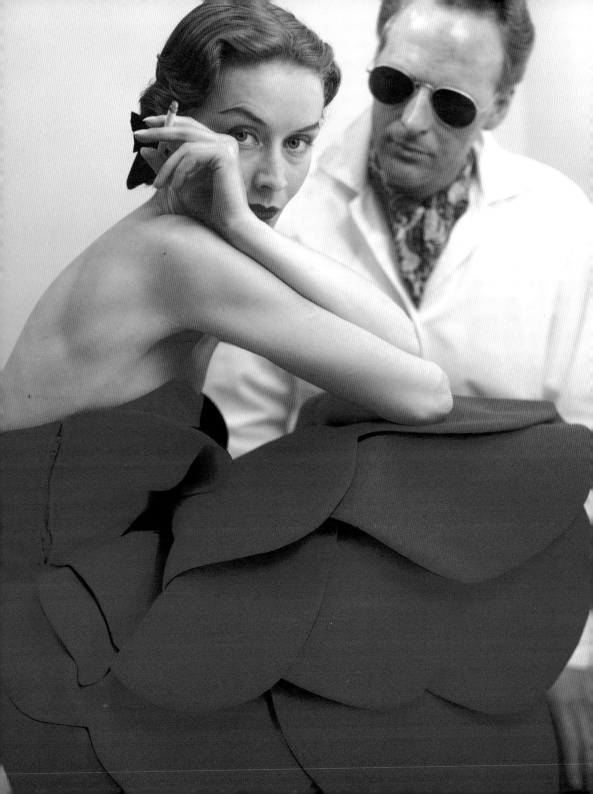

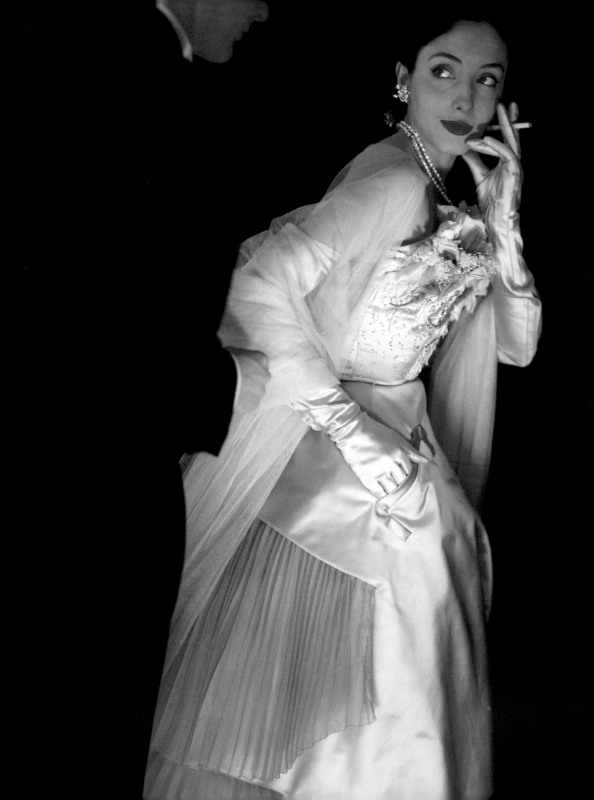

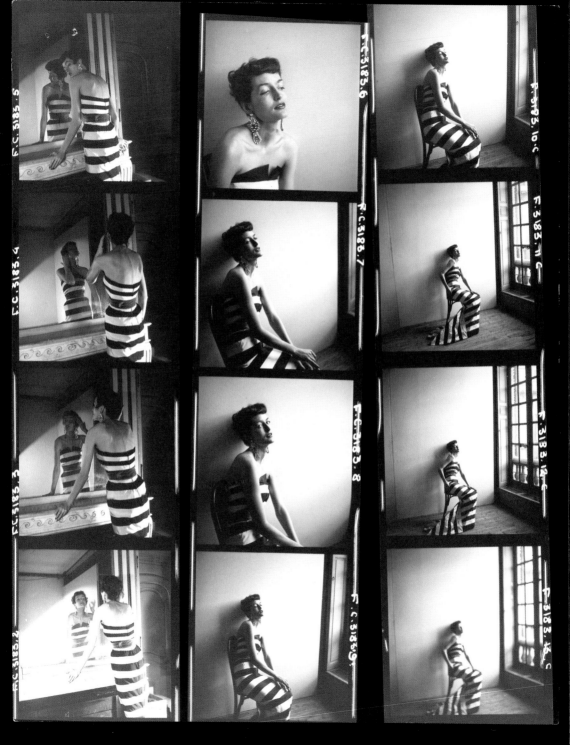

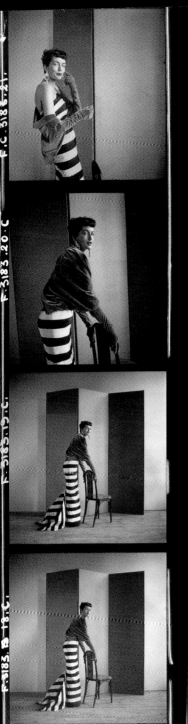

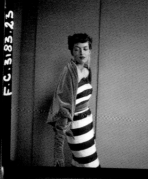

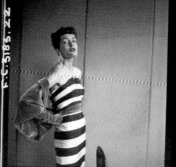

CECIL BEATON
COMTESSE ALAIN DE LA FALAISE, 1950

The Comtesse was born Maxime Birley, daughter of the respected society portrait painter Sir Oswald Birley and his wife Rhoda. She is sister of the restaurateur and club owner Mark Birley and her daughter is Loulou de la Falaise. In the immediate postwar years, Horst, Coffin and Beaton all photographed her. This contact sheet by Beaton shows her wearing a black-and-white taffeta fishtail dress by Paquin, for whom she once worked. A striking figure (almost six feet tall), she was once reported to have quelled the temper of Pierre Bergé (the force behind Yves Saint Laurent) simply by kissing him on the nose.

following pages (left)
CECIL BEATON
MARGOT FONTEYN, 1950

Fonteyn was the most lauded ballerina of her generation and rarely far from the pages of *Vogue*, often accompanied after 1963 by her greatest dancing partner, Rudolf Nureyev. This is a portrait from a private sitting for Beaton, the negative of which he never reclaimed from *Vogue*. They had first met 16 years previously, when Beaton was commissioned to design the sets and costumes for *Apparitions*, a new ballet by his friend Frederick Ashton. 'The dancing of Margot Fonteyn,' he recalled, 'makes one weep a little; for here is a combination of extreme youth, tenderness, elegance and virtuosity.' They became close, but over the decades had their ups and downs. Designing the sets and costumes for *Marguerite and Armand* (another Ashton ballet), Beaton wrote to his secretary in 1963, 'Margot does not wear her hat. I could have kicked her…'

following pages (right)
CECIL BEATON
ANYA LINDEN, 1955

A soloist with the Sadler's Wells Ballet, Anya Linden was first famous as 'Bluebird' in *Sleeping Beauty*.

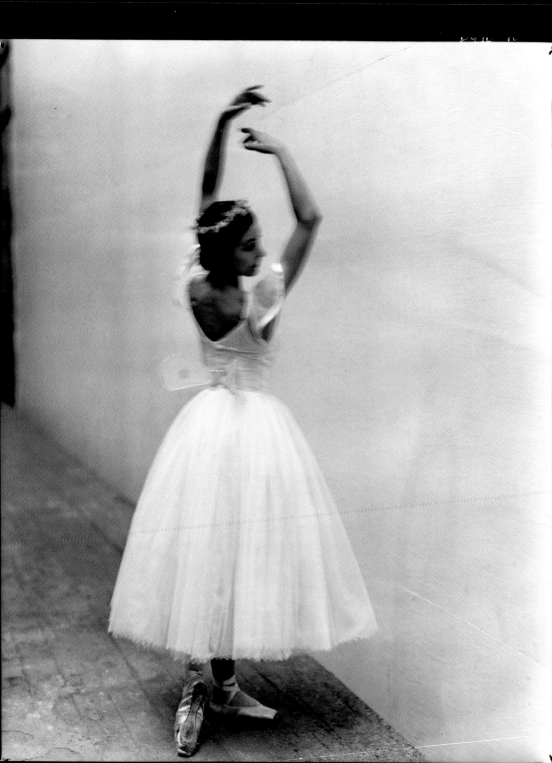

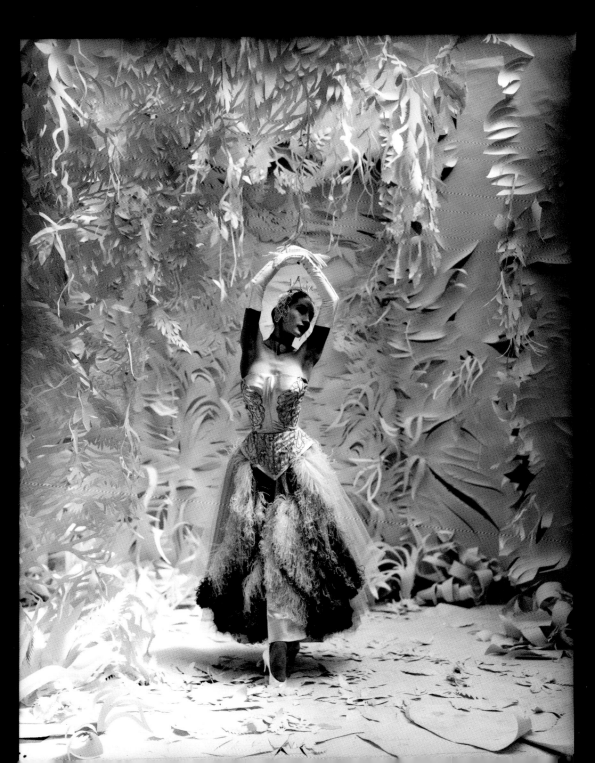

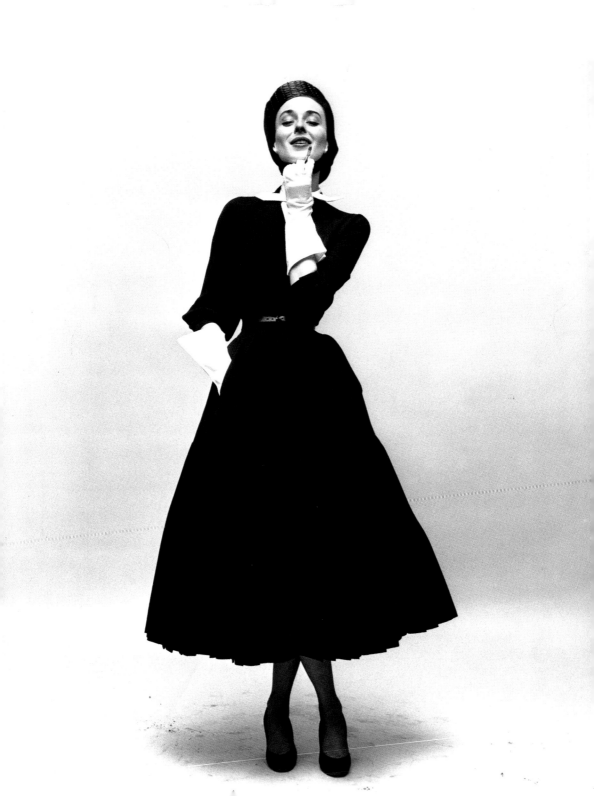

IRVING PENN
'DORIAN LEIGH IN BLACK DRESS', 1950

This photograph is one of a series of images contributed by Penn to American *Vogue*'s January 1950 issue, of which seven were published. The portfolio celebrated half a century of fashion. It ran in British *Vogue* too, but this shot, taken to illustrate the 'New Look' of 1947, was dropped. Penn's first photograph for *Vogue* appeared in 1943 and his first cover for the magazine was also *Vogue*'s first to feature a photographic still life. He started working for *Vogue*, in 1943, as an assistant in the magazine's art department, under its then recently appointed art director Alexander Liberman, and the two collaborated closely until Liberman's death in 1999. Penn had yearned to be a painter and spent time in Mexico, attempting to perfect his technique. But, dissatisfied by his failure to meet his own exacting standards, he abandoned it and used his canvases instead as tablecloths. So great has been the influence of Penn on *Vogue* photography – and he still works regularly for American *Vogue* in his eighty-fourth year – that how the magazine might have developed without him is barely conceivable. So prolific was he, and so intensely honed his vision, that Liberman was told that his pictures 'burned too much on the pages'. He once remarked that at *Vogue*, he felt 'like a street savage surrounded by sophisticates'. And, having produced a highly stylised fashion oeuvre, defining for posterity the postwar notion of a linear fashion silhouette, he moved on to work on projects of his own, far removed from the elegance of *Vogue*, such as studies of voluptuous nudes. This extra-curricular activity flourished in the 1970s, manifesting itself in large-scale platinum-palladium prints of street detritus – cigarette butts matted with pigeon feathers, bones and other *objets trouvés*. The mannequins of his famous fashion pictures set, like Dorian Leigh, against a neutral seamless paper background, are arranged as specimens might be for a still-life study by a discriminating eye. 'I have always stood in awe of the camera,' Penn has revealed. 'I recognise it for the instrument it is; part Stradivarius, part scalpel.'

NORMAN PARKINSON
ISABEL JEANS, 1952

The English actress was about to appear, dressed by William Chappell, as Mrs Lancaster in a revival of Noël Coward's *The Vortex*. She frequently partnered Ivor Novello and, as one obituary writer observed in 1985, 'she exuded style in the grand manner and the kind of unselfconscious elegance that allowed her to wear period costume as if to the manner born.'

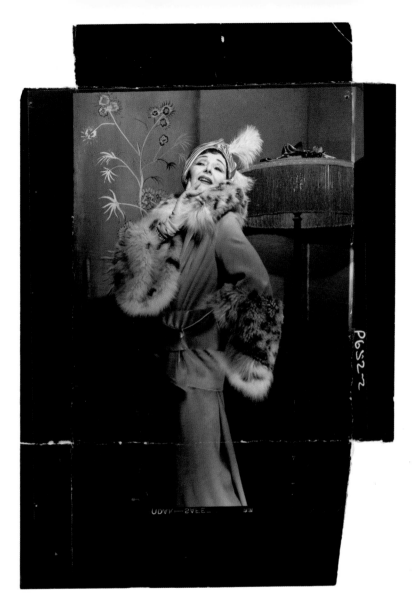

NORMAN PARKINSON
WENDA ROGERSON, 1950

The collaboration of Parkinson and Wenda Rogerson was one of the most enduring in fashion photography. She had been an aspiring actress before being noticed by Beaton, and although it was Coffin who gave her first proper assignment as a fashion model, it was Parkinson who made her a star. He placed her in any number of neo-romantic settings, pastoral and urban, as the epitome of something that the war years had temporarily obscured – the classically elegant 'English Rose'. In 1951, he also made her Mrs Parkinson. Of his pictures of Wenda in the early 1950s, he wrote years later, 'Girls change, clothes change, but beauty itself, in whatever form it is viewed, is sealed there for ever – it is frozen, it is permanent and it does not

age.' Wenda predeceased him by three years and, four weeks after her death, their home in Tobago was destroyed by fire. He was distraught: 'If I didn't have a passport,' he remarked to a friend, 'I wouldn't know who I was.' The caramel satin evening dress is by Molyneux, the Rolls-Royce is a 1907 Silver Ghost.

NORMAN PARKINSON
CORDUROY MOTORING SUIT BY BEDFORD, 1955

The car is the Conquest roadster by Daimler, capable of speeds in excess of 100mph. It has a folding hood and retractable side windows for *plein-air* motoring.

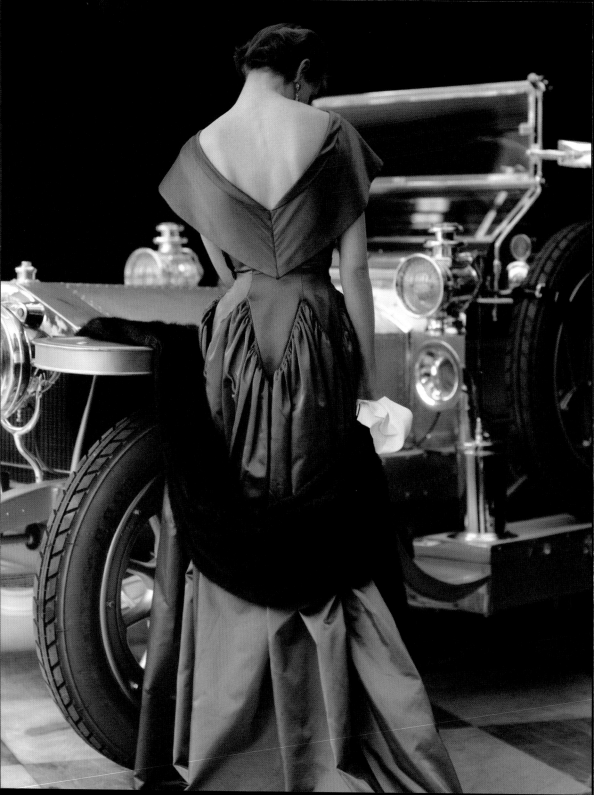

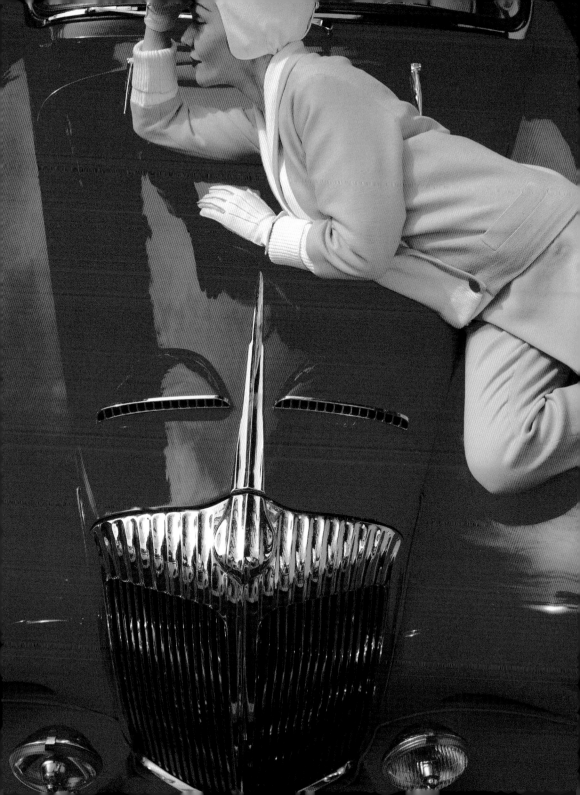

ANTHONY DENNEY
EVENING PUMPS BY RAYNE, 1950
Anthony Denney was best known as a
photographer of room-sets and was himself
a talented interior designer -- he pioneered
audacious mixes of pinks and reds. For
Vogue he most often carried out still-life and
accessory assignments, and is also known
for his collaborations with Elizabeth David,
the celebrated cookery writer.

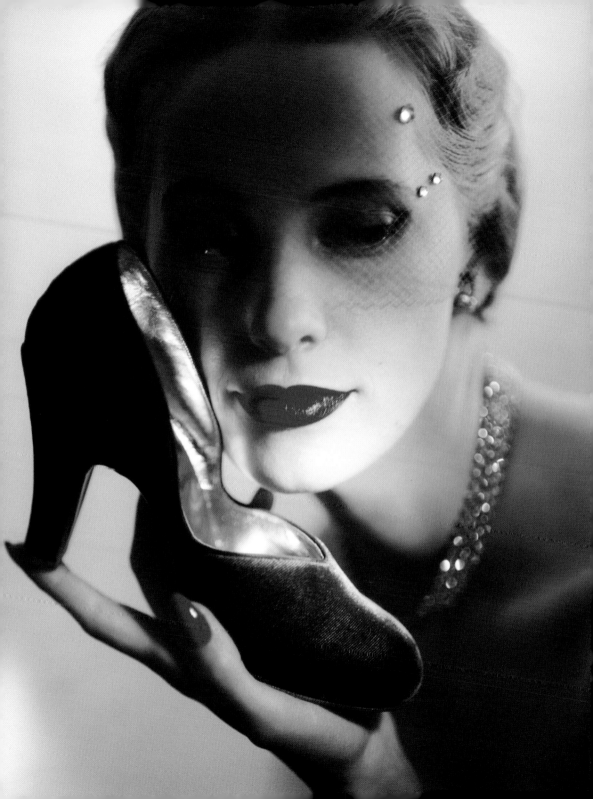

Colour and black & white

DIOR's TUNIC COAT

Dior started tunic coats in New York but has continued them
here in every variation. This one is in Oxford grey long-haired
fabric buttoning in an arc over the bosom and with the stiff
peplum standing out from the narrow black dress below. On the
sleeve is a little pocket with a green handkerchief tucked into
it. The little black toque is worn forward over one eye.

#71 Ambassade

ATTRIBUTED TO HENRY CLARKE
COAT BY DIOR FROM THE PARIS COLLECTIONS, 1950
Stored with the unpublished transparency is its descriptive caption (*above*). Typed on
extremely thin paper, to enable the typist with carbon paper to make three copies at once,
this copy, the third, is the 'flimsy'.

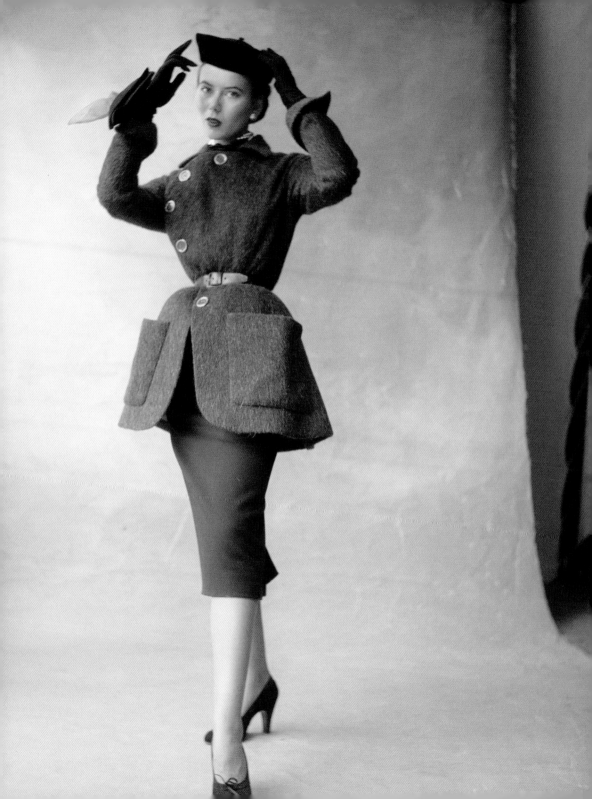

NORMAN PARKINSON
NUDE, c.1950
With Parkinson's inked initials on
the top right-hand corner, this
beauty picture predates, probably
by a year, his first published nude –
a decidedly more modest study.
Even allowing for more relaxed
attitudes in the postwar era, and
Parkinson's own ascendancy at
Vogue, this was far too daring for
the magazine to consider. It is
unlikely that it even reached the
editor's desk. This was after all an
era when an employee, such as
Anne Scott-James, could still be
admonished for 'going into
Claridge's not wearing a hat'.

following pages
JOHN RAWLINGS
ENSEMBLES BY FATH, 1951
This photograph, originally
published in American *Vogue*, was
reproduced in a cropped version
in the British edition.

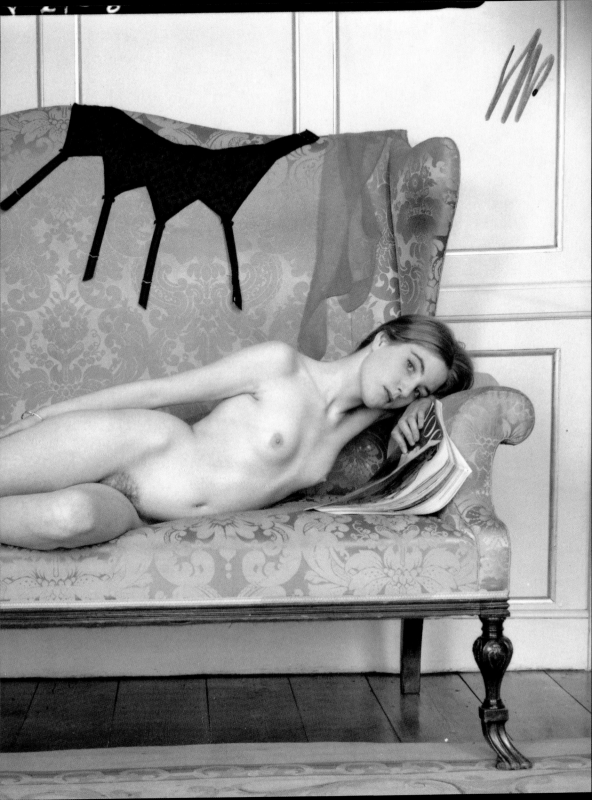

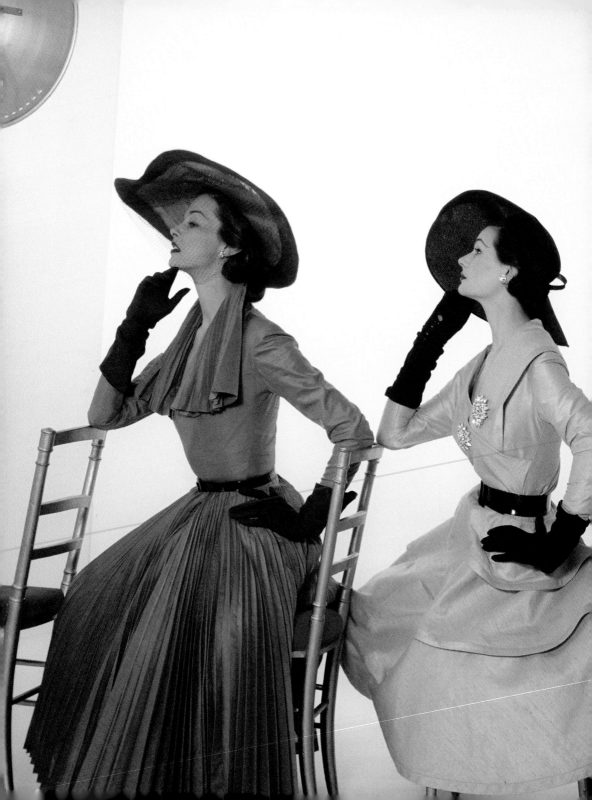

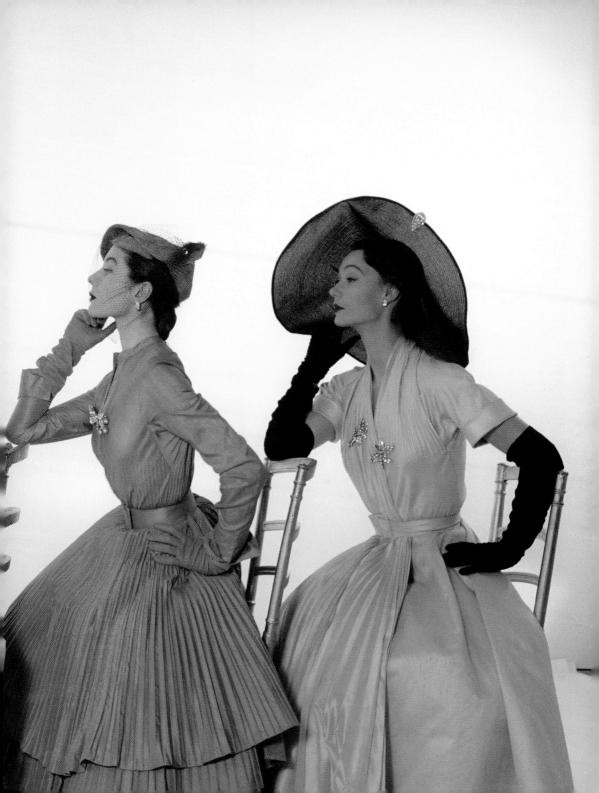

DON HONEYMAN
SUIT BY PETER RUSSELL, 1952, AND 'THE BLONDE LOOK', 1952
Two working prints, showing (*above*) an art director's required crop (the area of the image to be printed),
and (*opposite*) instructions to the printing-plate-makers, indicating a 'cut-out' picture.

Retain areas
of tone background
between arms
and body.

Jade off
tone
background

Cut-out
H. T.

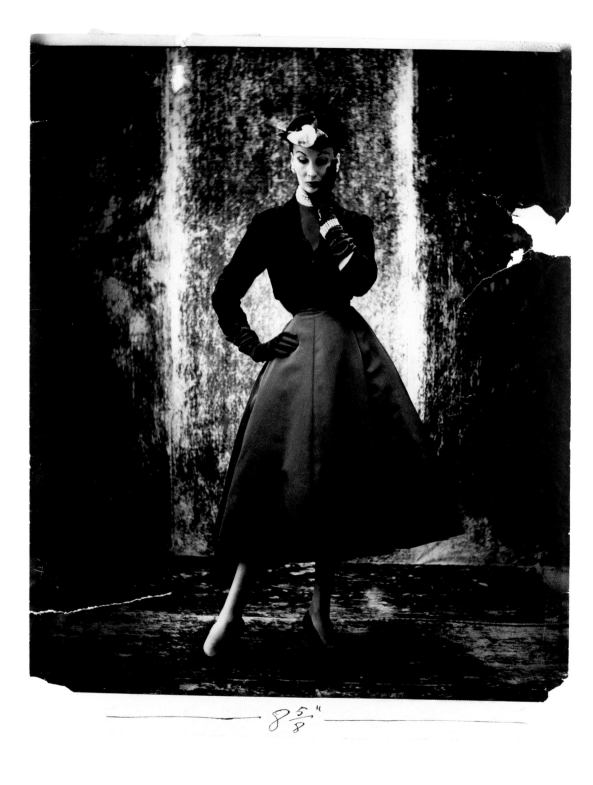

$8\frac{5}{8}"$

JOHN DEAKIN

PHOTOGRAPHER

8th September 1948.

Dear Audrey,

Thank you for your letter and the cheque for September.

Re. the cheque in the nature of compensation for loss of office. Do you think it would be possible for me to have it now ? You see I lost my own camera in Paris last year and have been use the studio cameras ever since. Until I can get another I am rather up a blind alley, and what money I did have has gone into getting this studio ready.

I should be most grateful if it could be arranged.

I did not say goodbye to anybody at ne office or the studio, I thought it was better that way.

Yours sincerely,

Studio equipment —
(Rolleiflex and
Exposure meter)

Returned —

John D.

67, Egerton Gardens, S.W.3.
2, Hasker Street S.W.3.

Kensington 2775
KEN 7968.

JOHN DEAKIN
BARBARA GOALEN, 1951

John Deakin is now recognised as one of the most influential British photographers of the twentieth century. His reputation rests on a remarkable, if dog-eared, body of work: his portraits of the creative characters and maverick talents that haunted Soho, London's artistic quarter in the 1950s. The painters, poets, writers and others who defined an era of the cultural life of postwar England were all raked by his lens – Francis Bacon, Lucian Freud, J. P. Donleavy, John Minton and Dylan Thomas, among others. Deakin's vision was frequently brutal; whether his sitters were Hollywood stars for *Vogue* or friends in Soho, he made no concessions to vanity. As a staff photographer for *Vogue*, he was obliged to carry out fashion work as well as portraiture. He was only fleetingly successful in this area and did not much care for it. He enjoyed two periods under contract to the magazine and remains the only photographer in its history to be hired and fired twice by the same editor. The letter (*above*) was written immediately after his first dismissal. This print (*opposite*), the uncropped version of a published fashion study, shows the ravages of age but more significantly Deakin's nonchalant attitude to this aspect of his work for *Vogue*.

PRIVATE.

Miss Withers Mr Matthews
cc.Miss Hill
Mr Parsons 11th. February 1954.

You may have heard that John Deakin was
unable to take some photographs today, and that
we had to substitute Sadovy at short notice. I
am very worried about John Deakin at the moment,
since he is obviously a very sick man, and should
not really be working at all. As you know, he
has noone to look after him, and in his present
condition he is finding it extremely difficult
to wash, shave, etc., and I think that the whole
business is beginning to get him down. He has
a tremendous will to do the work, and obviously
does not want to let us down, but, quite frankly,
I think that the struggle is beginning to be too
much for him.

In view of the fact that we have a monthly
guarantee clocking up whether he works or not,
makes me feel that we should let him off all
photography for the time being.

His illness could not have come at a more
unfortunate time, in view of our discussions on
his future, but I do not feel that we can give him
notice at this particular time.

Do you think, perhaps, that if the position
were explained to him he could be laid off, at a
reduced rate until such a time as he recovers?

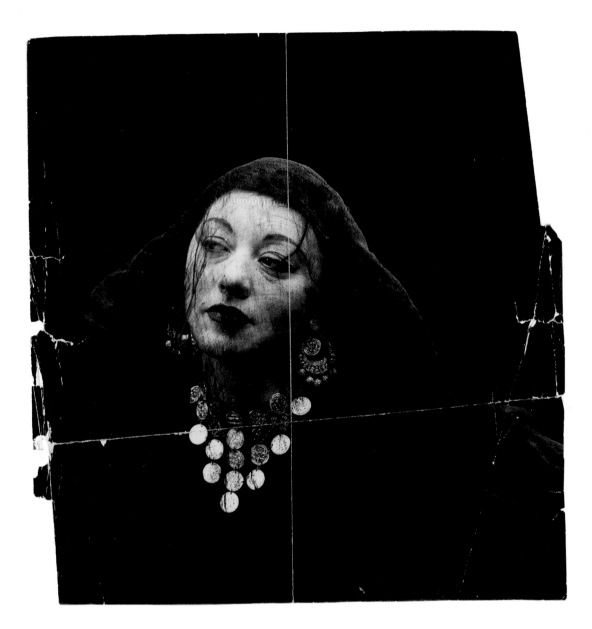

JOHN DEAKIN
ISABEL LAMBERT, 1952

If Deakin's fashion and beauty photographs were successful, it was because he treated them as portrait sittings – for example, this shot of Isabel Lambert, muse to Bacon and Giacometti. Fashion photography did not come easily to Deakin, and reports of collapsing tripods, crying models and exasperated fashion editors led to his sacking. His habitual disregard for *Vogue's* photographic equipment did not help his cause – he lost or pawned at least two Rolleiflex cameras, some plate slides and an exposure meter. With his catalogue of misdemeanours and soaring entertaining expenses, he drove to breaking point the patience even of *Vogue* editor Audrey Withers, so often his staunchest champion. The internal memorandum (*opposite*) from the director of the *Vogue* Studio to the editor of the magazine helped seal his fate for a second time.

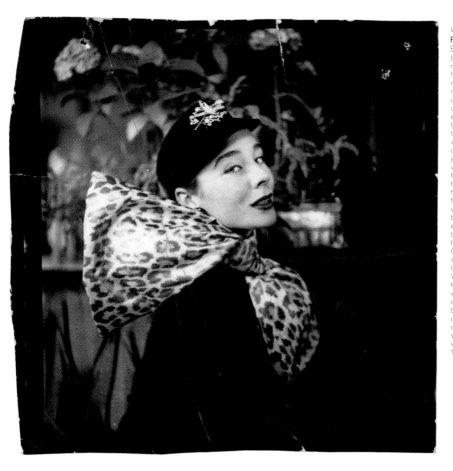

left
FRANCES McLAUGHLIN-GILL
BETTINA, 1952

Jacques Fath created 30 dresses for his muse Bettina, though by 1950 she had left his atelier for a career as a model. By the mid-1950s she was probably the world's most highly paid mannequin, frequently charging 7,000 francs for a sitting. This is an uncropped contact print of a published enlargement. In her heyday she was one of the most recognisable Frenchwomen in the world, not least for her ill-starred affair with Prince Aly Khan, who died in a car crash. In Britain she was a cover star not just of *Vogue* but also of *Picture Post*. She was so famous, that the password to Shell's first computer was 'Bettina'. She moved Henri Cartier-Bresson to take portraits of her – perhaps the nearest he ever got to fashion photography; Françoise Sagan wrote about her for French *Vogue*; Chanel based one of her last collections, in 1969, entirely around her. Bettina also found time to work with Lucien Lelong, and to help the fledgling couturier Hubert de Givenchy set up his fashion house. For a short time she was couture director for Ungaro, public relations director for Valentino and muse to Azzedine Alaïa, whom she met in 1946. Here she wears a taffeta scarf by Dior, whom she met in 1946. She turned down his spur-of-the-moment job offer, because she was en route to her first day with Lelong. She thus rejected a chance that was more significant than she could have guessed; for the next season Dior produced his landmark 'New Look' collection.

opposite
HORST
DRESS BY FATH FROM THE PARIS COLLECTIONS, 1952

In 1952, Jessica Daves was appointed editor-in-chief of American *Vogue*. Clear-headed and practical, she had a shrewd grasp of the business of mid-century American fashion. She produced twice-yearly 'Americana' issues, the fashion pages (to which Horst was a reluctant contributor) filled with cardigan-clad girls bicycling to doughnut shops. Horst was told that no model should 'stand with her feet more than twelve inches apart…' For Beaton, in his diaries, 'their present editor suffocates my enthusiasm.' Horst spent much of Miss Daves's 10-year tenure travelling abroad and working for *House & Garden* before being asked by Daves's successor, Diana Vreeland, to return to *Vogue* in 1962. This uncropped version of a published photograph is typical of Horst's mid-century fashion work.

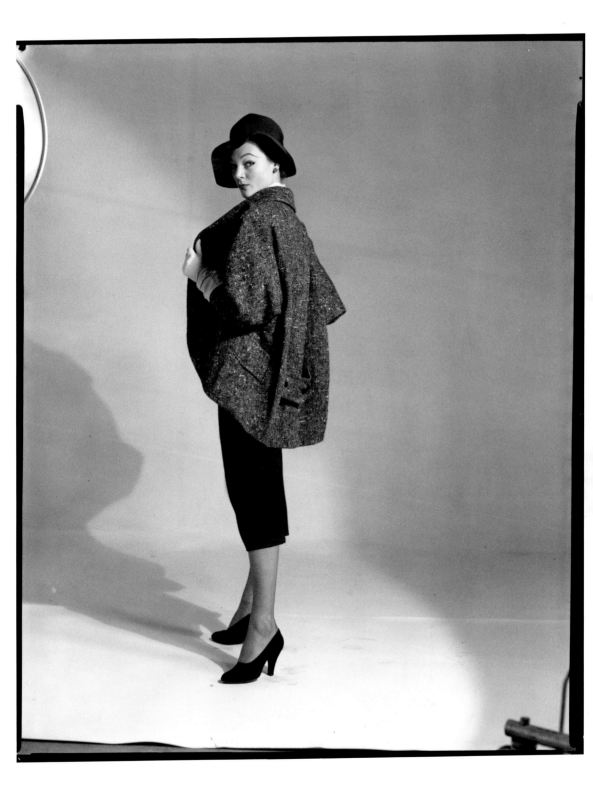

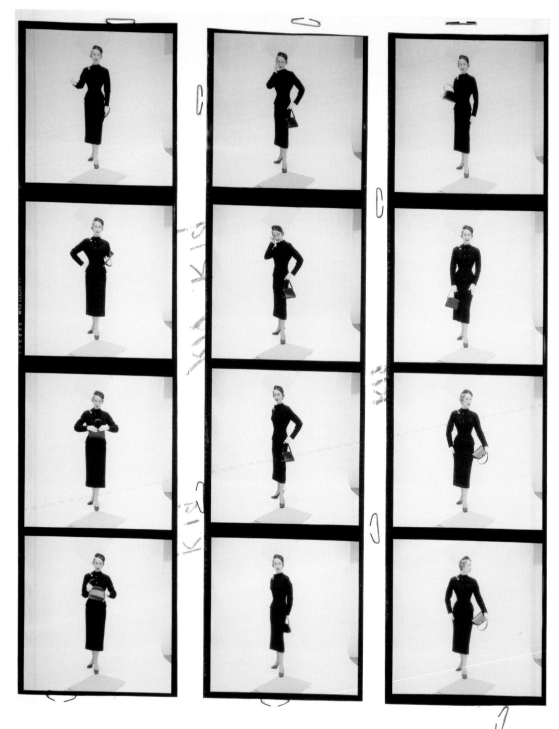

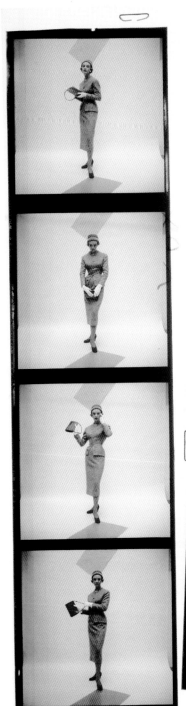
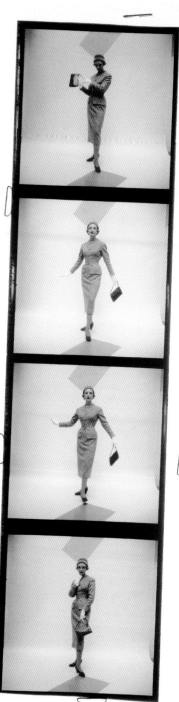
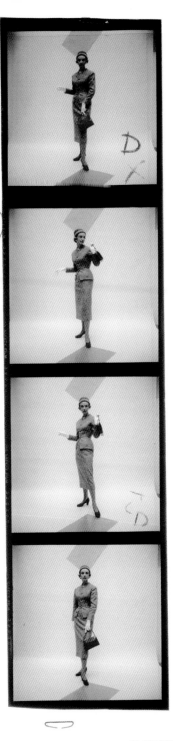

little
more detail
in trousers.

$10\frac{1}{2}$"

NOTE add at least
1" of white at left
and lower edges

above

ANTHONY DENNEY
'THE CONTEMPORARY LOOK', 1955
A working print bearing an art director's cropping instructions
and measurements for the final enlargement.

opposite

NORMAN PARKINSON
BALL GOWNS BY HARTNELL FROM THE LONDON COLLECTIONS, 1953
Vogue noted in 1953 that there had been few state occasions, since the start of the reign of
George VI, at which clothes designed by Hartnell were not worn by members of the Royal
Family. Here, to celebrate the Coronation of Elizabeth II (for which he designed the new
Queen's robes), he is pictured with a range of ball gowns and a debutante dress.

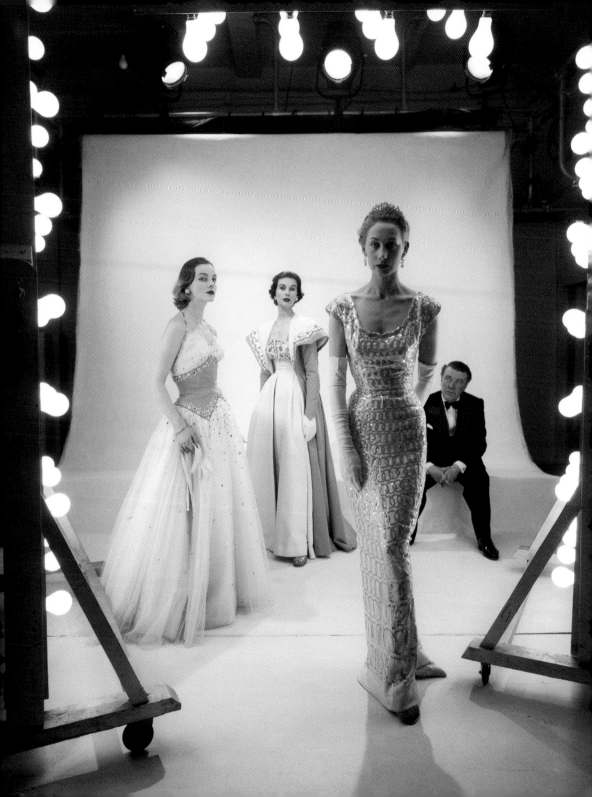

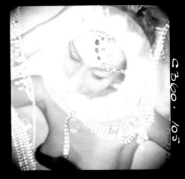
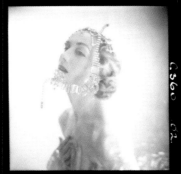
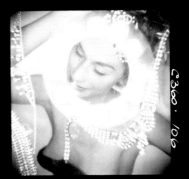
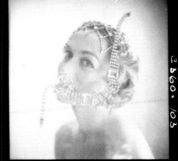
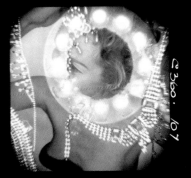
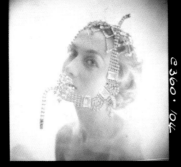
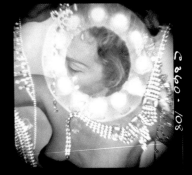

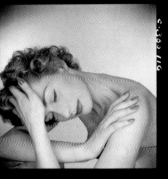

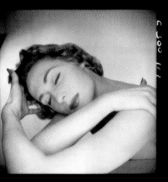

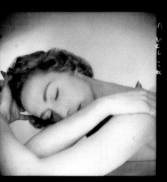

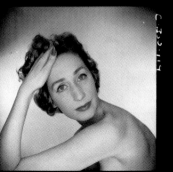

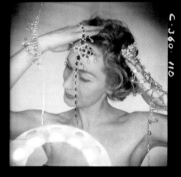

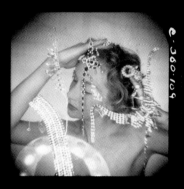

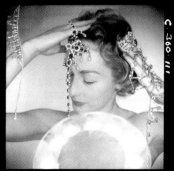

CLIFFORD COFFIN
HELEN CONNOR, 1954

Coffin's discovery of the ring-light, reflected here in a sheet of glass in several frames of this accessories shoot, has had a direct influence on successive generations of fashion photographers. A ring of twelve tungsten photo-floods, through which the lens of the camera was pointed, it had been adapted by Coffin from one he had seen his dentist use. Casting a fine black line around his sitters, it eliminated all other shadows and gave a superb degree of clarity to clothes and skin tones, bleaching out blemishes. As the light worked best in close-up, it all but blinded his models; and the heat generated was tremendous – on a par with two electric fires. The photographers Helmut Newton and Guy Bourdin found Coffin's prototype years later in the studio of French *Vogue* and adapted it further to work with electronic flash. David Bailey used one too, though his early version, he recalls, was 'incandescent. I got terrible burns on my f*****g forehead.'

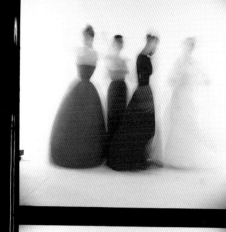

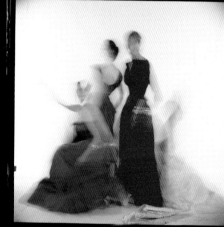
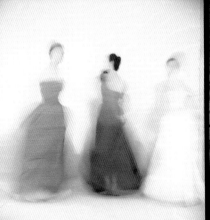
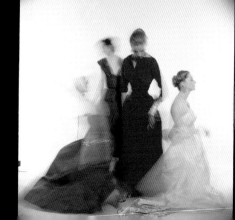

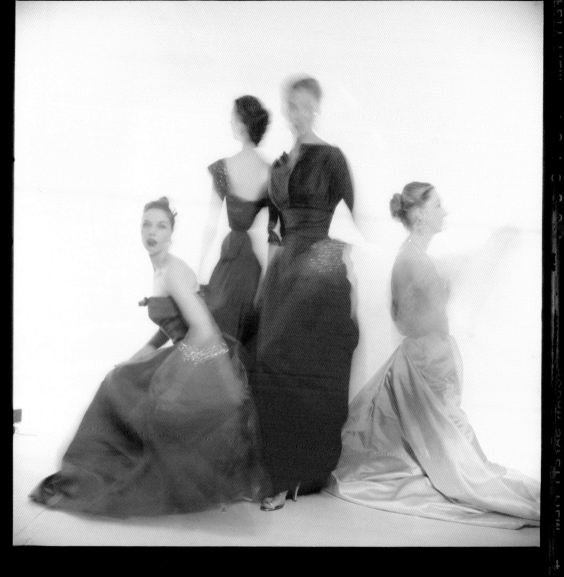

CLIFFORD COFFIN
'JEWEL' EVENING DRESSES, 1954

Always highly strung and volatile, addicted to alcohol and prescription drugs, Coffin admitted
later that by this time he was often out of control. He confided to colleagues that he also feared
for his sanity. In 1966 *Vogue* paid him this tribute: 'Coffin was a perfectionist. He could create
impeccable elegance from the simplest ingredients… Given a model and some make-up, he
could make a beauty. He taught all who worked with him a lesson in dedication. Nothing was
too much trouble. In his search for what he wanted, he reduced models to tears, fashion editors
to desperation and himself to complete exhaustion. From the rubble of emotion emerged
a perfect cool picture.' But not for *Vogue* in this case. These pictures, part of his last sitting
for British *Vogue*, were considered too experimental and were 'killed' (rejected for publication).

c. Mr. Yoxall

February 10th, 1955

Cecil Beaton Esq.,
8 Pelham Place,
London, S.W.7.

Dear Cecil,

I have unpleasant news for you. We have been forced to
kill every picture which you took recently for our April Lead. We all
found these pictures unpublishable, since they did not in any way embody
or put over the theme of our What to Wear With What feature.

This is a feature which we regard as extremely important,
and which we have reason to believe is liked and looked for by our readers.
I believe that John Parsons briefed you very fully by telephone on the whole
matter, and explained to you that these black and white photographs were
planned to bring into actuality the colour schemes which we were advocating
in a chart published in the same issue. This entailed getting clothes
in the basic colours of our chart, and carefully accessorizing them in every
particular according to the chart colour scheme. The whole feature therefore
fell to the ground when you rejected one hat in favour of another, eliminated
a handbag, and so on. The upshot was that these pictures, instead of being
object lessons in how an outfit should be put together and accessorized,
appeared in fact far less well accessorized than most normal fashion features.

I believe that though booked for two days you in fact spent a
very short time on these pictures, and on the second day barely an hour. I
feel that eight pages of photographs for a Vogue Lead required far more time
and concentration than you gave it in this instance.

While no-one can be more charming than you, Cecil, no-one either
can be more devastating. You had inexperienced models (one of them specially
picked by yourself), and an editor with whom you had not, I think, worked before.
Instead of building up an atmosphere of confidence, as you know so well how to
do, I get the impression that your attitude and comments depressed and deflated
your collaborators. I believe that you did not like the clothes, and in fact
after going through them all, as I have done since the sittings, I feel that
errors of judgment were made in two instances, one being the short evening dress

P.T.O.

94

which was in itself too elaborate to carry jewellery and was therefore unsuitable for this particular feature, and the other, the ~~checked~~ suit which was not, I think, well chosen as a subject to be accessorized for town and country wear. We are making changes in these two matters, which I am ready to concede were our fault, and I therefore feel we are responsible for payment on these two sittings which we might have wished to retake in any case. In regard to the other sittings, however, which we are retaking in the form in which they were originally planned, I do not feel that we can pay for sittings killed on grounds which arose from no fault of our own.

There are some features in which one is only too pleased to have the co-operation of a photographer in choosing clothes for a certain effect, and there are others in which atmosphere is everything and when details matter less, but there are ~~certain~~ features, such as the one in question, which must from their very nature be direct commissions, to produce certain results. The way in which a photographer gets these results is his business, and we are grateful for the talent which gives them to us, but these talents cannot be allowed to distort the results required.

I feel I must conclude by saying that for a long time now you have appeared increasingly reluctant to give sufficient time and your best thoughts to our work. It has seemed as if you were simply prepared to fit some fashion photography into the interstices of your busy life. The impression you give at sittings is that you want to get away as quickly as possible. Among your great gifts is an extraordinary turn of speed, but even you cannot indefinitely hope to prevent signs of rush and disinterest showing through your work. If you have reached the point of feeling that our fashion features no longer hold your interest, I think it will be better for us both if we ~~cease~~ to offer them to you.

I am going to New York at the end of this month and feel that we must have a talk on this subject before I leave. Could you have a drink with me one evening when you get back?

Yours ever,

Audrey Withers,
Editor

opposite, above and following pages
CECIL BEATON
'WHAT TO WEAR WITH WHAT', 1955
As is obvious from the accompanying exchange of letters, this fashion sitting was not a success. Beaton had clearly grown tired of fashion photography. Indeed as early as 1947 he remarked, 'suddenly to me it has become lowering to the spirit.' This appears to have been the final straw in a succession of poorly received fashion stories coupled with behaviour nonchalant to the point of reproach. Despite his spirited defence (*following pages*) Beaton's contract, which had been signed by both parties annually since the late 1920s, was not renewed.

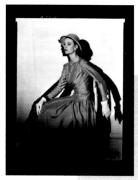

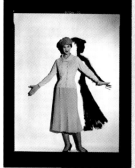

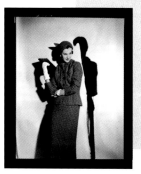

21st February, 1955.

My dear Audrey,

 I am extremely sorry that you have been put to so much last minute trouble and expense by my failure to produce a lead for your April issue. I am disappointed, too, because I left London under the impression that I had done a good job.

 I am grateful to you for agreeing that you will pay me for the evening dress and check suit accessorized both for town and country. (That makes three sittings, does it not ?)

 There are a few points in your letter which I would like to take up now, though I daresay a lot more could be discussed when we meet, as you suggest, for a drink before you go to New York.

 There have been times when you have wanted me to do pictures for you at the last minute which could only be taken if fitted in between my other appointments. This last job was in no way a rushed sitting on my part, and two days were entirely reserved for photographing six dresses. (It is true I did make luncheon appointments, but then, perhaps unreasonably, most of us indulge in a midday meal.)

 For several days before the sitting I tried in vain to find out what were the intentions regarding this feature so that I could give thought and time to my preparations. Unfortunately, most of the staff who knew anything about the matter were either away or ill. Miss Patricia Hill told me that the feature was to be called "What to wear with What", and said that although John Parsons was ill he would call me to explain more fully. When a few days later I was able to speak to John, who was still recuperating at his house, I apologised for "badgering" him, but explained that it was much better if I could have time in advance to think about the sittings so that I might make plans for what was expected of me. He agreed. He told me about the sittings in principle, though he did not mention the colour chart of the accessories. I made a few vague suggestions, which did not appear suitable, and I said I would call him again later if I had any further ideas.

 I saw Davina Portman in the distance at the Ritz, thought, mistakenly, that she would be a good new model for us, and at once telephoned to you to know if we could photograph her, and if we should use the Ritz as a background. You agreed to the former suggestion.

 /....

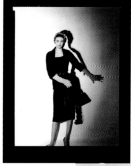

I later had another idea about photographing the series with a thick black shadow outlining the figures – white on black, black on white. John thought the idea sounded suitable for this feature, and I went ahead with this scheme. When John saw the results of the first day's session he was enthusiastic, saying he thought my pictures looked "quite new and exciting", and although the clothes were in his opinion poor (and I sighed in sad agreement) he said he thought that "I had saved the day". You are, of course, entitled to a difference of opinion with your Art Director, and I am not challenging your verdict on my pictures, but they were taken with care and as much enthusiasm as I could muster under difficult circumstances. When a photographer has once found a formula for a certain line or theme to run through a series of pictures, this can be repeated with ease and speed. For this reason I took no longer than one hour to photograph two dresses on the second day's work.

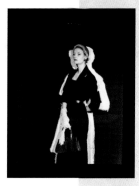

I must point out that the time taken over any sitting is not necessarily commensurate with the result. I think you know how stimulated I am when working at pressure, and inversely, how depleted of vitality I become if kept idling about an empty studio while activity is confined to the secrecy of the dressing room. I think possibly if you were to appear unexpectedly at some of our sittings you would be appalled at the apparent lack of organisation in that hours are spent awaiting the arrival of some special accessory, and at how much time the models waste between appearances. Even the assistants become dulled and apathetic with inaction.

I do not wish to make any criticism of Miss Gibson who is a delightful and sensitive person, and I am sure she and her staff did their best. It was the new and "inexperienced" model, Davina Portman, who so boldly aired her criticism of the hats and clothes. She looked extremely badly in some of the choices, so substitutes were agreed upon. I never eliminated a handbag. It did not arrive in time. I did not realise that without it the sitting would be of no interest and that we must all await upon the somewhat vague possibilities of its arrival. We agreed to retake one sitting the next day so that a more becoming hat could be found meanwhile, and I decided to retake another of the dresses as when I saw the negatives I thought the shadows had made the figure look thick. Although I contradicted Miss Portman when, on the second day, she continued to make criticisms of the clothes, I had by degrees to agree that she was right. In fact I came to the conclusion that I have seldom seen a collection of clothes, hats and accessories that were less inspiring.

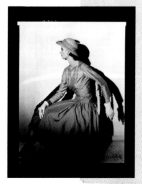

I am going into these detailed explanations so that you can see however unsuccessful you feel the results of this feature were, they were not brought about by any lack of integrity or interest on my part.

/...

However, I have reached a point where I feel that it is impossible for me to do any better pictures than those I produced with the fashion material put at my disposal. Since I agree with you that it would be better if you ceased to offer me such sittings, perhaps you would let Harry know that we have come to this agreement so that, in fairness, I should be allowed to put my continued interest in fashion photography elsewhere.

Yours ever,

Cable to Donald Silverstein, Ile de France May 2nd, 1955

WELCOME TO ENGLAND REGRET LUNCH ENGAGEMENT PREVENTS MEETING YOU BUT JOHN PARSONS
ART EDITOR WILL MEET TRAIN PADDINGTON WEARING GINGER BROWN KNEELENGTH COAT
CARRYING VOGUE HOUSE GARDEN GOOD LUCK WITHERS

DON SILVERSTEIN
ACCESSORIES PHOTOGRAPH, 1955
A photographer of 'West Coast' jazz album covers, Silverstein, an American, made the
transition to fashion photography uneasily. The message (*above*) was his introduction to
a new life in London from his new employer, *Vogue*'s editor Audrey Withers. Though
occasionally successful, he was often frustrated and felt under-used at *Vogue*. 'With the
exception of two minor sittings,' he wrote to Audrey Withers, 'I will again be faced with
two weeks of self-introspection, and frankly I don't find myself that interesting.'
Silverstein was an early champion of the Paris-based photographer Guy Bourdin, whom
he all but supported by buying his Surrealist-inspired drawings. In time, Silverstein left

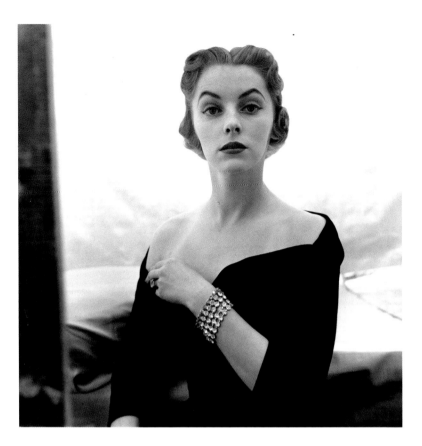

above

HENRY CLARKE
HAIRSTYLE BY STEINER, 1953

right

HENRY CLARKE
DOVIMA, 1956

The photographs of Henry Clarke capture the rarefied world of 1950s Couture more consistently throughout the decade than any other photographer. His photographs of the *sang-froid* elegance of Anne Saint-Marie, Dorian Leigh and Dovima (here in a dress by Fath) are identified by their attention to the minutiae of fashion and maquillage. Clarke's productivity rate was high, not least because of a unique contract allowing him to photograph, from 1951, for all three *Vogues* (French, British and American). However, he shared none of the versatility of, say, his colleague Irving Penn, having little interest in photography outside fashion at its most elegant, and celebrity portraits – which, being heavily 'styled', were for him fashion pictures anyway. This refusal to diversify, coupled with his propensity for over-elaborateness, may be the reason that his work has lost some currency.

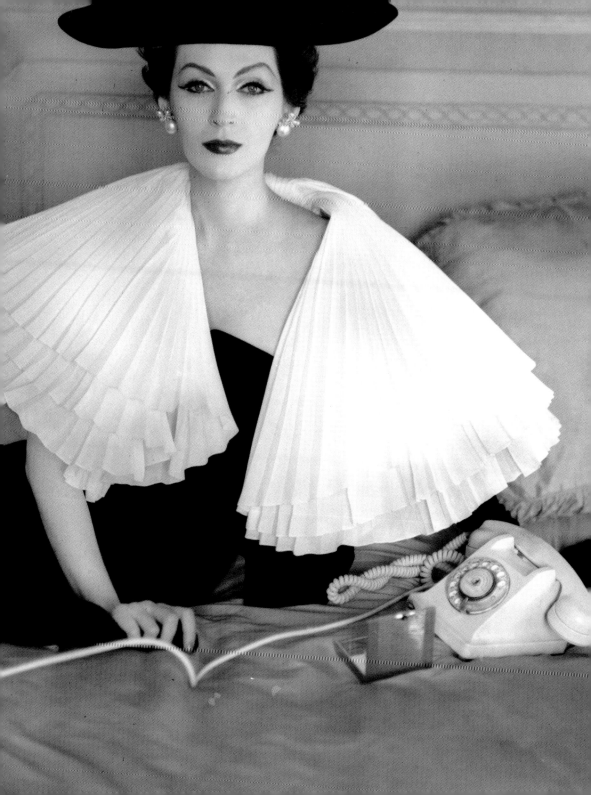

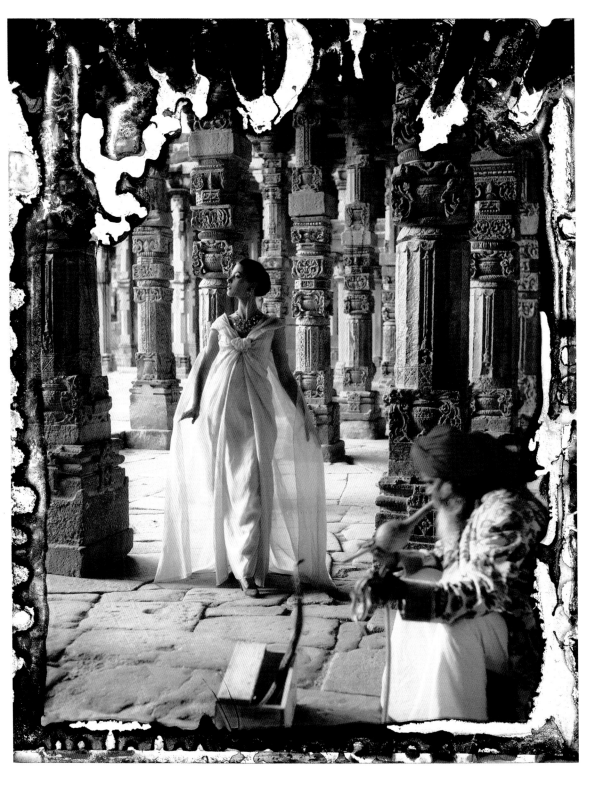

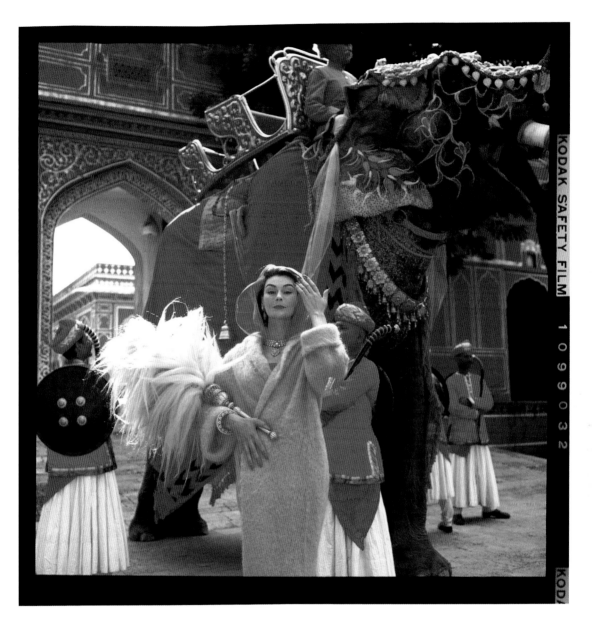

NORMAN PARKINSON
ANNE GUNNING AND BARBARA MULLEN, 1956
The photograph of Anne Gunning (*above*), a variant of one of Parkinson's most famous fashion photographs, inspired an equally famous aphorism from legendary *Vogue* editor Diana Vreeland: 'How clever of you to know, Mr Parkinson, that pink is the navy blue of India.' The photograph of Barbara Mullen (*opposite*), its emulsion cracking, is also a variant.

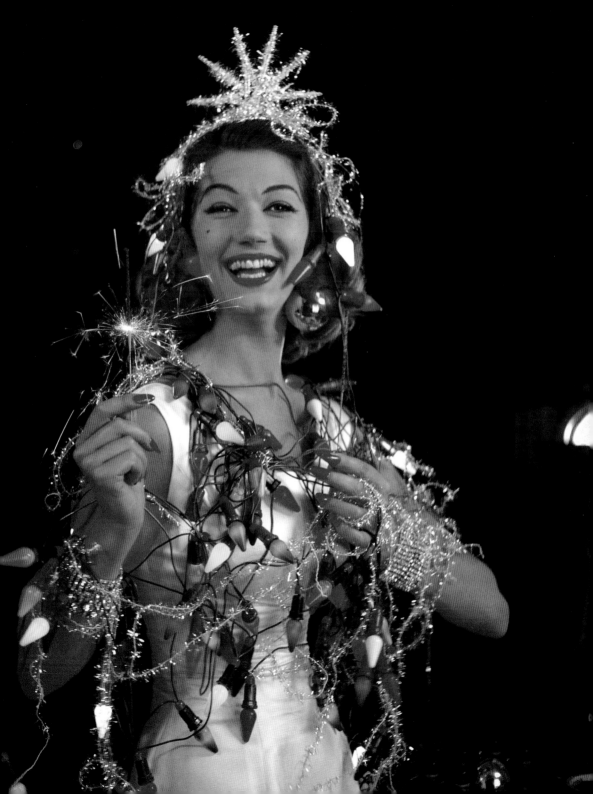

The Condé Nast Publications Ltd

VOGUE
HOUSE & GARDEN
VOGUE PATTERN BOOK
VOGUE EXPORT
VOGUE BEAUTY BOOK
VOGUE KNITTING BOOK

37 GOLDEN SQUARE, LONDON W.1. TEL. GERRARD 9060 TELEGRAMS VOLON PICCY LONDON

August 17th, 1956

Helmut Newton Esq.,
353 Flinders Lane,
Melbourne, C.1.

Dear Mr. Newton,

Just before she left for her annual holiday Miss Withers
had discussions about your proposed visit to Europe next year and your staying
on in England for 12 months or so to work with us.

Naturally, we are all delighted at the propsect of developing
the very happy association which has grown up between us in Australia. We are
writing to tell you what we have in mind and, on hearing from you, we can cast
the proposals in a more definite form, which can be the basis of an agreement
between us.

As in every country, tax drains away so much of one's reward,
and we want to make this as least painful as possible for you, by suggesting
an expense allowance which we think should be passed by the tax authorities
without too much argument. But we find from experience that the tax people
look at expenses in relation to taxable remuneration. So what we suggest is
a basic salary of £1,000 (sterling) per annum, and an expense allowance (towards
living costs) of £750 p.a. All expenses incurred by you in taking photos for
us would naturally be re-imbursed also. In addition, you would be paid commission
on advertising photography done through our studio in accordance with our terms,
and we anticipate a reasonable minimum commission in your case would be say £450
p.a. This, unfortunately, is taxable.

This all adds up to about £2,200 p.a., subject to tax on say
£1,450, with the possibility of more from advertising commissions. In Australian
currency this £2,200 sterling is £2750 Australian, I believe.

In return, the Condé Nast organisation would have world wide
exclusivity of your fashion photography, and complete U.K. exclusivity of all

Cont'd.

DIRECTORS: H. W. YOXALL, AUDREY WITHERS, R. A. F. WILLIAMS, GERTRUDE PIDOUX, L. F. HARWOOD, N. HAYWOOD NELMS (BRITISH). I. S. V.-PATCÉVITCH, EDNA WOOLMAN CHASE (U.S.A.)

The Condé Nast Publications Ltd

VOGUE
HOUSE & GARDEN
VOGUE PATTERN BOOK
VOGUE EXPORT
VOGUE BEAUTY BOOK
VOGUE KNITTING BOOK

37 GOLDEN SQUARE, LONDON W.1. TEL. GERRARD 9060 TELEGRAMS VOLON PICCY LONDON

- 2 -

your work done during the period of contract. This means that you would be
free, subject to our having first call on your working hours in U.K. to take
non-fashion photos for the Australian press, etc.

 I hope to hear that these arrangements appeal to you. Exact
terms would be incorporated in an agreement later, but if, in the meantime, I
can give you any further information, I shall be happy to do so.

 Yours sincerely,

 N. Haywood Nelms,
 Director & Secretary

c. Mr. Yoxall
 Miss Withers ✓
 Miss Cooper
 Miss Pakenham-Welsh
 Mr. Parsons
 Mrs. Morton

DIRECTORS: H. W. YOXALL, AUDREY WITHERS, R. A. F. WILLIAMS, GERTRUDE PIDOUX, L. F. HARWOOD, N. HAYWOOD NELMS (BRITISH). I

HELMUT NEWTON
LETTER OF INTENT FROM VOGUE, 1956

Helmut Newton has tended to marginalise his early career
with British *Vogue*. Perhaps unsurprisingly. Of a one-year
contract given to him in 1957, he has said, 'it was the
unhappiest time of my life.' And he was used sparingly, to
say the least. Rosemary Cooper of the *Vogue Export* book
(which promoted British fashion abroad) is credited with
giving him his earliest fashion work for *Vogue* for a
supplement she also edited for the Australian market. An

émigré from Berlin, Newton then lived in Melbourne. And
it is difficult not to have some sympathy for his view. The
'twinset and pearls' atmosphere (as he calls it) of *Vogue* on
the cusp of the 1960s was not the obvious arena for a
photographer with an enquiring mind and a yearning to
push the moral boundaries. The photograph (*right*) is a
published one from August 1956, a special edition of the
magazine promoting Australia, Newton's adopted home.

Handwritten annotations on image:

EARLY SEPT VOGUE
SHOPHOUND
S/S

110 / Screen samp.
Sep oo 13 plates.

DAVID BAILEY
'SHOPHOUND', 1960

Bailey's first contribution to *Vogue* (*above*) prepared for the printer (together with still lifes by Cyril Readjones). Before taking these, Bailey had turned the magazine down at least twice (*Woman's Own* and the *Daily Express* paid better). Within a few months he was given his first cover (February 1961), and by a couple of years later he was the magazine's most prolific contributor. Young and working class, he was the antithesis up till then of the *Vogue* fashion photographer. He refused to hide behind a mask of self-deprecation like some of his contemporaries: 'I'll give them cute,' he vowed as the fashion editors patted his 22-year-old head in the corridors of *Vogue*. When Bailey's friend Terence Stamp, also from the East End of London, began to show an interest in acting, his father commented: 'People like us don't do things like that.' It was probably much the same for Bailey. Some years later he outlined the opportunities open to his sort: 'Being of humble beginnings, I had a choice at this time, age 16, time Monday 4.30 in the afternoon. I could either

be a jazz musician, an actor or a car thief. I was not so brave as to be the latter and I thought acting was talking posh.' So he became a photographer. He drew on his working-class roots, observing, without much regret, as his friend Terence Donovan put it, that he might 'reverse back to the East End at any time'. Bailey is now an icon of British photography, with work which extends beyond the boundaries of fashion and beauty shoots; he is part of our cultural landscape. Such is his reputation that over the years enough stories have sprung up around him to suggest that he was the kind of person of whom anything was possible. He married Catherine Deneuve – but not to win a bet; he has never said to a model, 'Move a little to the left, doll'; and it is apocryphal, too, that he planned to call his memoirs (unwritten) *When I Die I Want to Go to Vogue*. But it is true that, three years after these 'Shophound' pictures were published, he asked the managing director of *Vogue* to move his Humber so he could park his Rolls-Royce.

VOGUE

NDÉ NAST PUBLICATIONS LTD

NOVER SQUARE · LONDON W·1 GROSVENOR 9080

30th December, 1960.

, Esq.,

lapham Road,
London, S.W.9.

Dear Mr. Bailey,

This is just to confirm the agreement we have entered into verbally,
that we make you a guarantee of £600 for work done for Conde Nast
magazines during the period of one year from November 1st, 1960, terminating
on October 31st, 1961. We shall pay you a page rate of £15 and prorata.
You will continue to receive payment for your Shophound photographs separately,
for which we will pay at the rates already established.

In return for this guarantee, it is understood you will do no editorial
work for either Harpers Bazaar or the Queen.

It is further agreed that you will channel all your advertising work
through Vogue Studio Ltd. who will provide the necessary film, processing
and prints at their expense, and that we will pay you a commission of 33-1/3%
on the net sum received for each advertising assignment that we may offer you
or you may bring to the Studio. Your commission will be credited to your
account monthly. It is further understood that all advertising work will be
placed through Vogue Studio Ltd. and that you will not undertake advertising
work other than through Vogue Studio Ltd. All prices for advertising sittings
must be arranged by the Manager or Assistant Manager of Vogue Studio, and their
decision as to the amount charged must be final.

I shall be very glad if you will be kind enough to sign the attached
copy of this letter signifying your acceptance of this arrangement, which will
then be considered binding on both parties for the length of the agreement.

I am very pleased to have you working for us, and I am sure you will
make a very handsome contribution to Vogue pages.

Yours sincerely,

John Parsons
Art Director.

DIRECTORS: H. W. YOXALL (CHAIRMAN), REGINALD A. F. WILLIAMS, AUDREY WITHERS, GERTRUDE PIDOUX, L. F. HARWOOD, J. PERRY, I. S. V. PATCÉVITCH (U.S.A.)

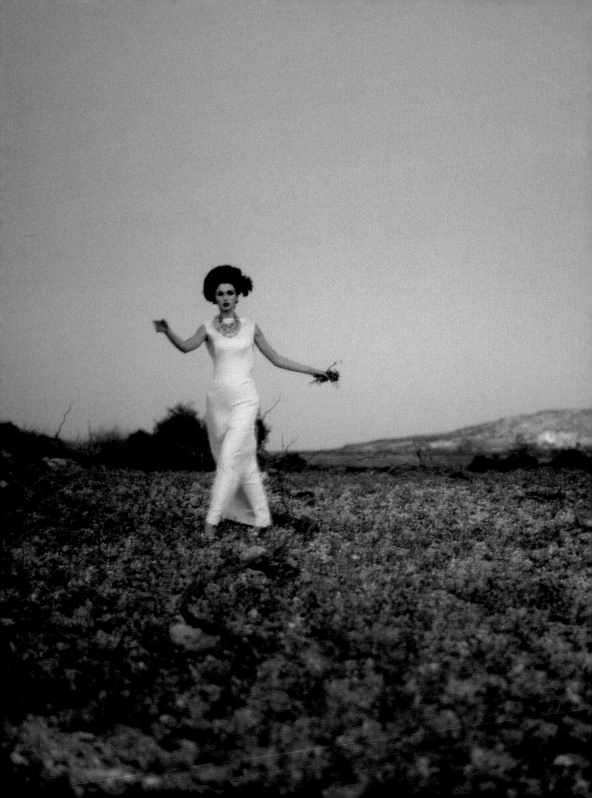

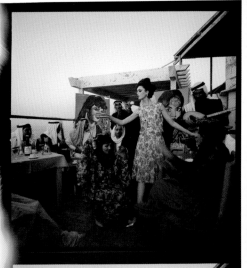

WILLIAM KLEIN
DOROTHEA McGOWAN, 1961

Alexander Liberman, American *Vogue*'s art director, found in the photographs of William Klein, a Paris-based abstract painter and sculptor, a riposte to the energy Richard Avedon was bringing to the pages of *Harper's Bazaar*. 'He was an American from the Bronx,' explained Liberman, 'with a brashness and a sort of violence that I admired.' Klein returned to New York to assist Liberman, but it soon became apparent that the art department wasn't where he was going to be for long. Struck by the changes he found in New York, a city he no longer felt part of, he wanted to be among the chaos of its streets, raking the subways, cinemas and grocery stores for snatches from the lunatic display of everyday life. 'I felt like a Macy's parade balloon floating back after a million orbits,' he wrote later. 'I knew the city, but it was now in a different focus.' That Klein was allowed to bring his style to the pages of a mainstream fashion magazine, says much for Liberman's own vision. For the next 10 years, Klein took witty surrealist vignettes on the streets of Paris, New York and Rome, which often, as anticipated, outplayed Avedon's in dynamism and verve. Klein's models refused to run and jump across the sidewalks, but stood resolutely in the road, like showroom mannequins abandoned in the heavy traffic. Up on the Brooklyn Bridge he made them hold mirrors to accentuate the absurdity of their situation. *Vogue* often curbed Klein's desire to experiment. He wanted once, for example, to shoot evening wear underwater and, for another fashion story, requested that he might himself hand-tint the black-and-white photographs; the magazine rejected both proposals. His wish to work in a 35mm format, which would have allowed him greater spontaneity, was also blocked at first, because the editor of *Vogue* was unable to examine properly the tiny contact-sheet images. Commenting on his time with the magazine (1954 to 1966), he told the writer Martin Harrison, 'I regret that the restrictions of the period prevented me from going further.' For British *Vogue*, in the years of early jet travel, he was often sent on assignment to exotic locations. These pictures, for example, published in black and white, were shot in the Lebanon and Jordan. He shot Dorothea McGowan with a telephoto lens (*left*) from a considerable distance. Miss McGowan was 'rescued' by a Jeep-load of location scouts for the film *Lawrence of Arabia* who, unable to see the *Vogue* team, mistook her arm-waving for genuine distress; they also wondered why she was wearing an evening dress by Susan Small and jewellery by Adrien Mann. Klein eventually tired of the fashion world – of which he had never truly wanted to be a part. 'Liberman kept me away from the fashion editors,' he commented, 'which was best for everyone. We wouldn't have had much to talk about…'

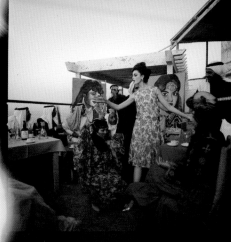

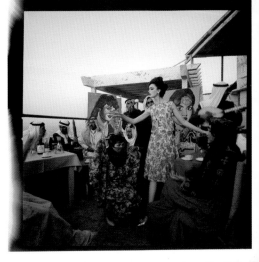

WILLIAM KLEIN
SIMONE D'AILLENCOURT, 1961

These photographs were taken for the Paris Collections but never ran in British *Vogue*. Miss d'Aillencourt wears evening dresses by Dessès (*above*) and Lanvin-Castillo (*opposite*). Not long after these were taken, Klein's frustration with the fashion world was compounded by the appointment of Diana Vreeland as editor of American *Vogue*. He was unmoved by her offbeat take on the fashion of the times. 'Her arrival,' he wrote in *In and Out of Fashion* (1994), 'was the beginning of the end of my collaboration with *Vogue*. She was a fashion fundamentalist and I was an infidel. The distrust was mutual. Her grail was pizzazz and we were all to assist her in her quest. When I asked once, "What exactly do you mean by pizzazz?" she was shocked and almost pained. It was only much later that I found out she was a friend of people like Fred Astaire and Josephine Baker. I didn't know either that Nicky de Gunzburg, an effete male editor, had helped finance Murnau's *Nosferatu* and played a main role… Now I regret that my prejudices kept me from being more curious about my *Vogue*-mates, who were less one-dimensional, surely, than I had imagined.'

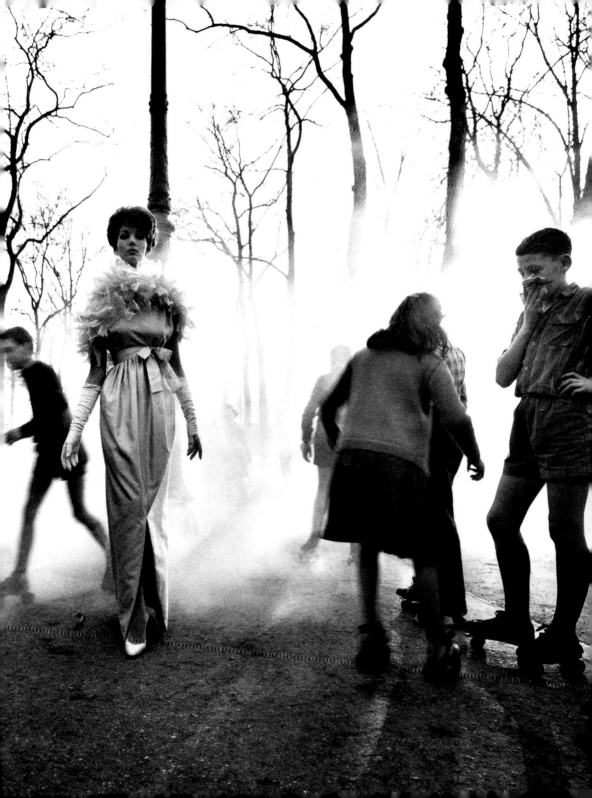

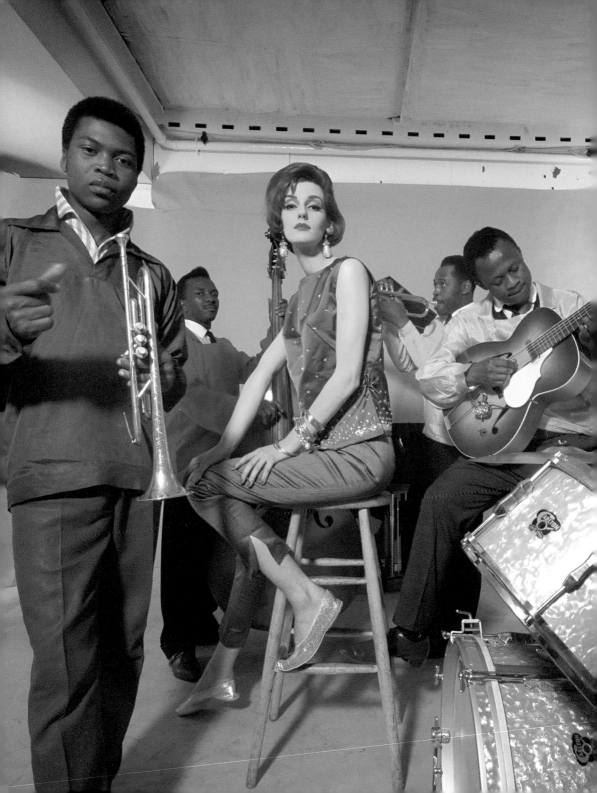

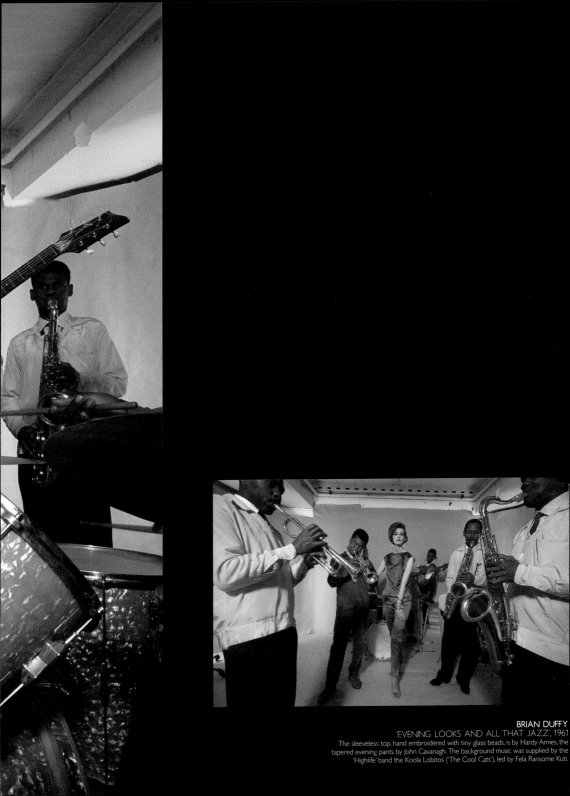

BRIAN DUFFY
'EVENING LOOKS AND ALL THAT JAZZ', 1961
The sleeveless top, hand embroidered with tiny glass beads, is by Hardy Amies, the
tapered evening pants by John Cavanagh. The background music was supplied by the
'Highlife' band the Koola Lobitos ('The Cool Cats'), led by Fela Ransome Kuti

THE CONDÉ NAST PUBLICATIONS LTD.

MODEL PAYMENT SLIP

NAME Jean Shrimpton.

ADDRESS

DATE 12th. July. 1962.

AGENCY Lucie Clayton.

TOTAL AMOUNT £ 21 : 0s : 0d.

Date of Sitting	Feature	Issue	Photographer Artist	Amount
	Cover			
9.7.62.	Thoroughbreds	~~VOGUE~~ V. Oct.15	Bailey.	£10. 10s. 0d.
10.7.62	"	"	"	£10. 10s. 0d.

Purchased by	Recorded by	Approved for payment by	Date paid	Voucher No.

DAVID BAILEY
JEAN SHRIMPTON, 1962
As Bailey's career with the magazine progressed, his photographs began to represent a reaction against a certain slickness he perceived in the fashion world. Determined that his pictures should stand out, he made a deliberate effort to bring a more casual sensibility to mainstream fashion photography. He achieved this early on with the aid of a 35mm camera and a hand-held informal style. This reached its apogee in 'Young Idea Goes West', a 14-page assignment for *Vogue* in New York City (of which these are variant transparencies), which is characterised by a documentary realism that Bailey seldom used again for fashion reporting. The final layouts contain around 30 photographs. Apart from the fashion pictures, they include assemblages of a street vernacular: billboard signs, discarded bottle tops, advertising hoardings, shop fronts, road signs and cinema posters – all indicative of Pop Art's infatuation with symbols of consumerism and one of British *Vogue's* earliest acknowledgments that such a movement pervaded popular culture. Diana Vreeland remarked on seeing Bailey and Shrimpton, 'But they are adorable! England has arrived!'

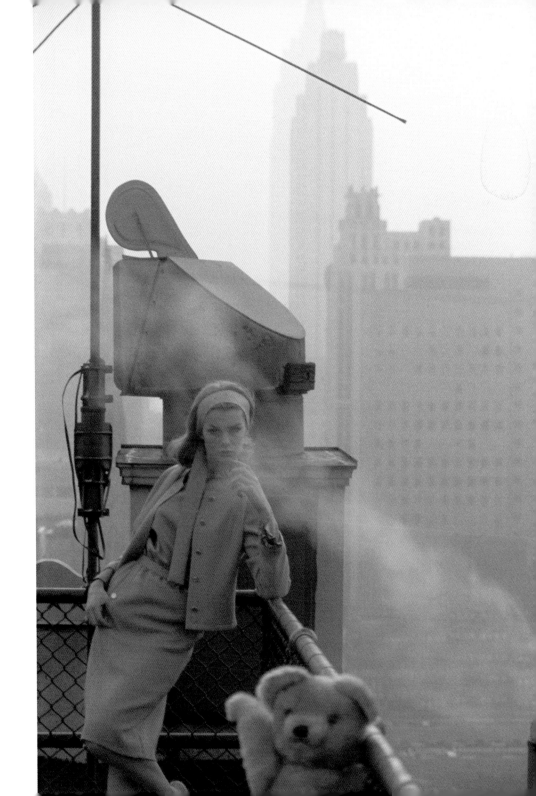

CECIL BEATON
JEAN SHRIMPTON, 1964
By the 1960s, Beaton, a *Vogue* contributor since 1926, was becoming outmoded. But in the middle of the decade a new breed of young fashion photographers began to explore the heritage of earlier fashion photography including, naturally, Beaton's. Chief among these was David Bailey, who counted Beaton among his idols – along with Picasso and Fred Astaire. Bailey 'lent' him his model and girlfriend, Jean Shrimpton, and the results were given four pages and an article in *Vogue*, 'Beaton: Faces from Shrimpton'. This picture of her in Japanese-inspired make-up and wig was published in black and white and severely cropped (only the central part of the image appeared). According to Shrimpton, the sitting 'did not go well. I wasn't feeling good and Beaton didn't like me. He had no time for me. I was not titled and I wasn't much good at conversation… He photographed me in a Scottish kilt and a huge white Pompadour wig. I wasn't comfortable in either, but I do appreciate now that the wig picture is rather special…'

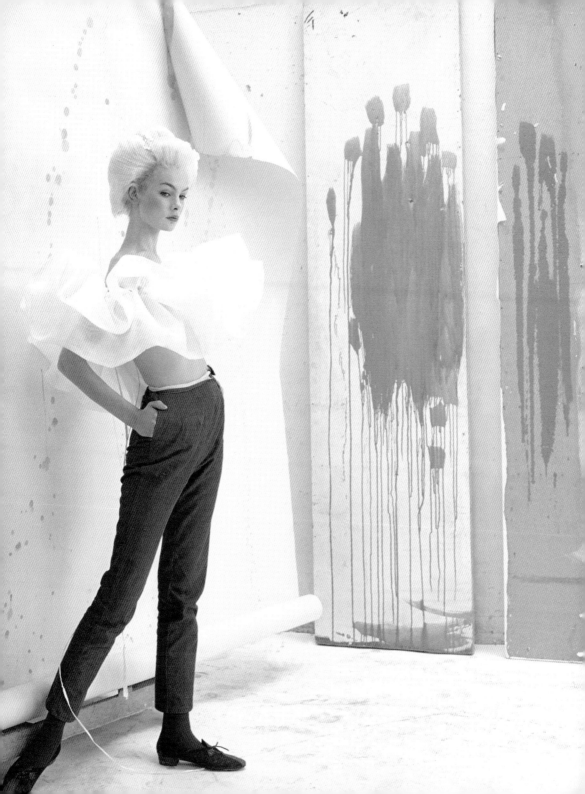

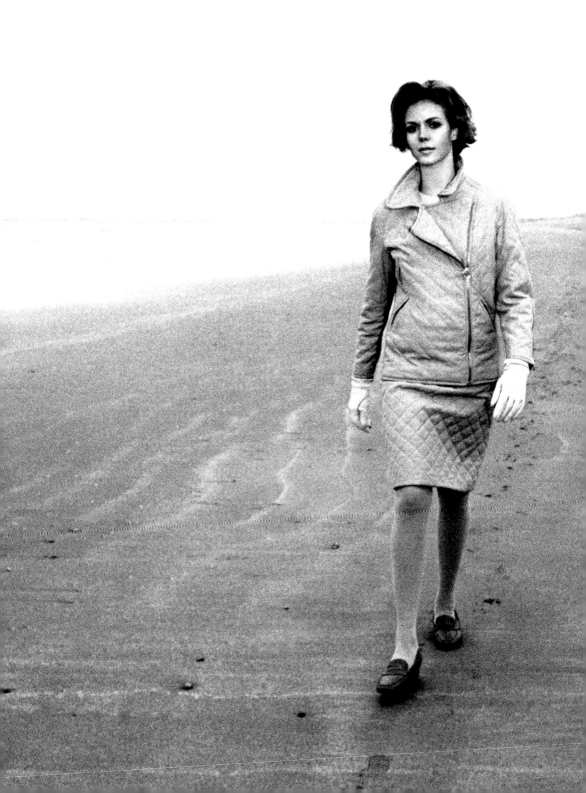

NORMAN EALES
'YOU SUIT RAIN', 1965
At *Vogue*, Eales never quite matched the success of his East End contemporaries David Bailey and Terence Donovan. He found fame mostly as a cover photographer for *Cosmopolitan* and as a reliable photographer for the fashion pages of British newspapers. He did, however, have his admirers at *Vogue*. The fashion editor Sheila Wetton wrote, 'he understood fashion and the way women would like to look. Any fool can photograph fancy dress, but not everyone can make a woman look glamorous in a twinset and pearls.' In the mid-1970s, finding his native city increasingly and appallingly dirty, Eales relocated to Los Angeles; but from there, to his chagrin, found he was working more and more for British publications. In 1984 he lied about his age by 14 years (he was by then 48), and joined the United States Marine Corps. He was quickly promoted to Sergeant of 'A' COY 40 CMND RES. He died five years later in Beverly Hills. This uncropped version of a picture published in *Vogue* shows a quilted 'anti-squall' suit by André Ledoux.

right
DAVID BAILEY
JEAN SHRIMPTON, 1965
The published version, of which this is a cropped variant, is a full-length double portrait of Shrimpton, in a black jump suit and, to her left, the singer Anita Harris in a lace minidress.

following pages (left)
FRANCO RUBARTELLI
VERUSCHKA, 1965
Considered at first too exotic to be a model, Vera von Lehndorff, daughter of Count Heinrich von Lehndorff-Steinort (who was executed for his part in the 1944 von Stauffenberg 'July plot' to assassinate Hitler), found her niche at American *Vogue* in the 1960s. There Diana Vreeland's pursuit of the odd, the eye-catching and the offbeat allowed the 6ft 1in Countess the chance to shine. Photographed by Avedon, Bert Stern, Horst and many others, she became famous chiefly as a result of the painstaking tableaux constructed by the Italian Franco Rubartelli. She would become anything the magazine wanted her to be: a Valkyrie, a leopard asleep in a tree, an ice maiden, a sea nymph or, as here, herself.

following pages (right)
FRANCO RUBARTELLI
BEAUTY PHOTOGRAPH C.1965

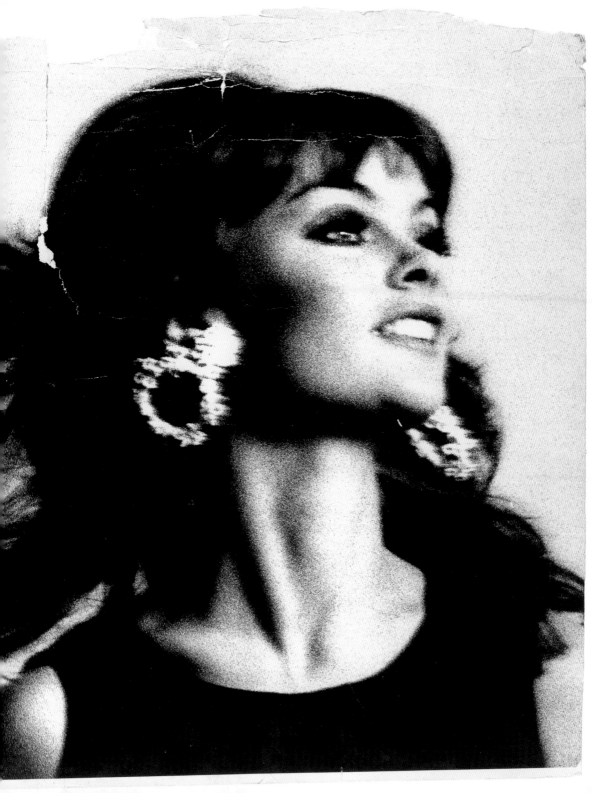

TURN 1.

S/S
110 Seven
Sep 004
HSP 5587.

SHOPHOUND AUG VOGUE

TURN 2

TURN 4

TURN 3

Size marked.
Scales 4 as one.
Sep as 3.
110 Screen

|← —— 3 5/16 —— →|

SHOPHOUND AUG VOGUE

HSP 5587

MICHAEL COOPER
'SHOPHOUND', 1965

Michael Cooper's reputation as a photographer rests for the most part on his relentless documenting of the Rolling Stones. A constant member of the band's entourage until his early death in 1973, by his own hand, he was in effect their court photographer. His photographs of the London art scene, in particular his grainy reportage portraits of the early British 'Pop' movement, are a little-known record of the times. In addition, Cooper was in demand as a fashion photographer and, for a while, a staff photographer for *Vogue*. But commissions for more 'cutting-edge' magazines, such as *Town*, offered him more artistic freedom than the glossier titles. *Vogue*'s regime stifled him, and (unlike his colleague David Bailey) he found it pointless or perhaps too much effort to subvert the magazine's style to suit his preferred idiom. Despite the best efforts of the magazine's art director John Parsons, who designed these layouts, and the magazine's innovative 'Young Idea' editor Marit Allen, Cooper's time at *Vogue* lasted barely two-and-a-half years. Cooper photographed with an energy – and perhaps an urgency – the happenings and events that reflected the lifestyles of, as George Melly has written, 'the glittering, talented and potentially tragic creatures, who, like dragonflies, darted and hovered across those careless years'.

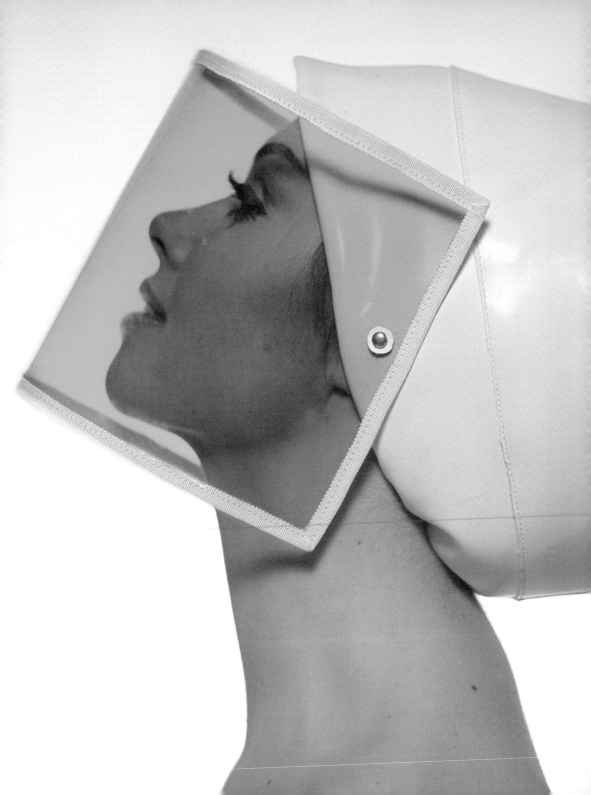

BRIAN DUFFY
URSULA ANDRESS, 1966
Famous for her role in the first James Bond film
Dr No (1962), Ursula Andress was also a star of
the spoof Bond film *Casino Royale*, directed by
John Huston and filmed at Shepperton and
Pinewood studios. *Vogue* was allowed on to
one of the sets. Its reporter was mystified by
Huston's Surrealist take on the spy-film genre:
'In one scene what looks like the massed pipe
bands of Scotland march (playing loudly)
through misty clouds, while Peter Sellers and
Ursula Andress [as Vesper Lynd] stride
alongside them in kilts. Ursula then shoots
everyone dead; but this ran into some
confusion when it was discovered that Peter
O'Toole [a main character], also dressed in a
kilt and a bearskin, was among the dead…'
Here Ursula Andress wears a futuristic white
and green acetate helmet designed specially for
the film by milliner James Wedge.

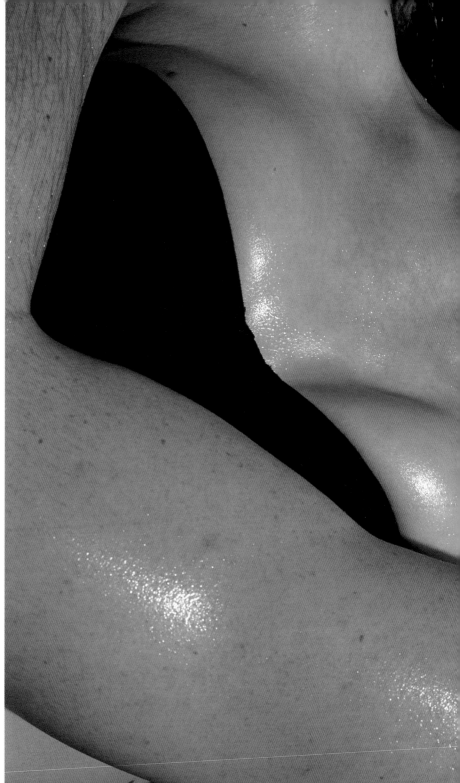

HELMUT NEWTON
JEAN SHRIMPTON, 1966
Having moved to Paris around
1962, Newton still contributed
occasionally to British *Vogue*, the
magazine which discovered him.
He was able to explore with *Vogue*
some elements of that erotic,
narrative style to which he
would frequently return in a long
career in fashion photography.
A month after this beauty
photograph of Shrimpton
appeared (the male arm is
obscured in the published frame),
Vogue ran a 10-page fashion shoot,
an implicit lesbian ménage,
featuring Shrimpton and Celia
Hammond, which foreshadowed
the style that became his
trademark at French *Vogue* in the
following decades. By 2002,
Newton's eighty-first year, his
position seems as entrenched as
ever it was in 1957. 'I do not really
understand the English at all,' he
explained to the writer Christa
D'Souza. 'Maybe that is why I've
never been able to take a really
good picture over there…'

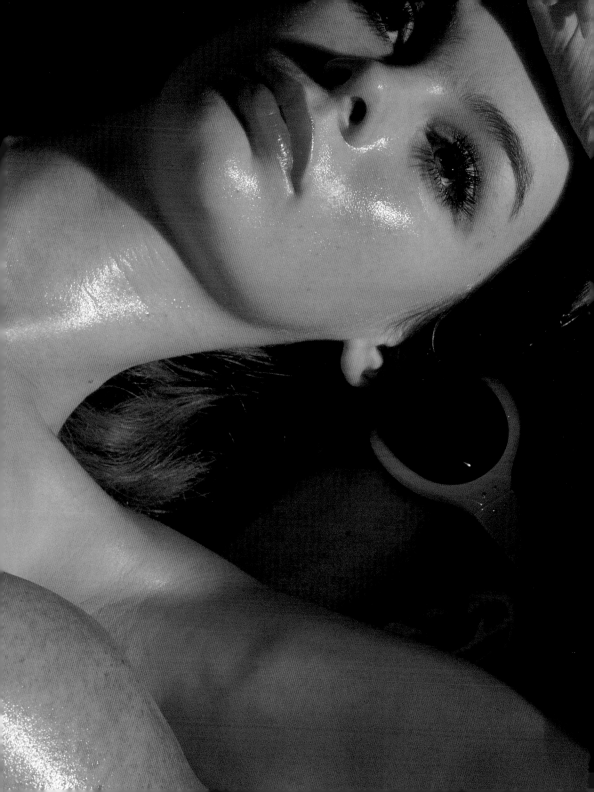

SAUL LEITER
BEAUTY PHOTOGRAPHS, 1966

Though Saul Leiter photographed fashion for *Harper's Bazaar* and *Vogue*, this part of his work has almost vanished. A key member of what is now known as the 'New York School' (after a landmark exhibition at the Museum of Modern Art, New York, in 1992), he is celebrated now for his photographs of the city's streets, which share the sensibility of the work of his colleagues Louis Faurer and Robert Frank, who also both turned their hand to fashion work. Like them, Leiter was determined to bring to the fashion pages of *Vogue* a more casual approach, and to divest himself of any traces of the self-conscious 'glamour' to which fashion photography is prone. Leiter's pictures are frequently too subtle for the more primitive colour reproduction of the times; his penchant for shooting through shop and car windows, as in these variants from beauty stories, made such subtlety even more pronounced. As he told the writer Martin Harrison, 'When I worked for fashion magazines I had the hope that the result would look like a *photograph* rather than a fashion photograph; that occasionally something else was going on there.' The model (*above*) is Jean Shrimpton.

left and opposite

BOB RICHARDSON
SUE MURRAY AND JILL KENNINGTON, 1966

following pages

BOB RICHARDSON
JILL KENNINGTON, DONNA MITCHELL,
SUE MURRAY, 1966

If Bob Richardson was known at all in the years immediately after he vanished from the pages of *Vogue* and *Harper's Bazaar*, it was as a maker of fashion photographs, heavy with languor. He was later remembered as a rebellious, difficult, egocentric, rude, impossible contributor, whose moment had come and gone, leaving few who worked with him at all surprised at the rapidity of his fall. Drug addiction and schizophrenia undermined him, but the narrative tableaux he produced are masterpieces of postwar fashion photography. 'He had an incredible intensity and an ability to reach into your soul and pull it out,' recalled Jill Kennington, a frequent model for him. 'It was as if no one else existed for him.' His rehabilitation was tardy, but kick-started by Martin Harrison's survey of postwar fashion photography, *Appearances* (1991), and boosted by a profile in *The New Yorker* in 1995, which revealed that for some time he had been homeless, living on the beach at Santa Monica. Now so vital are they to *Vogue*'s heritage (and so recognisable in much of today's fashion pictures elsewhere), that the absence of his pictures in a history of the magazine's contribution to photography would be unthinkable. Much of his work was never published, including these and the photographs on the following pages. Kennington recalled the editor calling her in, '"Now, Jill, you know Bob and I know Bob and what we don't want is a 'druggy' look." I had a funny idea these wouldn't be used…' As he told Harrison, 'Beatrix Miller [British *Vogue*'s editor] called my photographs "decadent, immoral and vulgar" – the last hurt.' He is an unmistakable inspiration to the generation of disaffected 'anti-fashion' photographers of the 1990s, who aspired to emulate his seditious approach, and also to his son Terry, a frequent contributor to *Vogue*.

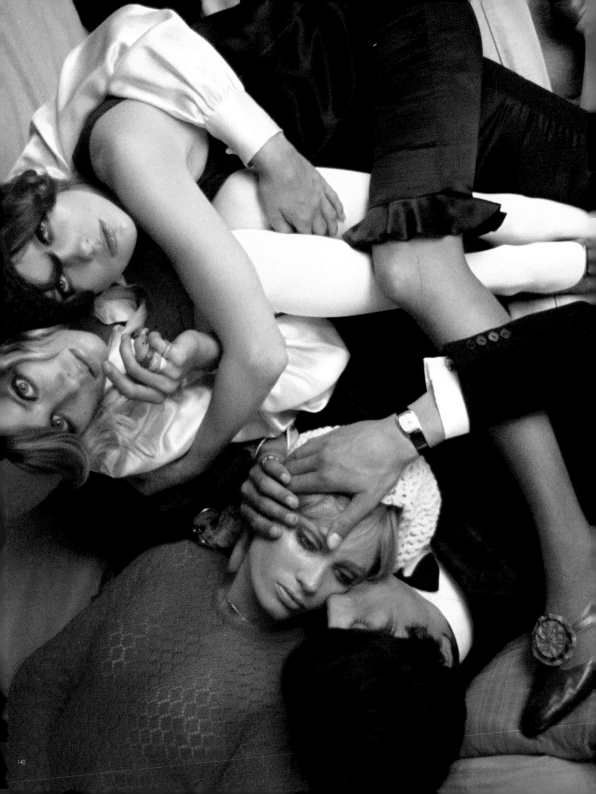

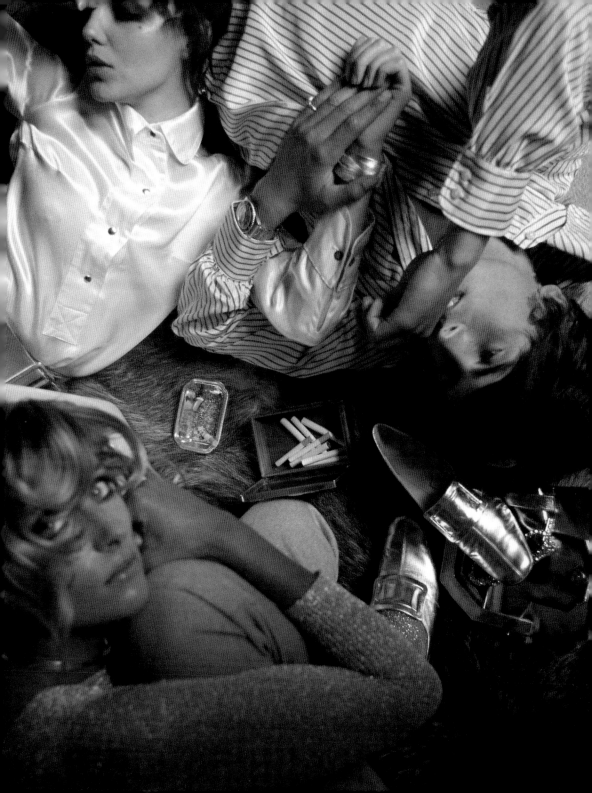

BOB RICHARDSON
DONNA MITCHELL, 1966
Candida Lycett Green and Robin Fraser Pay
designed the velvet shooting suit.

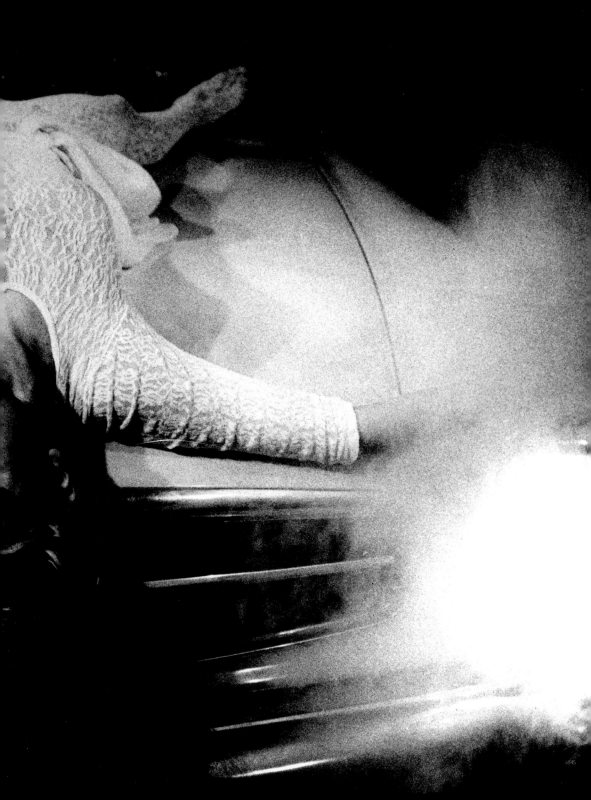

JOHN COWAN
RACQUEL WELCH, 1966

John Cowan was all but forgotten until
reintroduced as a photographer of considerable
talent, and as a life-enhancing, if rakish, adventurer
by Philippe Garner's compilation *John Cowan –
Through the Light Barrier* (1999). His tale is a
cautionary one for the photographer *manqué* –
meteoric rise, brief creative span, unravelling
career, looming bankruptcy. Cowan's lifestyle is so
close to the fast-living, high-rolling 1960s
photographer-hero of popular imagination, that it
could have served as a model for the script of
Antonioni's *Blow-Up* (1966), whose lead
character is a young, anti-heroic photographer.
The Italian director did indeed use Cowan's
studio as the principal location for his
metaphysical fable of the London scene, and for
three months its owner lived in a van parked in
the street. Cowan dispensed useful technical
advice and authenticated details of the main
character's methods, as well as lending several
large prints to decorate the set. Much of the
staccato 'studio patter' of David Hemmings (the
lead) to his model (played by Veruschka) is,
according to witnesses, unadulterated John
Cowan: 'That's good. Yes! Go on. That again. That
again. That again. Go, go. Great. That's it. Lovely.
Love for me. Love for me. Now. Yes. Yes. Yes.' In
1966, Cowan told an interviewer, 'A great part of
my life in photography is playing, and there are
some pretty marvellous toys. Aeroplanes, cars,
armies, models, ships…' This photograph of the
young star of *One Million Years BC*, splayed across
the bonnet of a Mercedes 230sl for the *Men in
Vogue* supplement to *Vogue*, is thus quintessential
John Cowan.

JUST JAECKIN
TWIGGY, 1967

An unpublished cover try (a shot styled specifically
as a possible cover). A fashion and beauty
photographer for *Vogue* throughout the 1960s, Just
Jaeckin reached another audience as a screenwriter
and film director. His films include the soft-porn
classics *Emmanuelle* (1974) and *The Story of 'O'*
(1975) and *The Perils of Gwendoline in the Land of
the Yik Yak* (1985).

BERT STERN
CLOTHES BY COURREGES FROM THE
PARIS COLLECTIONS, 1967

Originally published in American *Vogue*, this double-
page spread was removed from the British edition's
coverage of the Paris Collections. A protégé of
Balenciaga and a former civil engineer, André
Courrèges was fêted by *Vogue* as 'the first Space-
Age designer'. Although it was Pierre Cardin, with
his futuristic designs, who paved the way for the
later success of Courrèges and Paco Rabanne, it
was Courrèges's geometric cut and experiments
with unisex wear which captured the imagination.
His designs – big-zippered coats and outsize
pockets – almost always in white (inspired, he said,
by the whitewashed villages of his native southern
Spain), inspired all manner of tributes. The
redoubtable French intellectual Violette Leduc,
writing for American *Vogue*, ends a four-page
stream of consciousness: 'Enormous owl eyes of
white mica, little mechanic's gloves… Valentin the
Boneless Wonder's acrobat tights, Othello's black
calves arrayed in daisies, rodeo champions
disguised as model little girls, Alcibiades shod in
snow, in bearskin, in the footgear of polar angels, all
this, too, is Courrèges and it is breathtaking. I have
dashed down this last paragraph in order to admire
again what I have admired. Yes Courrèges.'

GUY BOURDIN
BEAUTY PHOTOGRAPH, c.1969

When Guy Bourdin died in 1991, much of his life's work lay in his apartment, abandoned in shoe boxes and rubbish bags. According to those who knew him, that is exactly how it should have been, for he believed that his images belonged only on the pages of magazines. His first exhibition of black-and-white photographs held in Paris, in 1953, was also his last. He would make no compromise to the integrity of his vision – even in the face of bankruptcy. In the early 1980s, the late Sam Wagstaff once thrust a blank cheque into his hand in exchange for a print. Though Bourdin was broke, he refused it, offering the great collector instead a picture postcard of a Bourdin photograph. His photographs for French *Vogue*, where he remained for 30 years, reached a wider audience, and were admired for their saturated colours and their highly stylised Surrealist content. Bourdin had forged an early friendship with Man Ray and, throughout his life, himself painted Surrealist works. His long-running advertising campaign for Charles Jourdan shoes is famous for sublimating the product to the point of obscurity, and for his inventive scenarios. Bourdin's photographs for British *Vogue*, mostly produced with Grace Coddington, are still largely unknown, though as obsessively wrought as his later work for French *Vogue*, French *Photo* and *Marie Claire*.

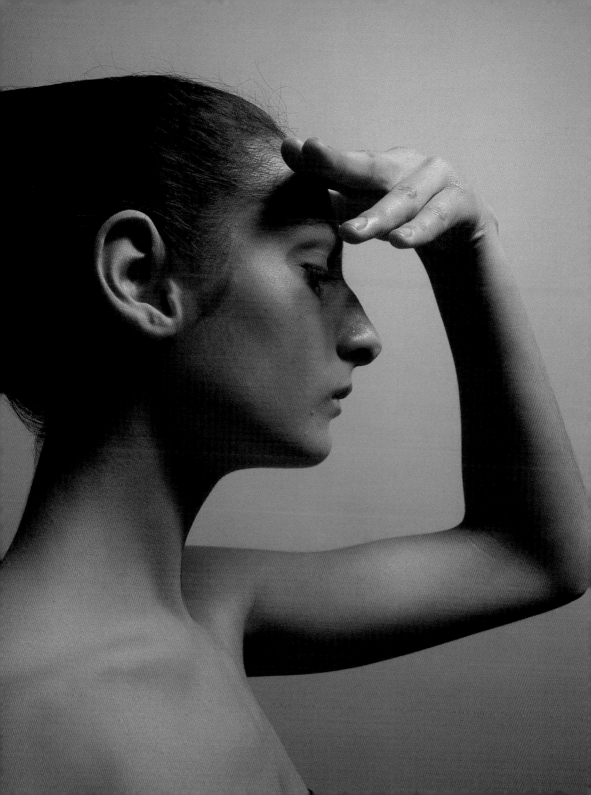

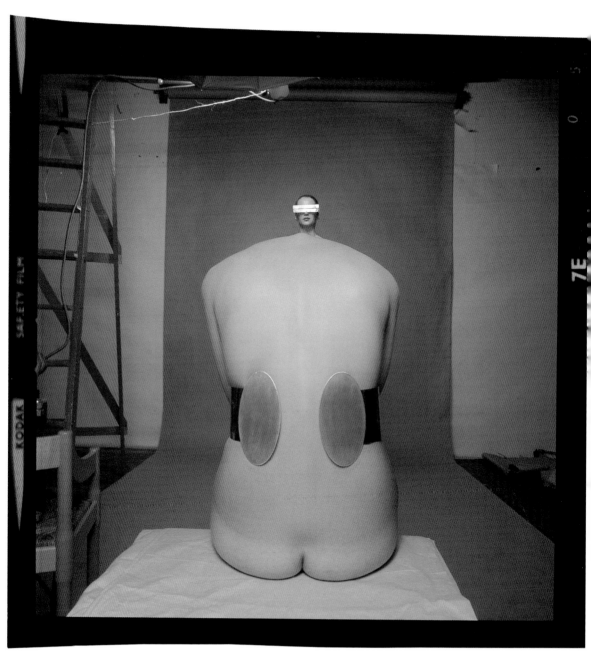

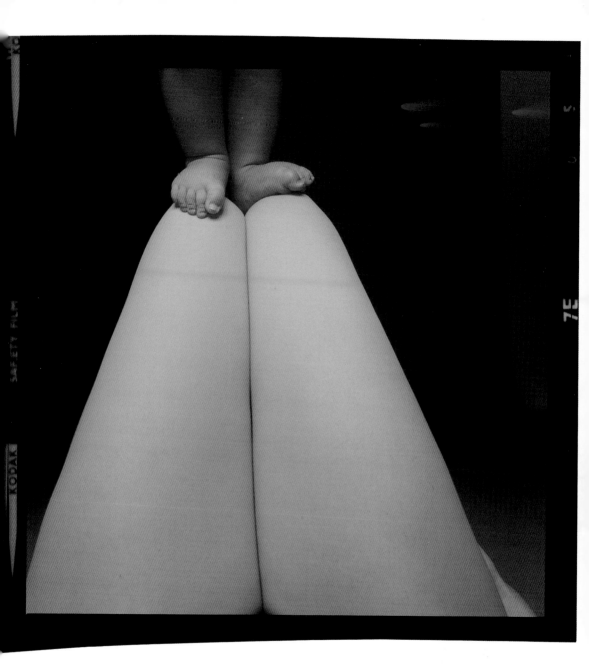

GUY BOURDIN
BEAUTY PHOTOGRAPHS, 1969
Variants from the *Vogue Beauty Book*

BARRY LATEGAN
BEAUTY PHOTOGRAPHS, 1969

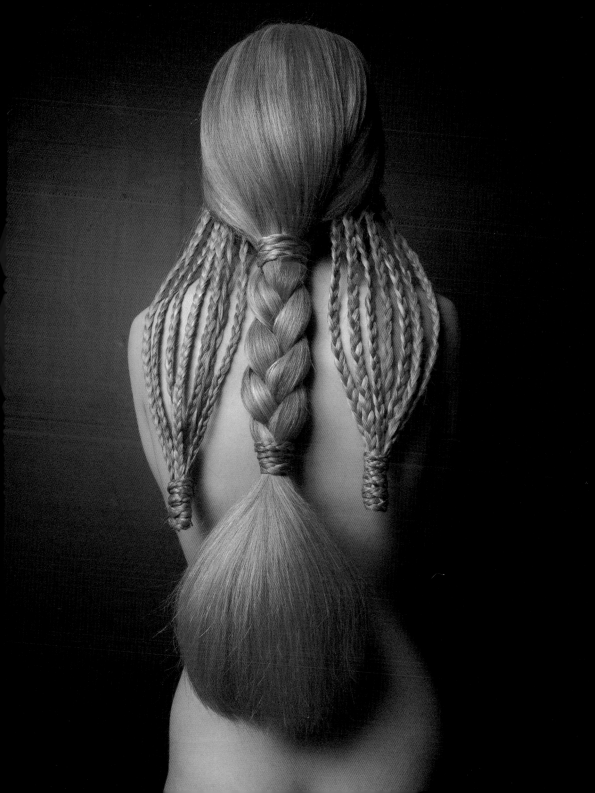

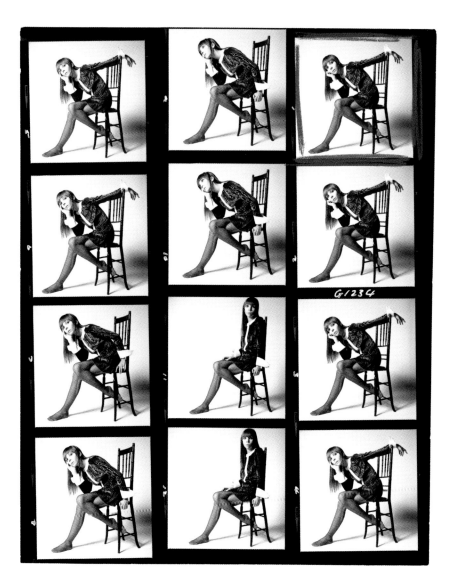

above

DAVID BAILEY
PENELOPE TREE, 1967
When *Vogue* arranged a photographic session with the 17-year-old Penelope Tree and appointed Bailey to carry it out, the photographer was told to be on his best behaviour: 'no swearing; no pouncing'. He did both and they fell in love. Tree's no-eyebrow looks were striking and unique – like a Martian, a flower child and a Pre-Raphaelite muse rolled into one stick-thin frame. 'She is never only of today,' pronounced Richard Avedon, while Bailey compared her to an 'Egyptian Jiminy Cricket'. The pair embraced an alternative lifestyle; it was alleged that Penelope had installed a UFO detector at Bailey's London home. This is the contact sheet of a well-known example from their collaboration.

opposite

CECIL BEATON
PENELOPE TREE, LATE 1960s
Pursuing Penelope across his lawns, during filming for the documentary *Beaton by Bailey*, Beaton, then 66, experienced severe chest pains. But, reinvigorated perhaps by 'Swinging London' and also by Bailey's attention, he was to live for another decade; indeed, he was so alive to the cultural climate of the times, he was nicknamed 'Rip-Van-With-It'.

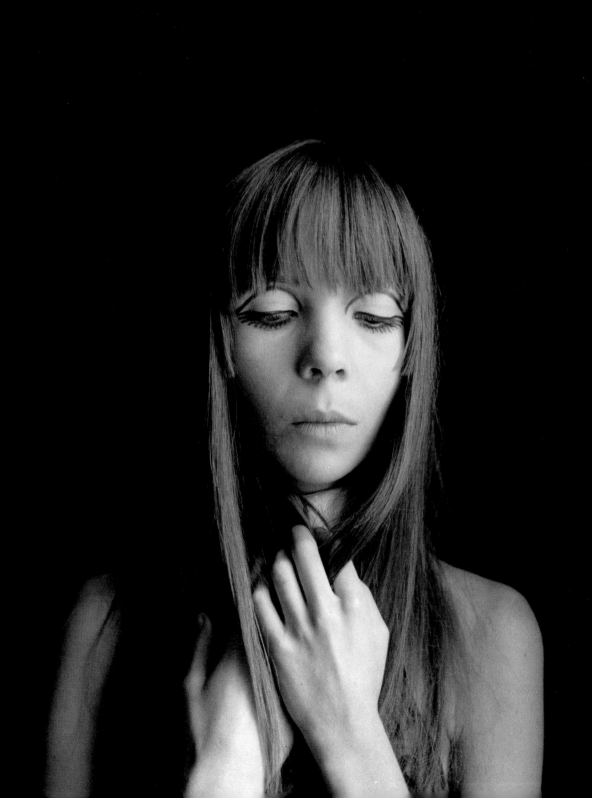

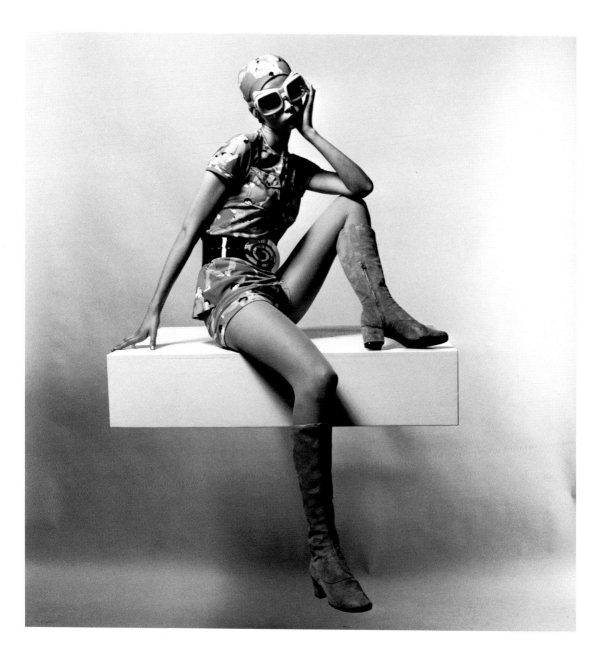

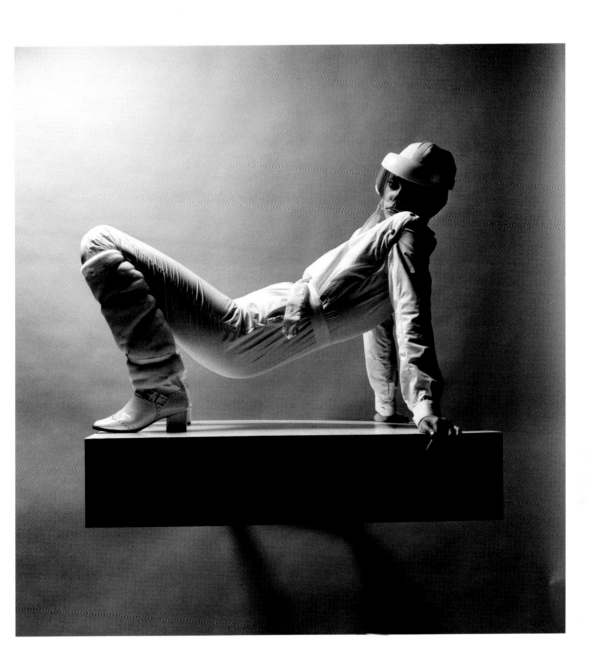

GUY BOURDIN
MOUCHE, 1969
Judo suit (*opposite*) by Ken Scott overprinted with images of
martial-arts combatants. White ciré space suit and visor by V de V
(*above*). Both out-takes (unused shots) from a published sitting.

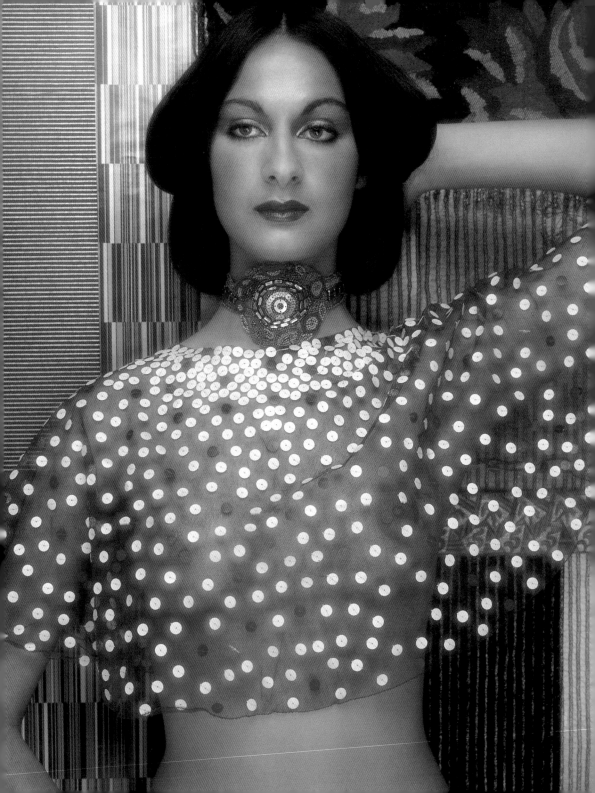

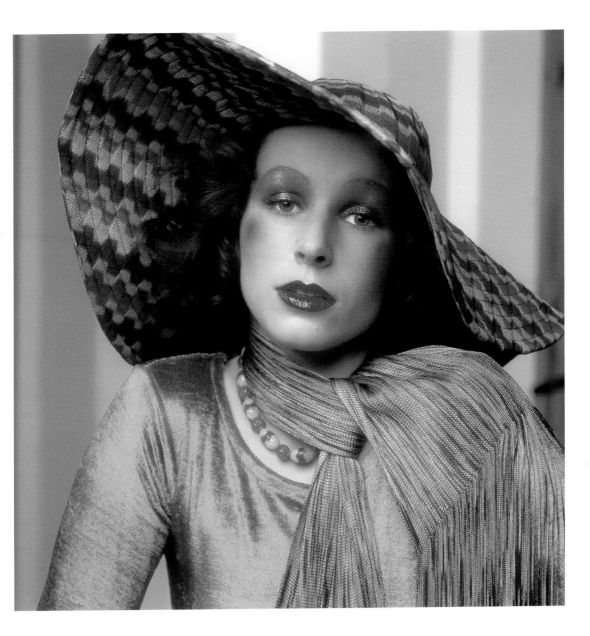

BARRY LATEGAN
BEAUTY PHOTOGRAPHS, c.1970

This photograph (opposite) announced a new range of make-up by Orlane. Hair: Oliver of Leonard. Electric green velvet T-shirt (above), from Mr Freedom, with knitted silk hat and fringed scarf, both by Missoni. Hair: Leonard. Fashion editor: Grace Coddington. Coddington, who became creative director of American Vogue in 1995, first made her mark on the fashion pages of Vogue as a model, winning Vogue's 'Young Idea' model contest. She went on to become one of the magazine's most influential fashion editors. 'She was a Merlin who could magic the best from a given set of circumstances,' said Barry Lategan,

with whom she produced whimsical beauty pictures throughout the 1970s, and who was the photographer at her wedding to the restaurateur Michael Chow. Her own style was equally influential: 'She could be a suntanned St Tropez athlete or a pale Virginia Woolf in baggy cardigans,' as her Vogue colleague writer Georgina Howell put it. Of her perfectionism, the photographer Clive Arrowsmith told Vogue, 'You walked in and there was this breathtaking sight: the models, the clothes, the accessories. Everything was perfect… Postman Pat with a Polaroid camera could have taken those photographs.'

→ 14 → 14A → 15 → 15A → 16

→ 26A → 27 → 27A → 28 → 28A

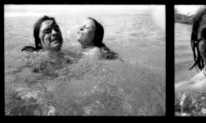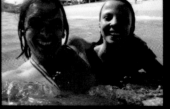

→ 20A → 21 → 21A → 22 →

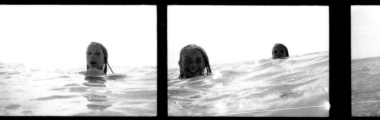

UNKNOWN
DAVID BAILEY
AND PENELOPE TREE,
c.1970

A → 8 → 8A → 9 → 9A

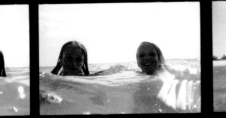 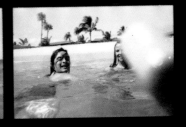

→17 →17A →18 →18A →19 →19A

KODAK TRI-X PAN FILM

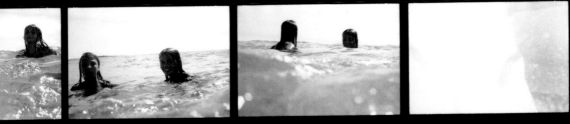

→29 →29A →30 →30A →31 →31A →32

KODAK SAF.ETY FILM + KODAK TRI-X PAN FILM

→23 →23A →24 →24A →25 →25A →26

KODAK TRI-X PAN FILM KOD

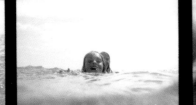

→10A →11 →11A →12 →12A →13 →13A

CAO
BEAUTY PHOTOGRAPH, 1971
Shot from a blue-themed
promotional feature for Max Factor.

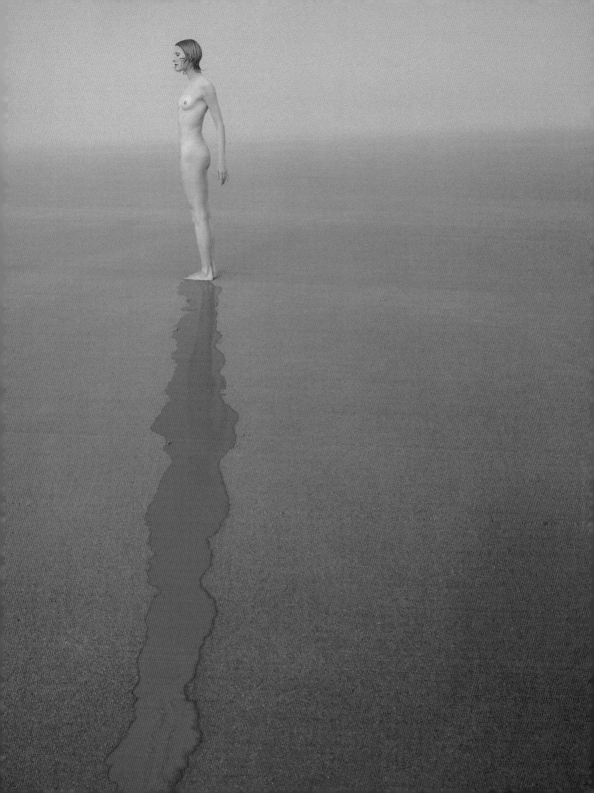

above

GUY BOURDIN

'YOUR HANDS AND YOUR FEET', 1971

Bourdin's marked-up contact sheet. Inadequately fixed, it has the
faded quality that distinguishes Bourdin's contact sheets from
those of his contemporaries.

right

GUY BOURDIN

CHANDRIKA, 1970

Waistcoat and long fluted skirt, by Stirling Cooper. A severely
cropped version of this photograph appeared in the magazine.

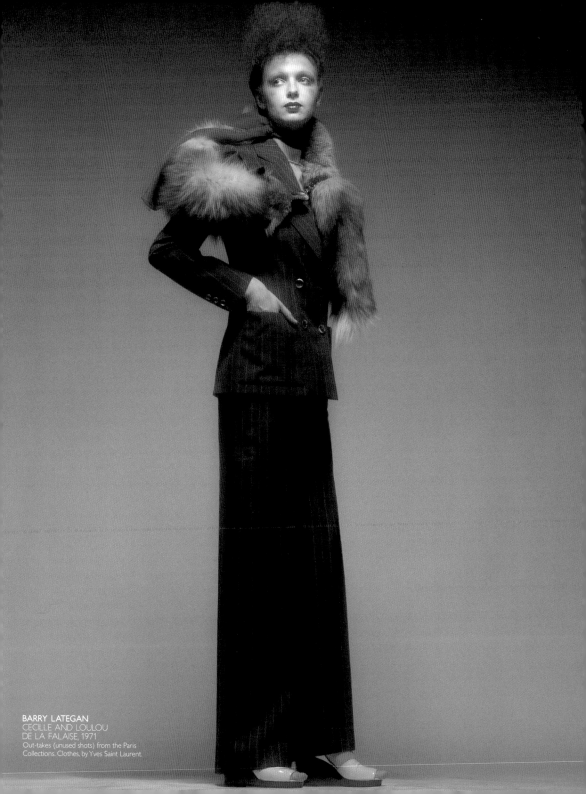

BARRY LATEGAN
CECILLE AND LOULOU
DE LA FALAISE, 1971
Out-takes (unused shots) from the Paris
Collections. Clothes. by Yves Saint Laurent.

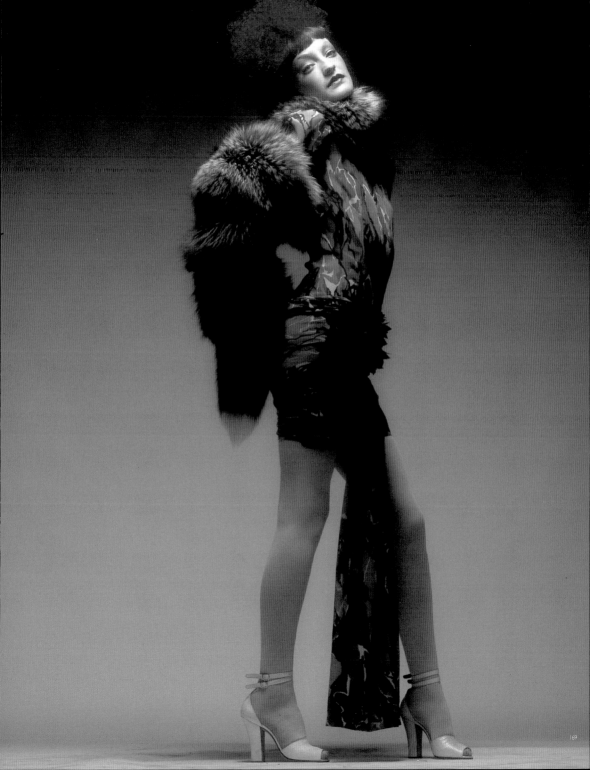

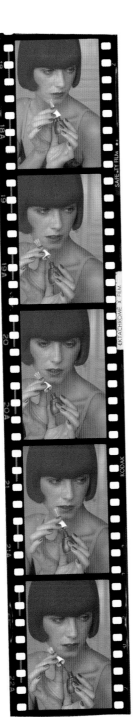

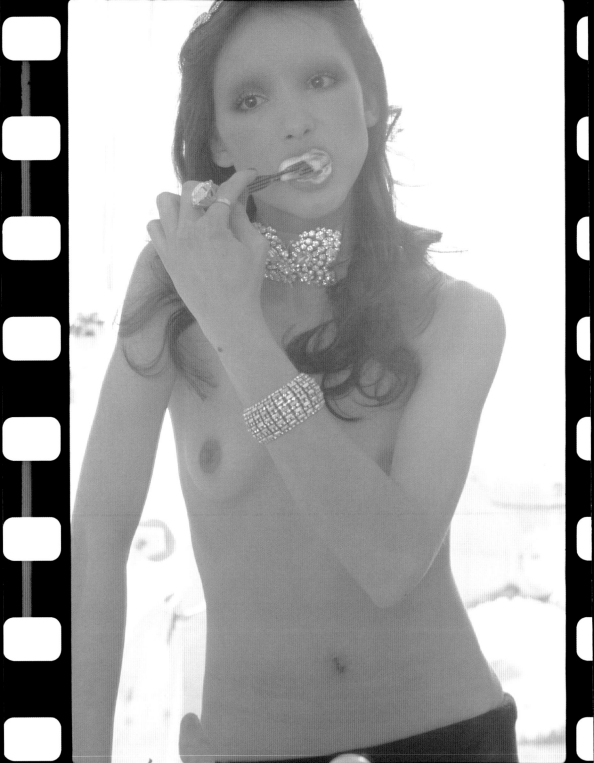

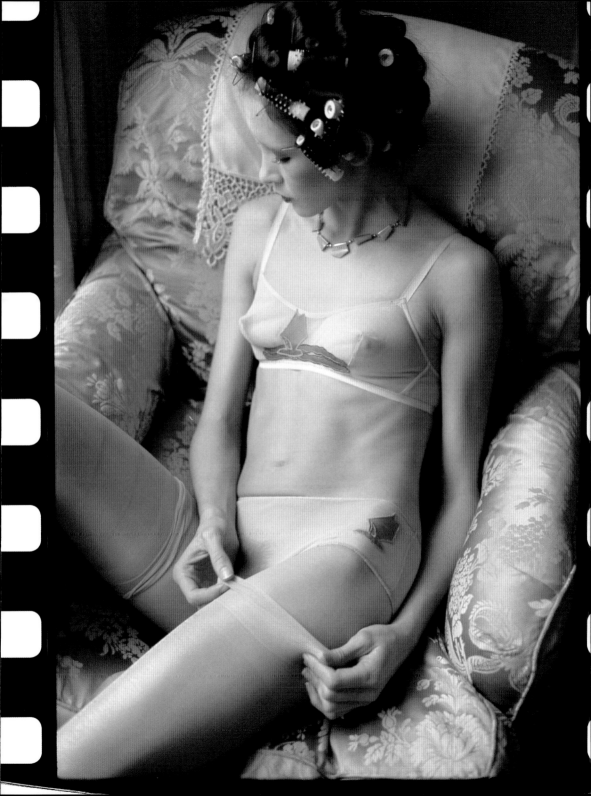

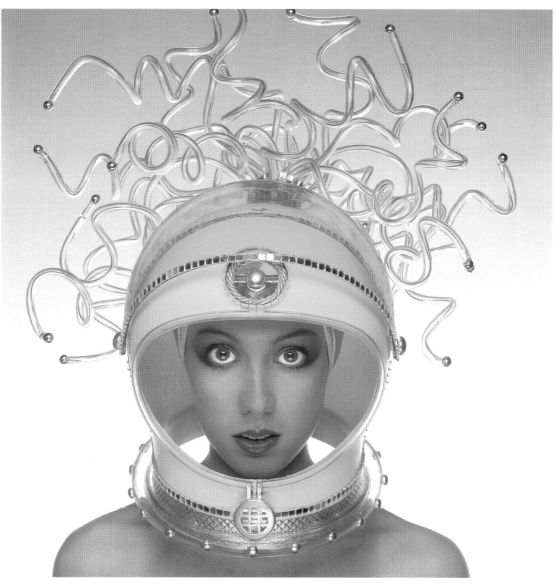

above
BARRY LATEGAN
BEAUTY PHOTOGRAPH, 1970
Originally taken for Italian *Vogue*.

opposite
BARRY LATEGAN
MARIE HELVIN, 1971

Originally published in black and white, this is the earliest photograph of Marie Helvin taken for *Vogue*. Her first published pictures were produced by Clive Arrowsmith and, although taken after Lategan's, appeared a month before these. A muse for the designer Kansai Yamamoto, Helvin modelled his first London collection. Inspired by Kabuki theatre, the theme for the show required that Helvin shave her off eyebrows. She was warned on no account to 'spoil the mystique' of the show by revealing that she was not strictly Japanese, but American. Grace Coddington and Barry Lategan spotted her, and this sitting was arranged.

Throughout the shoot, Helvin, when she spoke at all, assumed a thick Japanese accent. The coat, in shaggy acrylic fur, is by Jaeger. In her memoirs, *Catwalk* (1985), Helvin recalled of this session with Lategan, who became a friend, that it was a 'baptism of fire. Maudie James, Kathy Damon (sic), and Moira Swan, who were then the most famous models in London and whose pictures I had seen in *Vogue*, were also on the shoot. They all looked quite perfect, and I felt ridiculous without my eyebrows. Kathy was really kind and did my make-up, but I sensed a tension and unfriendliness in the air that I had never encountered before...'

CLIVE ARROWSMITH
MARIE HELVIN, 1971
After the success of the collection which included these pieces appliquéd with Oriental motifs, Kansai Yamamoto became costume director for David Bowie's world tour as 'Ziggy Stardust'. His own early shows were often performances playing to crowds of 5,000 aficionados. He later showed in Paris, part of a contingent of Japanese designers, which included Yohji Yamamoto and Comme des Garçons' Rei Kawakubo, who were among the first to espouse the marriage of East with West.

BOB RICHARDSON
ANJELICA HUSTON, 1971
Anjelica Huston wears a ginger
and brown plaid coat by Bus Stop.
Huston and Richardson
collaborated for around four years,
until 1973. 'When one looks at
[Richardson's] photographs that
followed,' wrote Ingrid Sischy
in *The New Yorker*, 'it's hard not to
think that the break-up marked
a turning point.'

179

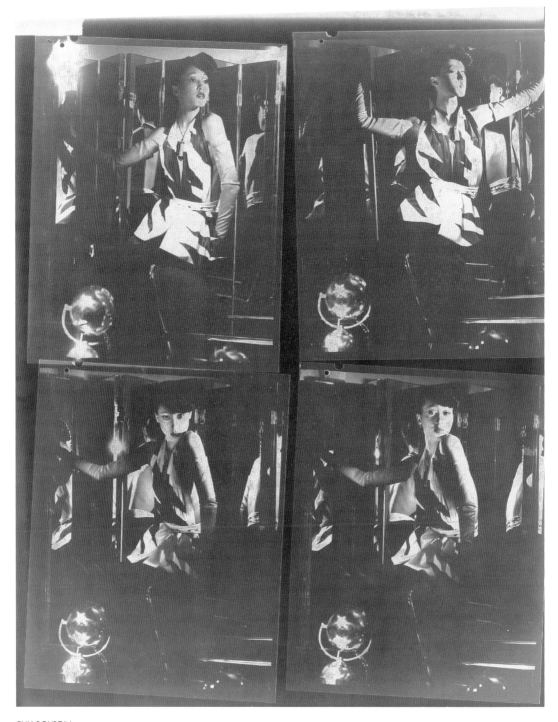

GUY BOURDIN
PAT CLEVELAND, 1972
The contact sheets (faded, like all Bourdin's contact sheets) for a fashion story
focusing on the fashion house Chloé, then under the direction of Karl Lagerfeld.
Fashion editor: Grace Coddington. Hair: Jean-Louis David. Make-up: Dominique Bertola.

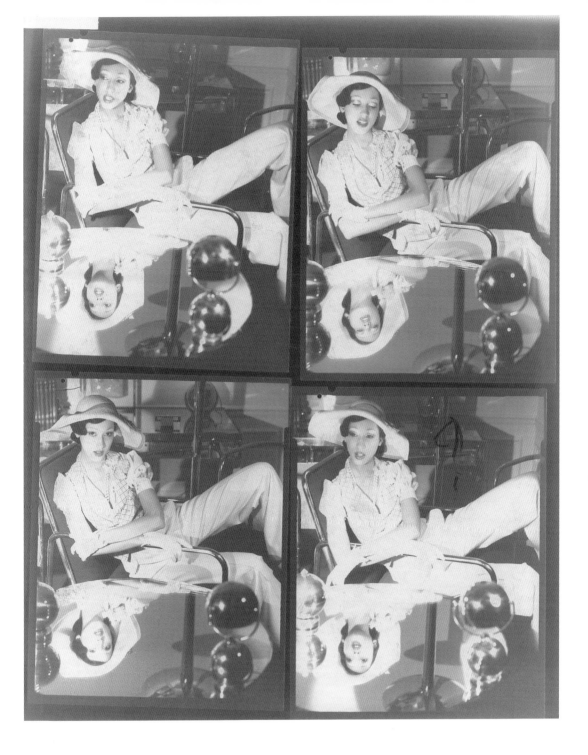

SACHA
'TAKE AWAY PARIS', 1972
Variants from a published fashion
story. The clothes in both shots
are by Dorothée Bis.
Hair: Jean-Louis David, Paris.
Make-up: Orlane. Sacha van
Dorssen, always known simply
by her first name, is now well
known for her fashion
photographs for *Marie Claire*.

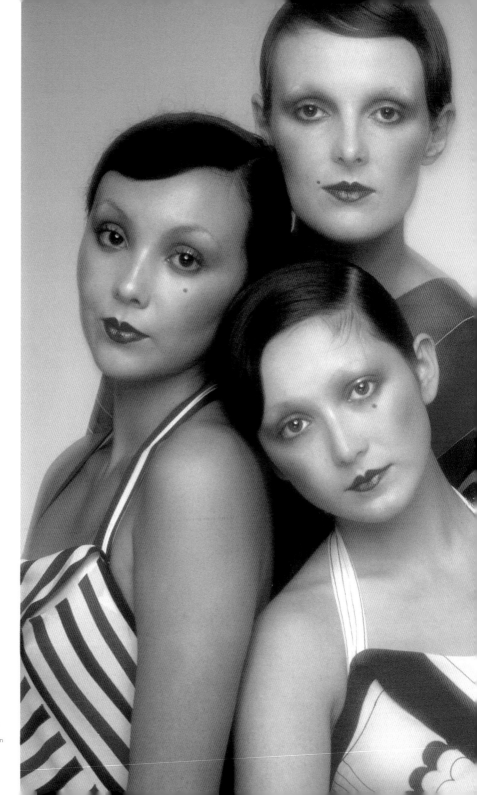

BARRY LATEGAN
BEAUTY PHOTOGRAPH,
1972
 The models include Marie Helvin
(*left*) and Grace Coddington
(*above right of Helvin*).

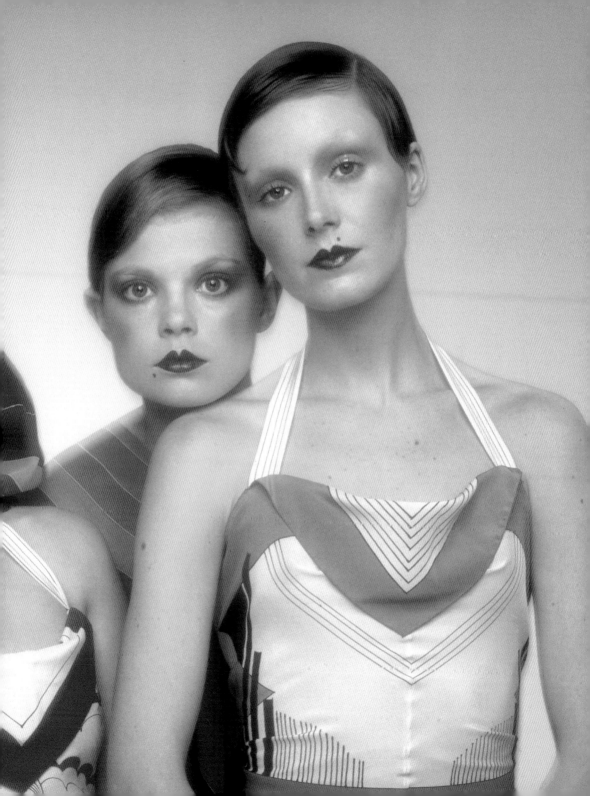

NORMAN PARKINSON
'IN TUNE WITH THE MACHINE', 1972
White leather battle jacket by Jorn Langberg. The Aston
Martin V8 was then the fastest saloon car in the world,
with a top speed of over 160mph. It was also the safest
car of its class, having passed a MIRA test involving
high-speed crashes into solid concrete.

ALFA CASTALDI
'NEW COLOURING FROM ITALY', 1973
Castaldi was a prolific contributor to Italian *Vogue*, *L'Uomo Vogue* and
the short-lived *Vanity*, not least in collaboration with the idiosyncratically
dressed fashion guru and woman about town Anna Piaggi. The writer
Martin Harrison has noted that Castaldi's features for *L'Uomo Vogue*
'on the vernacular roots of Italian men's fashion… were both
informative and visually effective.' In this variant of a published
picture, the black sequin jacket and gold lace blouse are by Valentino.
Cigarette holder by John Jesse. Hair: Dina of Milan. Make-up: Gil.
The photograph was taken in the Dina salon at 23 Via della Spiga.

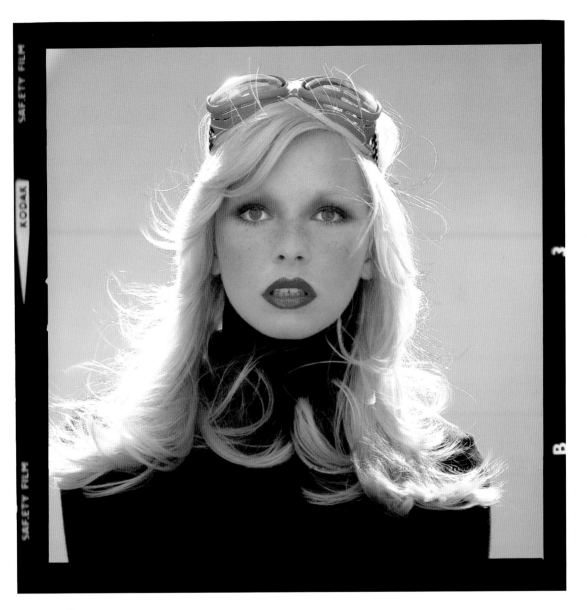

PATRICK HUNT
MAUDIE JAMES, 1973
The first fashion sitting of Liz Tilberis,
later Vogue's editor-in-chief was with
Penelope Tree and Maudie James.
She later told David Bailey, 'To me,
they were the most extraordinary
supermodels of the late 1960s.'
This is a cover try (a shot styled as
a potential cover). Hair: Celine at
Leonard. Make-up: Barbara Daly.

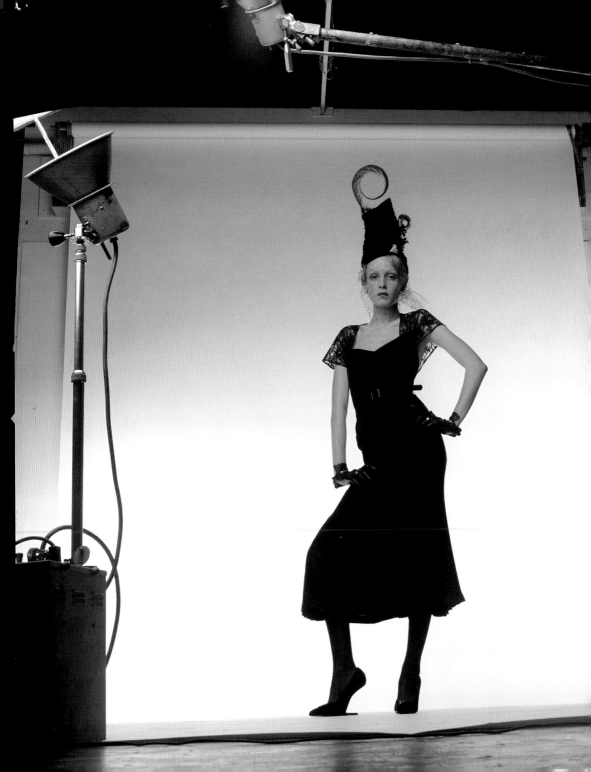

JUSTIN DE VILLENEUVE
TWIGGY, 1973

The uncropped version of a published fashion photograph. Twiggy wears a black crepe and lace suit and a velvet 'chimney pot' hat from City Lights. For many years the careers of Justin de Villeneuve and Twiggy were inextricably linked. Indeed, they shared a similar past: she was Lesley Hornby, an apprentice hairdresser in North London; he, Nigel Davies, a former hairdresser ('Mr Christian'), bouncer and debt collector. De Villeneuve kick-started her modelling career, persuading her to undergo a seven-hour haircut by his friend Leonard, to complete her new persona. It was he, too, who became the skilful media manipulator when it all took off – as her boyfriend and manager. But when Twiggy no longer needed him (and later claimed it was his brother, Tony, who saw the potential in Lesley Hornby), Justin de Villeneuve slipped from view. In the early 1970s *Vogue* writer Polly Devlin recognised his predicament: 'Justin always talks as though he and Twiggy were one creature, one spirit. Everything is "Us", "We", "Ours". Well it might, since almost everything for him hinges on them being together...' His photographic career with *Vogue* was brief, and he appears to have photographed nothing else but his prized main asset; but he had flair and ability enough to have survived the Twiggy phenomenon. His photographs of Twiggy illustrate better than anything else that slice of their time together, coinciding with a fascination with Art-Deco crepe de Chine and the trappings of 1930s ocean liners. His pictures are as much part of the iconography of Twiggy the fashion model as the more famous images by Helmut Newton or Barry Lategan, who photographed her first. Twiggy and de Villeneuve worked together for the last time in 1973, on a double portrait of her and David Bowie; it was probably the most famous picture from their collaboration of nearly 10 years. Rejected by *Vogue* as a cover, it was used by Bowie for his compilation of 1960s songs *Pin-Ups*.

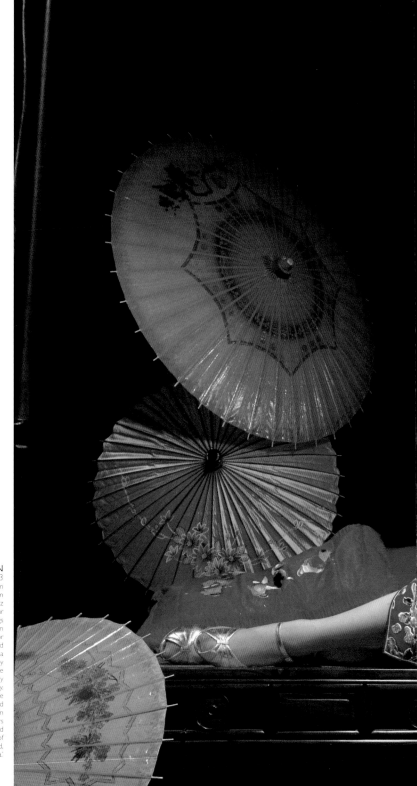

CECIL BEATON
TINA LUTZ, 1973

Reclining on an early nineteenth-century opium bed, wearing a cheongsam from her own collection (acquired in Beverly Hills), Tina Lutz sits for 'Chinoiserie by Beaton'. This colour variant from one of Beaton's last fashion sittings for British *Vogue* never appeared – the story ran entirely in black and white. The fashion editor was Grace Coddington, whose former husband Michael Chow, Lutz later married. When Tina Chow died at 41 in 1992, *Vogue* ran a tribute by Michael Roberts, part of which read: 'To the general public, alas, Tina Chow will probably always remain a glossy-magazine personality. Her life was laid out – as is her death – on the luxuriantly printed page. In social spread and fashion feature. In party snap and beauty tip. On cover line and Best Dressed List. Photographers adored her. That image of shiny, lacquered perfection, as aesthetic and eloquent as one of the Dunand vases collected by her husband, was manna for the most maladroit camera.'

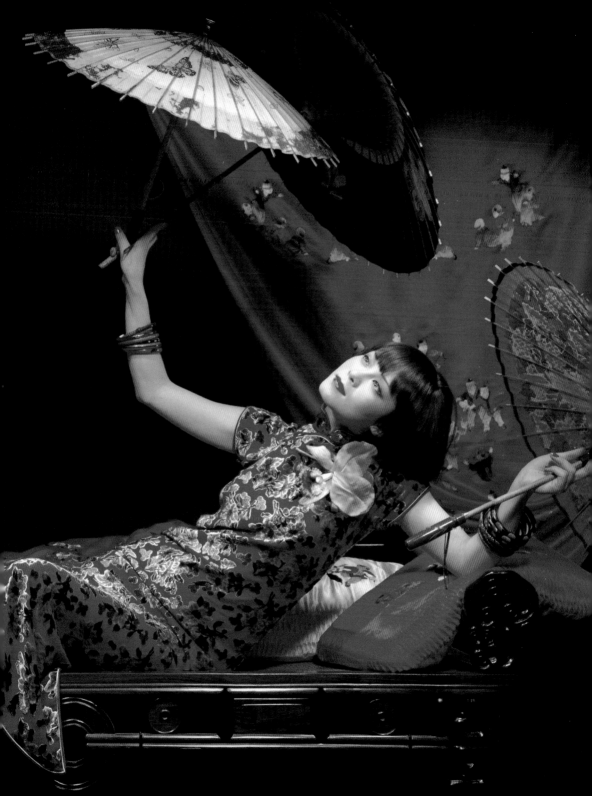

DAVID BAILEY
OLIVIERO TOSCANI AND
ANJELICA HUSTON, 1973
Photographed in Milan on a
Harley-Davidson Duo-Glide 1200,
Anjelica Huston wears a sweater,
cloak and skirt, all by Missoni.

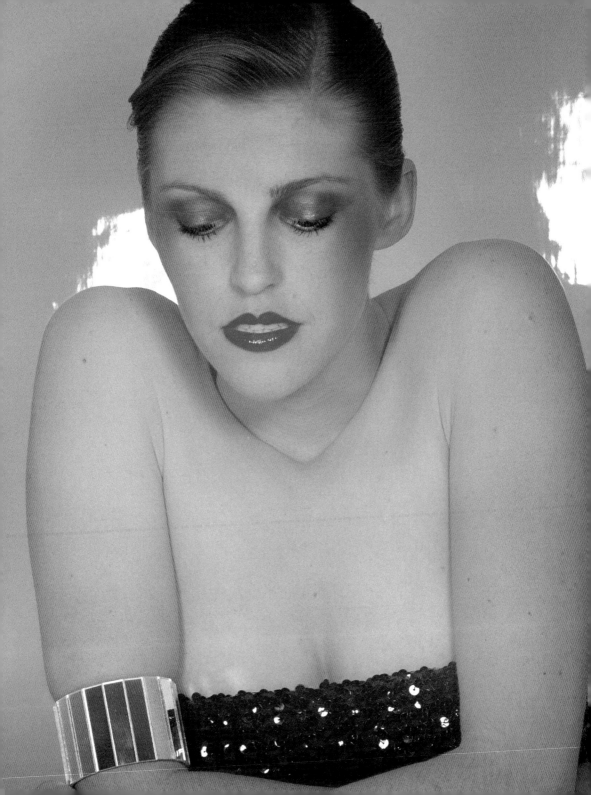

HELMUT NEWTON
'IN THE LIMELIGHT NOW', 1973
Styled by Grace Coddington, who also appears
as a participant (in the swimming pool of the
Hotel Byblos, St Tropez). The other models are
Karen Fedderson and (*opposite*) Barbara Carrera
with Uve Barden, who became her first husband.
'Although it makes my life more complicated,'
observed Newton recently, 'I prefer to take
my camera into… places often inaccessible to
anyone but the rich.'

UNKNOWN
FASHION
PHOTOGRAPH, c.1974
This single transparency was found
in the *Vogue* archives among a
collection of Guy Bourdin's work.

following pages
GUY BOURDIN
'PERFECTION:
PABLO & DELIA', 1974
'Something rare in a classic world
– droll beautiful follies by Pablo &
Delia, who never make anything
that bores them and dress all the
clowns and angels in London.' The
creations of the two designers,
much championed by Grace
Coddington, were rooted in a
notion of 'lost' times. They strove,
wrote one fashion historian, to
re-create, through their tunics
and tabards and shift dresses, 'the
honest lifestyle of the artisan'.

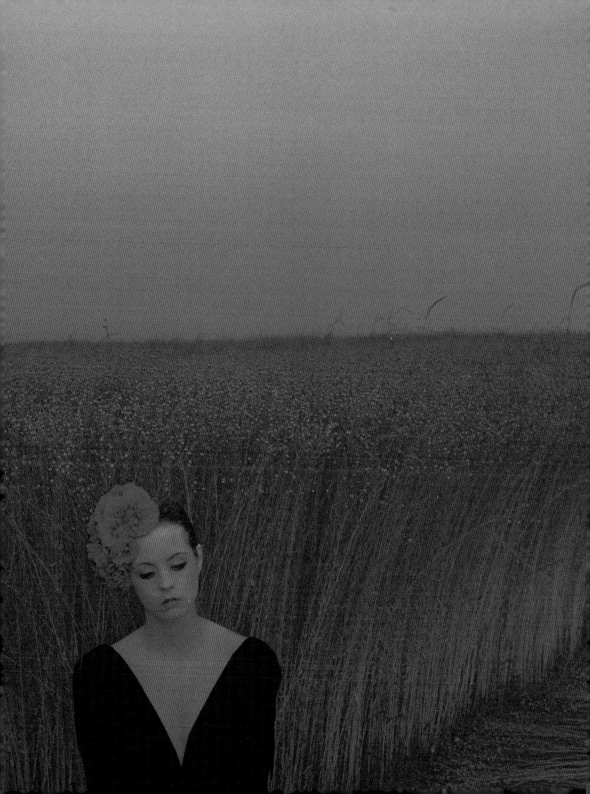

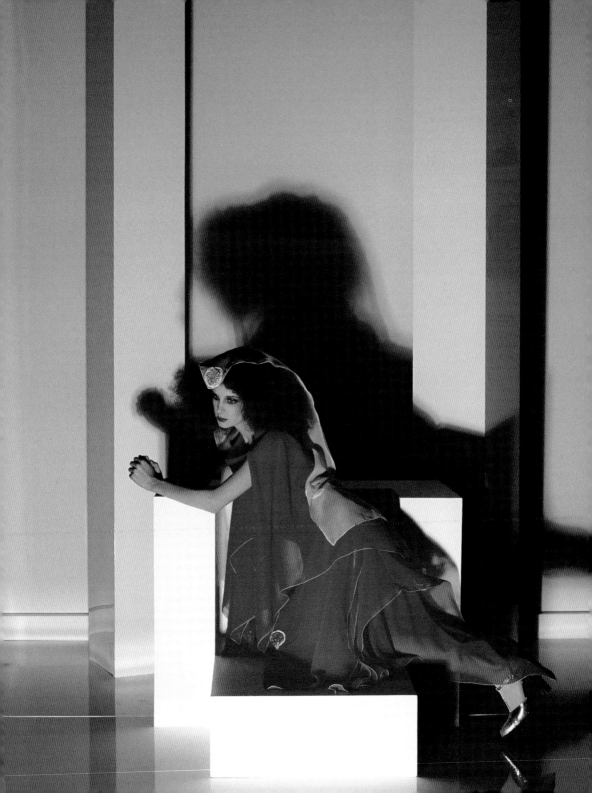

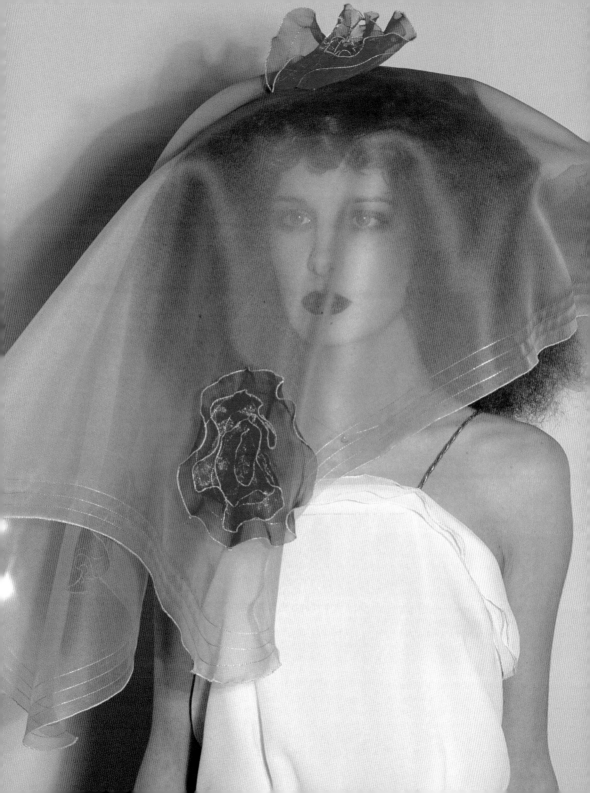

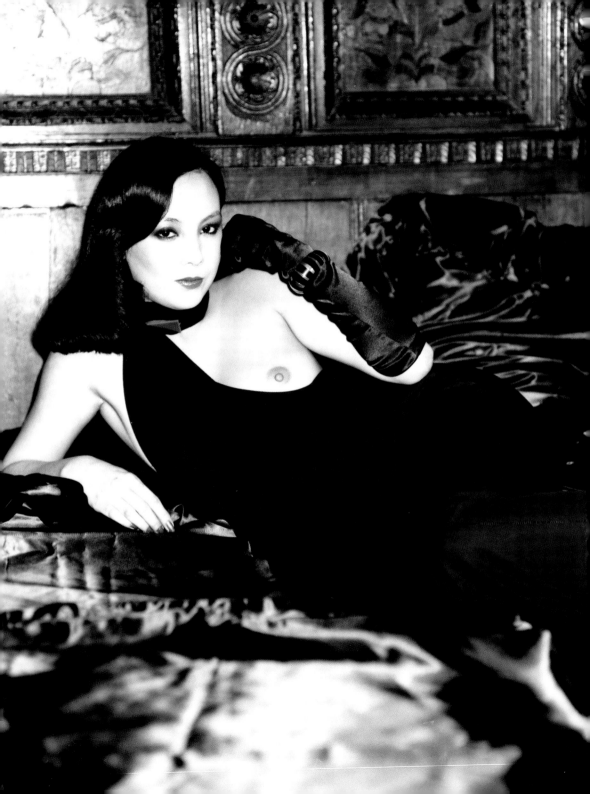

The contact sheet (*below*) and the unpublished print (*opposite*)
originate from Marie Helvin's second session with Bailey. It took place
in the bedroom of Bailey's house in Primrose Hill, London. As Helvin
recalled, 'Within a few months, the bed had become mine too, and we
shared it for over a decade.' Bailey's domestic establishment was highly
unconventional: he shared his home with Helvin, whom he later
married, the stylist Michael Roberts, 60 parrots, several dogs, a major-
domo called César and whoever happened to be passing. Bailey
reportedly sat in front of the TV throwing apple cores and old Coke
cans over his shoulder on to the carpet. Helvin brought to the
household her cats and splashes of colour to the 'Black Room' – where
she had posed for these pictures in clothes by Yves Saint Laurent.

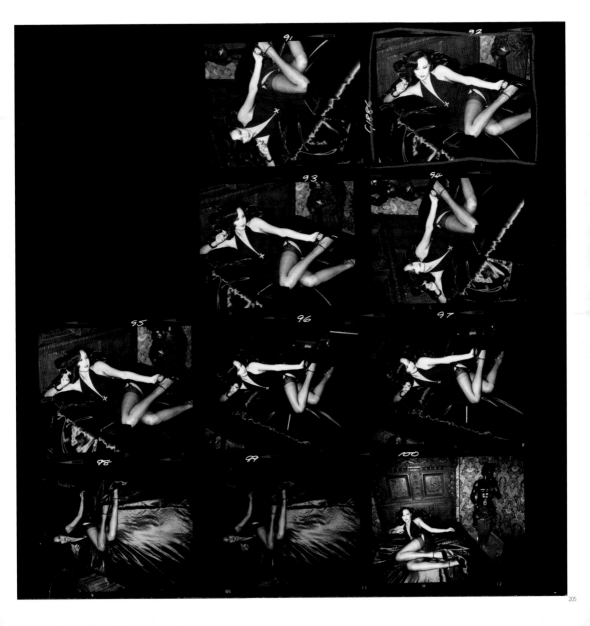

GRAHAM HUGHES
'HIGH HEELS AND OTHER
THINGS THAT GIVE YOU
A LIFT', 1974
Variants from an accessories sitting.
The leg belongs to the model Priscilla,
and the lifts are still in use in Vogue
House. The magazine's records show
that a snake-shaped scent atomiser by
Butler & Wilson was mislaid; the
jewellers were reimbursed £1450.

ERIC BOMAN
BIANCA JAGGER, 1974

Out-takes (unused shots) from a well-known *Vogue* sitting. The magazine observed that when Bianca Jagger says that she's 'the only person who has become a star without having done a thing, you tend to agree.' It revealed that she loves having her picture taken and that 'she'll bring not only the clothes and hats, but hundreds of everything in boxes and suitcases. She feels she can't be photographed unless she's spent four hours at the hairdresser.' In this case the clothes she supplied were by Scherrer. Hair: Yves at Jacques Dessange. The location is Maxim's, Paris.

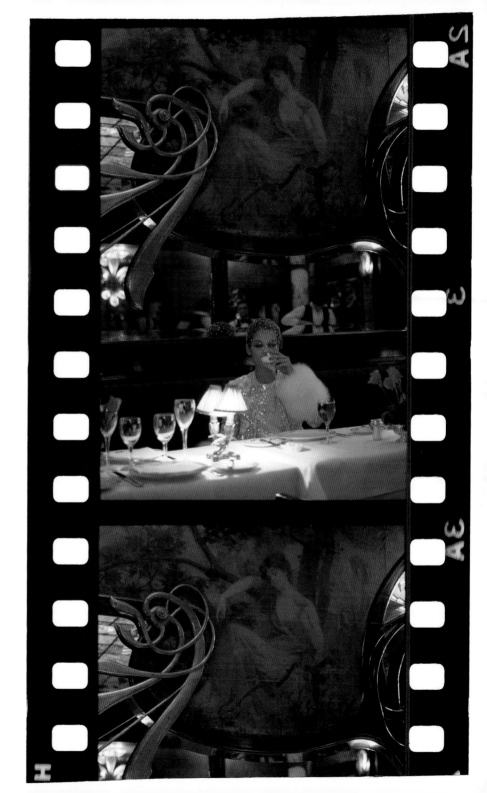

PHOTOGRAPHER UNKNOWN
INGRID BOULTING, c.1974
Taken for the *Vogue Beauty Book*.

OLIVIERO TOSCANI
'SHINE PLEASE, YOU'RE
BEAUTIFUL', 1974
A cover try (shot styled as a potential
cover). Black silk chiffon camisole dress
and blouse with organza appliqué, by
Thea Porter. The camera was the new
Polaroid SX70.

following pages
OLIVIERO TOSCANI
INGEMARIE, 1975
Discarded Polaroids from a cover
session. (Polaroids are used on fashion
shoots to give an instant impression
of what the final image will look like.)
Unusually, in this instance, a Polaroid
was used for *Vogue*'s front cover.
Red linen smock, by Jaeger.
Fashion editor: Liz Tilberis.

2 nd Choice

TWILIGHT
AMBIANCE
WASH AGAIN
Please

GUY BOURDIN
'YSL? WHY YES', 1975
Polaroid and its negative bag with Bourdin's printing
instructions. Double-breasted black gabardine tailored
jacket and silk-jersey skirt, by Yves Saint Laurent.

216

HARRI PECCINOTTI
FASHION PHOTOGRAPHS, 1975

Though he is well known as a photographer, in 1965 Peccinotti became the founding designer and first art director of the British magazine *Nova*. Never a rival to *Vogue*, *Nova* billed itself as 'A New Kind of Magazine to the New Kind of Woman', and its 10-year existence was characterised by an immediacy in graphic style, attention-grabbing cover lines, a non-dictatorial fashion policy and provocative features coverage. Peccinotti initially picked up a camera after finding no one else who could better translate his vision on to the printed page: 'I had stood around in studios observing,' he remarked recently, 'and I knew pretty well what to do and what not to do.'

BARRY LATEGAN
'YOUR MAKE-UP AND FRESH AIR', 1976
Photographs taken for the *Vogue Beauty Book*.
Beauty editor: Felicity Clark. Hair: John at Leonard.
Make-up: Anthony Clavet.

following pages
GUY BOURDIN
YVES SAINT LAURENT CHIFFON DRESSES, 1977
Photographed at Le Grand Hotel du Pavillon, Paris.
Hair: Valentin at Jean-Louis David. Make-up: Heidi Morawetz.

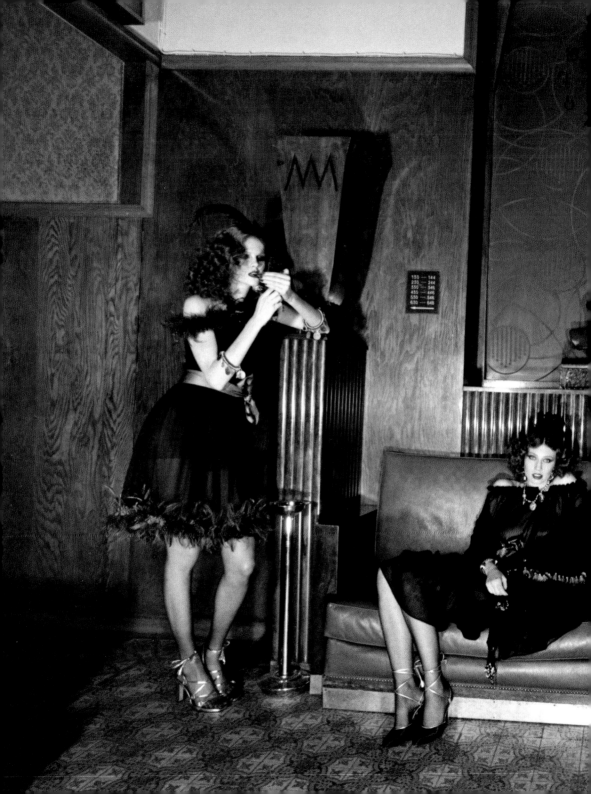

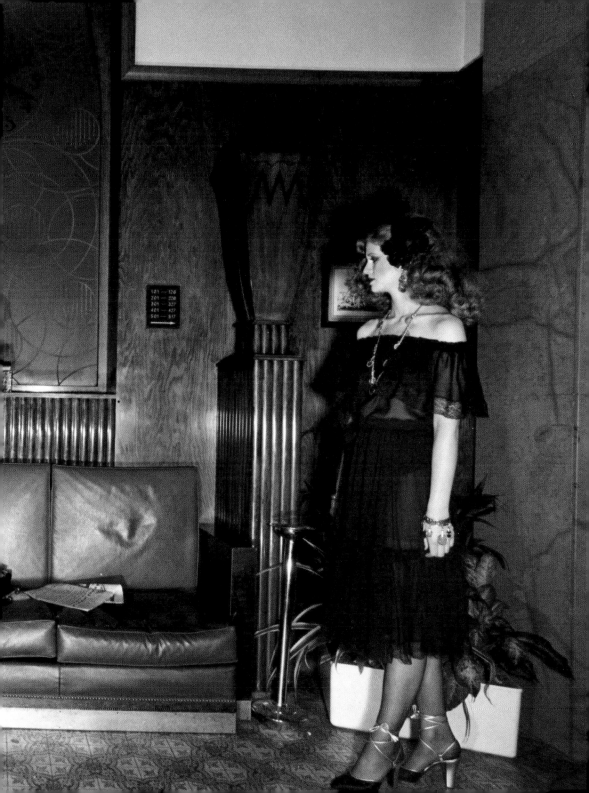

STEVEN MEISEL
JENY HOWARTH AND
KATE HATCH, 1982

These transparencies are the out-takes (unused shots) of Meisel's first major sitting for *Vogue*. As a top fashion photographer, Steven Meisel has been in demand for almost 20 years and, contributing to his enduring success – apart from his capacity for hard work – may be his defying definition. Michael Gross of *New York* magazine has come closest to articulating his style: 'If Richard Avedon and Andy Warhol had a baby, he would be Steven Meisel.' Meisel's ability to adapt his photography almost every season, coupled with a disarming enthusiasm for the minutiae of the fashion world, and a thorough knowledge of historic fashion photography, has resulted in a distinctive, allusive body of work. 'I am always influenced,' he has said, 'by the philosophy of the particular couturier whose dress I am photographing.' He dominates the pages of American and Italian *Vogues* like no one else. For American *Vogue*, in the last five years alone, he has photographed 47 out of 60 covers. His editorial spreads for Italian *Vogue* run to many pages (a 30-page sequence is not unusual). Given greater freedom for his advertising campaigns, he has occasionally explored – to controversial effect – the subversive nature of the genre. As he once told *The New York Times*, his style of photography is 'a little bit outrageous, a little bit crazy or sick – when I'm allowed to do what I want'. Another great strength, reported *Vogue* of Meisel, is that he 'can spot the girl of the moment well before the moment arrives'. Those straying within range of his radar have included Linda Evangelista, Stella Tennant and Karen Elson, among many others. Fashion editor: Anna Harvey. Hair: Sam McKnight. Make-up: Teresa Fairminer.

BRUCE WEBER
VINTAGE DRESS BY CHARLES JAMES, 1984

Now one of the great fashion photographers of modern times, Bruce Weber made his name in the early 1980s, photographing for British *Vogue* with the fashion editors Grace Coddington and Liz Tilberis, although he was already a fixture at American *GQ*. In her memoirs, Tilberis wrote that a shoot with Weber 'involves a cast of dozens, a journey, a narrative, an emotional intensity that wraps us up for days.' She added, 'The best fashion photography springs from the heart. Bruce Weber's photographs were always about something, and they were always emotional…' Almost single-handedly, he shifted the emphasis from the clothes the editors so assiduously brought him to those wearing them, eschewing professional models for people he met in the street, friends of friends, employees of the hotels he and the *Vogue* team found themselves in. His stories for British *Vogue*, frequently epic in scale and ambition, betray a wide-ranging knowledge of photographic history from Alfred Stieglitz to August Sander to Edward Weston, and of literary history – most famously for a homage to American novelist Willa Cather. The writer Martin Harrison has said of Weber: 'With implacable determination he was consistently pushing the fashion photograph into becoming a Bruce Weber photograph.'

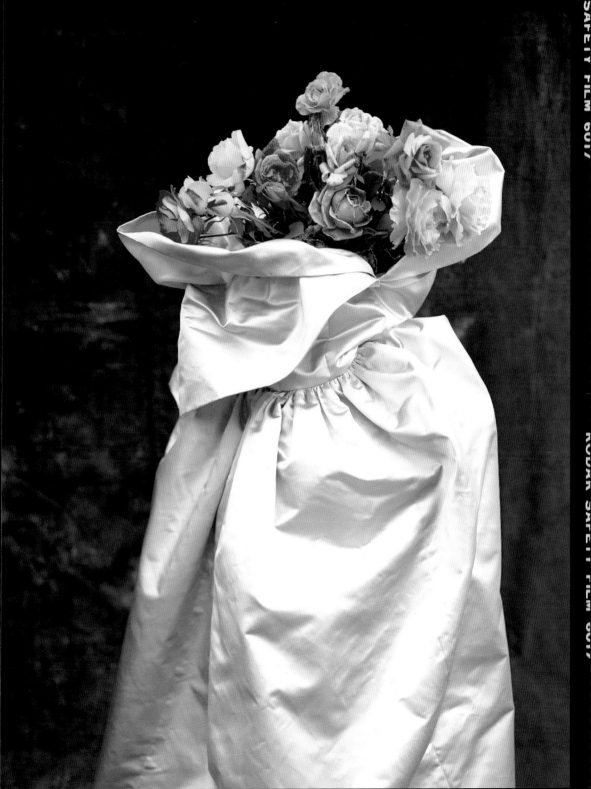

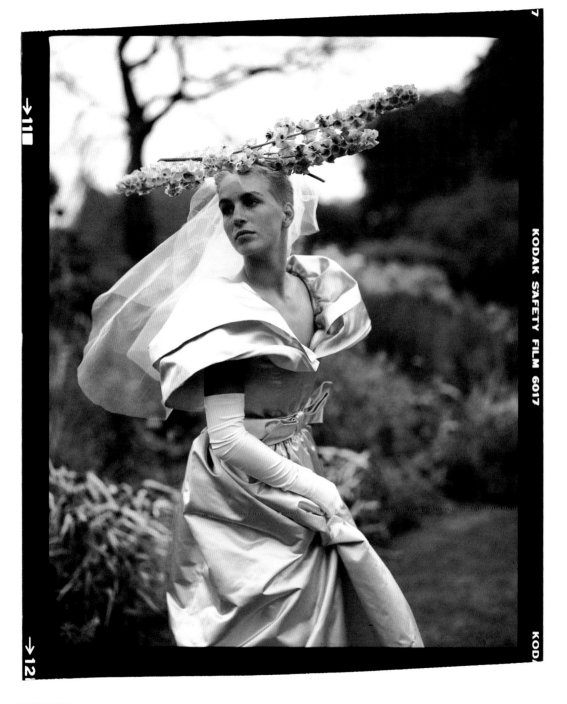

BRUCE WEBER
'A STYLE THAT COULD GROW ON YOU', 1984
The pearl-grey satin dress (*above*) is by Gina Fratini. The gold satin sheath, bodice and
bustle (*opposite*) are by Victor Edelstein. Hair: Didier Malige. Weber has a strong
attachment to the 'rejects' of a shoot. 'These photographs often mean more to me,' he says.

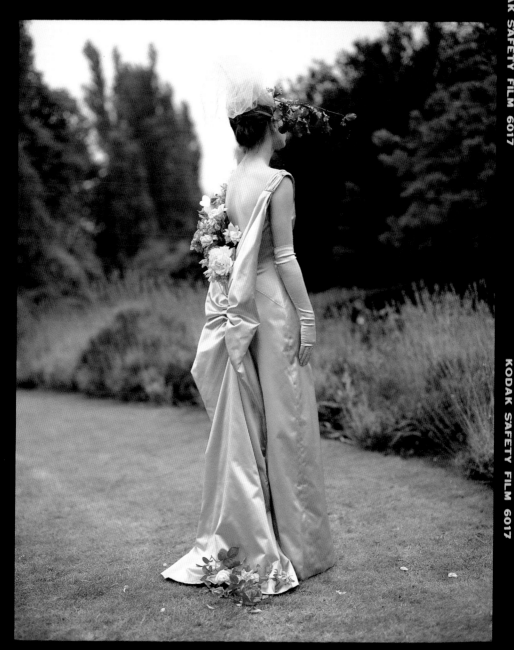

BRUCE WEBER
TALISA SOTO, 1982
In a picture first published in black and
white, the future Bond girl of 1989 (*Licence
to Kill's* Lupe Lamora) wears a violet satin
dress with ruffled hem by Givenchy.

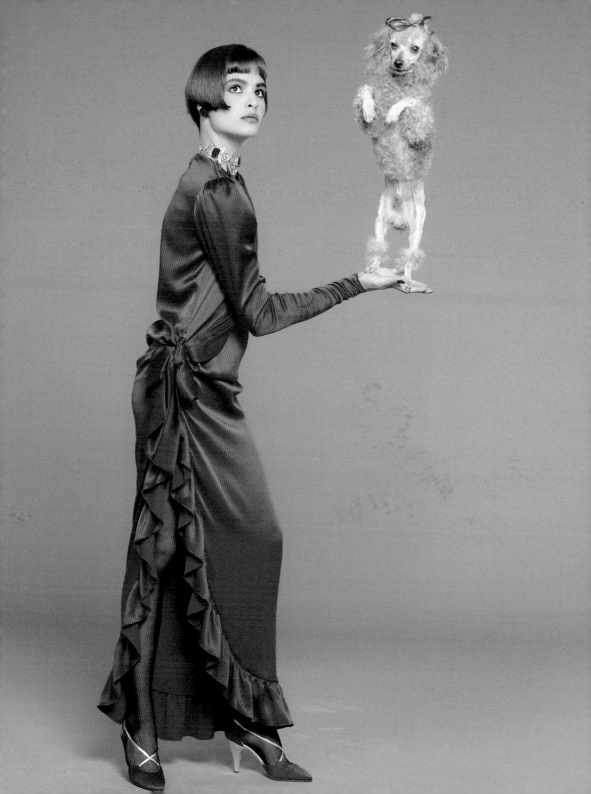

PAOLO ROVERSI
'THE SURREAL ART OF THE
EXTRAORDINARY HAT', 1985
Roversi's manipulation of 10 x 8in Polaroid
film (of which these are unpublished
examples), to create a distinctive painterly
style, has spawned many imitators since
the 1980s. His use of colour and
abstraction recalls the experimentation for
Vogue of Erwin Blumenfeld, a generation
previously. 'In looking for emotion and
suggestion rather than realism,' Roversi
told the writer Gabriel Bauret, 'I reject the
objectivity of colour and use it in a highly
subjective way. The magic mix of the
photographic image is the indefinable mix
of realism and fiction, abstract and
concrete, illusion and truth.'

SHEILA METZNER
UMA THURMAN, KATHLEEN
CARR AND CECILIA
CHANCELLOR, 1985
What sets Metzner's work apart from her
contemporaries is an untypical desire to
look back to photography's heritage – in
particular late-nineteenth-century
Pictorialism. In the context of *Vogue*, it
evokes the elegance of Baron de Meyer.
Metzner's use of the geometrical
decorative motifs of the 1920s and 1930s
adds to the sense of history, though her
work's modern feel never quite allows the
period reverie to last too long. For this
out-take from one of her better-known
Vogue sittings, Uma Thurman wears a black
tulip evening dress by Bruce Oldfield,
Kathleen Carr a silk organza dress by
Victor Edelstein and Cecilia Chancellor an
Armani evening dress in flesh-coloured
chiffon with gold embroidery.
Fashion editor: Grace Coddington.
Hair: Didier Malige. Make-up: Linda Mason
and Sophie Levy.

SHEILA METZNER
CHRISTY TURLINGTON,
1986
For an article to celebrate the
opening of the first Tiffany shop in
London since the late 1940s,
Christy Turlington wears Elsa
Peretti's serpent necklace (*left*),
inspired by a rattlesnake skeleton.
In the colour photograph
(*opposite*), she wears Paloma
Picasso's diamond and rubellite
earrings. All jewellery designed
for Tiffany. 'One of the great
entrepreneurs,' *Vogue* observed,
'Charles Lewis Tiffany took
$4.98 on his first day of business
in 1837; at his death in 1900
he left $35,000,000.'

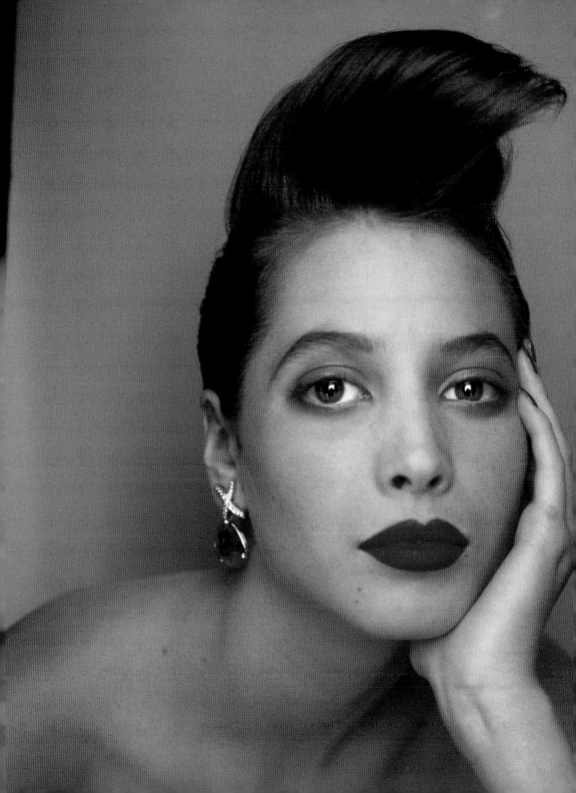

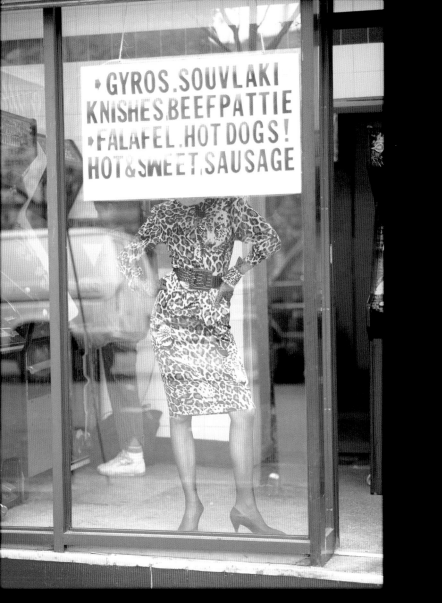

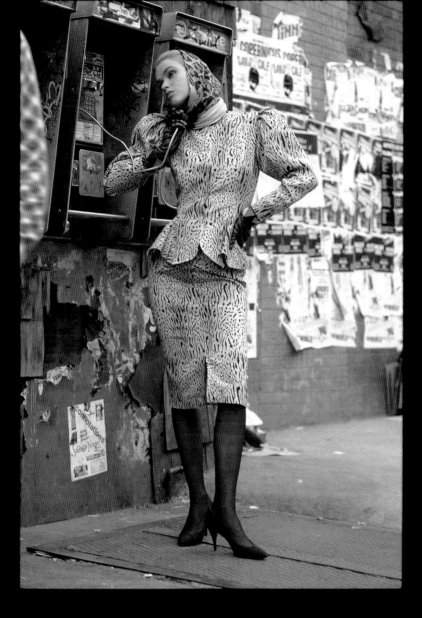

STEVEN MEISEL
FASHION PHOTOGRAPHS, 1986
Two pictures from a sitting on the theme of leopardskin, taken on location in New York City. Meisel later returned to the urban landscape for his most recent fashion story for British *Vogue*, 'Anglo-Saxon Attitude' (1993). Shooting this time on the streets of London, he introduced the models Stella Tennant and Honor Fraser.

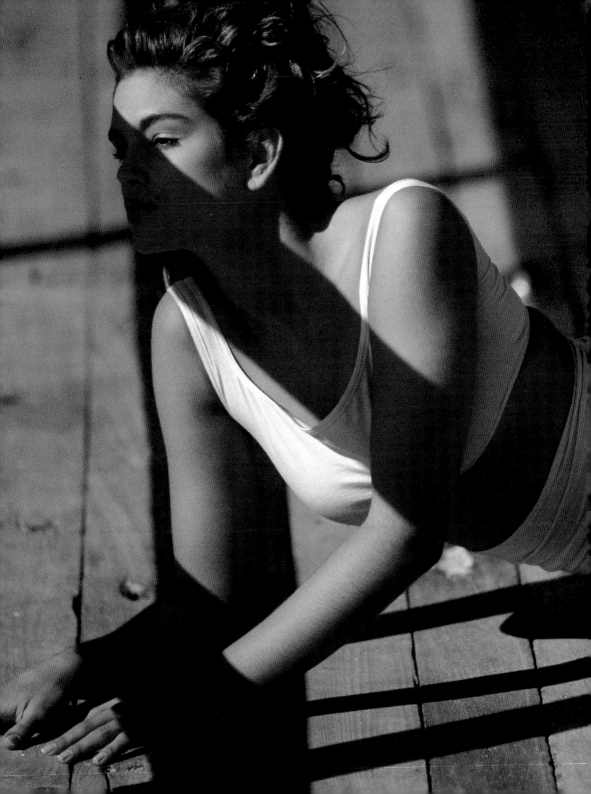

NEIL KIRK
CINDY CRAWFORD, 1987

Instantly recognisable for many qualities beyond the mole just above her lip – 'It's going to have its own talk show soon,' she told *Vanity Fair* wearily – Cindy Crawford, photographed here at the Hotel Splendido, Portofino, wears a banana-cream two-piece by Romeo Gigli. In the decade following pictures such as this, though her celebrated all-American curves gave way, through rigorous exercise, to a leaner silhouette, she ensured that, like her hairstyle, unchanged since she started out, the mole became her trademark. The girl from small-town Illinois also ensured that there was a whole lot else to know about Cindy Crawford: the marriage to Richard Gere and *that* full-page *Times* ad (asserting the strength of their marriage); the shoot for *Playboy* – 'I want to reach a different audience... Let's face it, most college guys don't buy *Vogue*.' But Crawford got where she wanted to be chiefly through gritty determination, diversification and the turnover of what became known as 'Cindy Inc': the $7-million Revlon contract; the product endorsements ('Cindy Crawford's Omega'); the celebrated exercise videos; the wildly successful calendars (all proceeds to leukaemia charities); the TV hosting; the acting parts; the jewellery lines; the books (most recently, *About Face*, a lexicon of toddlers' gestures and facial expressions). Sadly, we won't see the Cindy doll: 'I kept seeing the promotional picture of me holding a doll,' she told *Vogue*, 'dressed in exactly the same clothes I was wearing. That picture would speak a thousand words – and they are not the thousand words I want spoken.'

PATRICK DEMARCHELIER
LINDA EVANGELISTA, 1987
Linda Evangelista wears Ungaro (*left*)
and Yves Saint Laurent (*opposite*).
Demarchelier wrote of these
photographs from the Paris Couture,
'Because high fashion is traditionally so
serious, this year we decided to
explore a more frivolous, whimsical
mood. I wanted my models laughing
and enjoying themselves, so we stuck
an ostrich feather in model Linda
Evangelista's shoe to add to the spirit
of fun.' Such breezy *joie de vivre* has
marked out the fashion photographs
of Patrick Demarchelier for *Vogue*
since the 1970s. A protégé of the art
director-turned-photographer Hans
Feurer, Demarchelier first came to
prominence in the late 1970s, as one
of group of young Paris-based
photographers known in the business
as the 'Paris Mafia'. Apart from
Demarchelier, this loose-knit coterie
included Alex Chatelain, Arthur Elgort
and Mike Reinhardt, all of whom later
found success at British *Vogue*. They
distinguished themselves from their
predecessors (and contemporaries)
with a style that challenged the
formality of fashion photography,
especially in its studio-bound
manifestation, in favour of a more
upbeat outdoor spontaneity.
Demarchelier has acknowledged that
working with Grace Coddington
for British *Vogue*, on the eve of
the 1980s, was 'vital to the progress
of [his] career'. Fashion editor:
Anna Harvey. Hair: Didier Malige.
Make-up: Mary Greenwell.

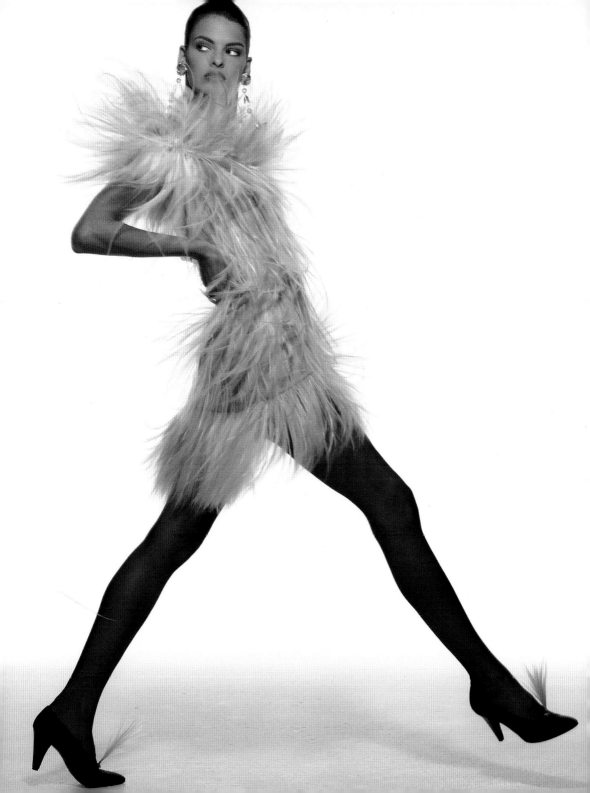

PATRICK DEMARCHELIER
DRESSES BY LACROIX, 1987
From the same Couture sittings as the photographs on the
previous pages, this was taken on the streets of Paris. It was
presented as a cover proposal for the 'Collections' issue;
the extension of the skyline was to create enough plain
background for the VOGUE logo. Fashion editor: Anna Harvey.
Hair: Didier Malige. Make-up: Mary Greenwell.

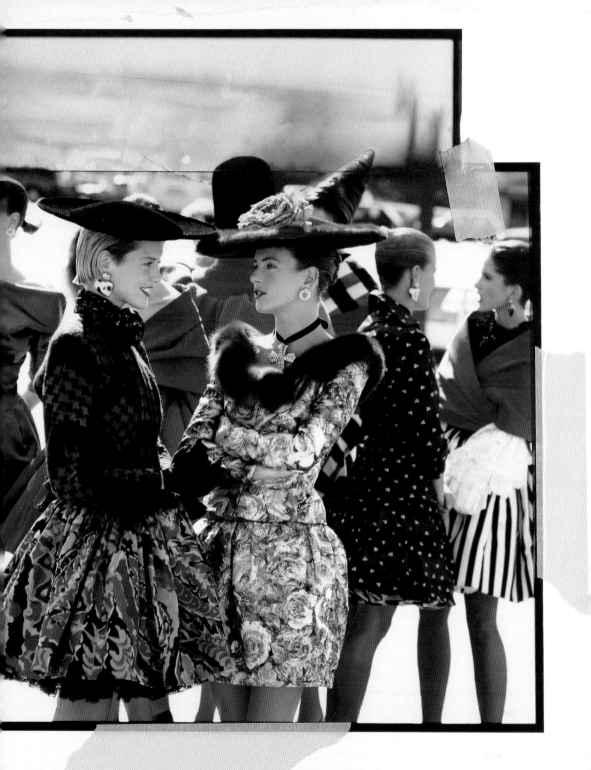

STEVEN MEISEL
NAOMI CAMPBELL,
CINDY CRAWFORD AND
LINDA EVANGELISTA, 1988
The genesis of the 'supermodel' is
hard to pin down. The moment of her
ascent, though, was probably her
adoption by Gianni Versace. She was
nurtured by British *Vogue* throughout
the early 1990s and celebrated in a
black-and-white cover photograph by
Peter Lindbergh of five of her
progenitors, including these three. It
was one of *Vogue*'s most famous cover
images. In 1992, with supermodel-dom
at its height, Naomi Campbell, Linda
Evangelista and Christy Turlington
accompanied Vivienne Westwood
down the catwalk of London Fashion
Week at another defining moment.
Collecting the award for 'Designer of
the Year', Westwood 'paused
emotionally at the microphone',
recorded *Vogue*'s Lisa Armstrong. 'As
she surveyed her rococo-print dresses
stretched – as never before – over
the beauteous curves of the "trinity",
she commented, "Now I understand
what all the fuss is about."'

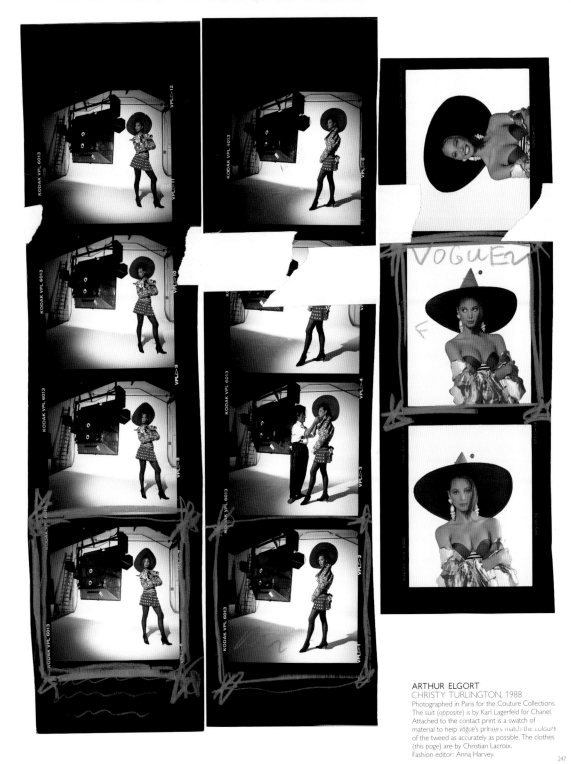

ARTHUR ELGORT
CHRISTY TURLINGTON, 1988
Photographed in Paris for the Couture Collections.
The suit (opposite) is by Karl Lagerfeld for Chanel.
Attached to the contact print is a swatch of
material to help *vogue*'s printers match the colours
of the tweed as accurately as possible. The clothes
(this page) are by Christian Lacroix.
Fashion editor: Anna Harvey.

PETER LINDBERGH
CINDY CRAWFORD, 1989

In the 1980s, Lindbergh's photographs were distinctive for their dramatic force. With a heightened graininess, and frequently taken against a bleak, urban backdrop, they possessed the qualities, meticulously lit, of a black-and-white film set. In a variant of a published shot, Lindbergh displays here what he has called 'my heavy German Expressionist side', employing stylised motifs of a futuristic industrial landscape and reworking themes of dehumanisation in the face of mass production found in films such as Fritz Lang's *Metropolis* (1926). He had explored this the previous year for an advertising campaign for Comme des Garçons. Photographed at Pinewood Studios, Cindy Crawford wears a silver nylon, one-shouldered cutaway swimsuit by Emilio Cavallini over a black wool body suit by Azzedine Alaïa. Fashion editor: Sarajane Hoare. Hair: Julien d'Ys. Make-up: Stephane Marais.

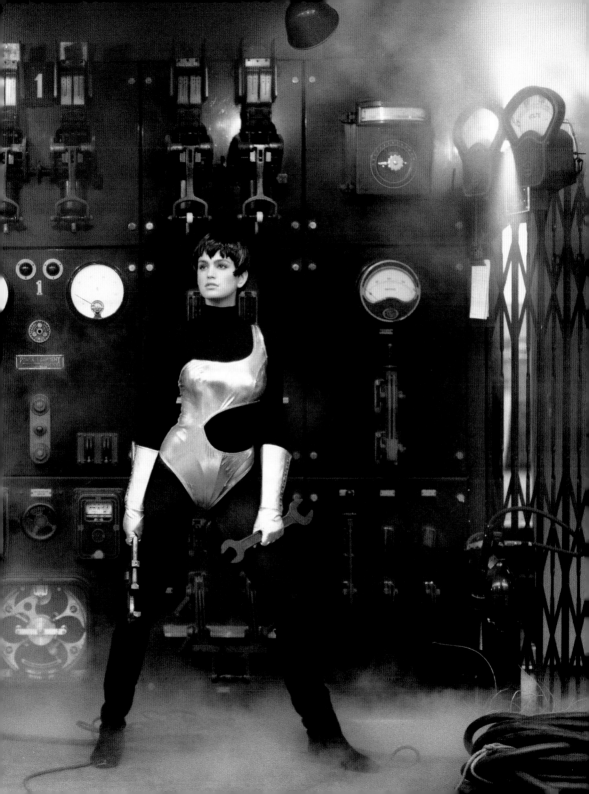

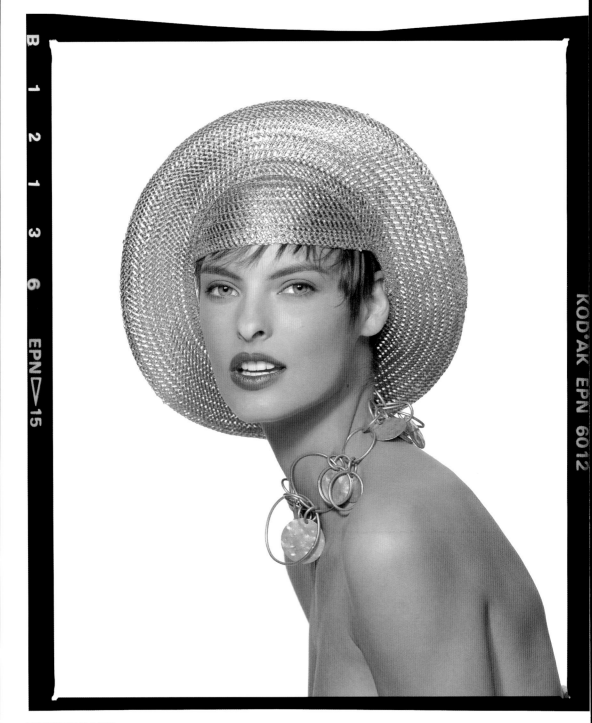

PATRICK DEMARCHELIER
LINDA EVANGELISTA, 1989
In his career with British *Vogue*, Demarchelier has
photographed 52 covers. These are two that never ran.

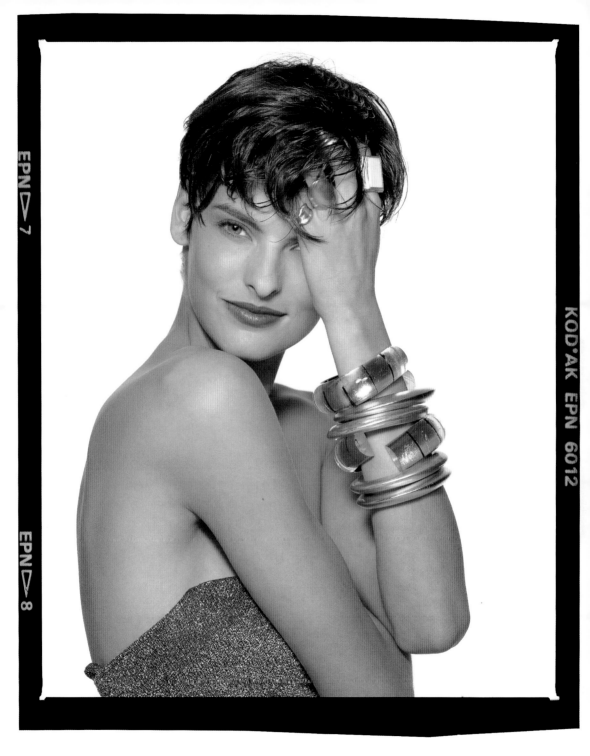

EPN ▷ 7

EPN ▷ 8

KOD·AK EPN 6012

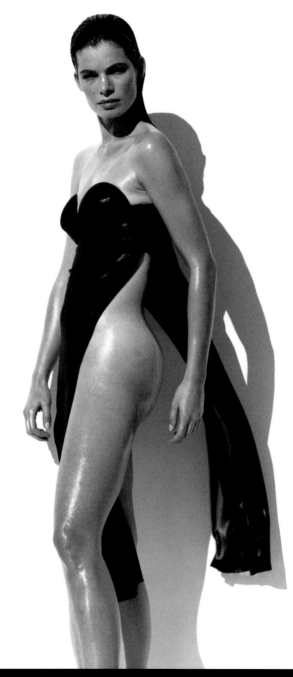

HERB RITTS
CORDULA REYER, 1989
Viscose strapless dress (*above*) by Michael Klein. Fashion editor: Sarajane Hoare.
Hair: Serena Radaelli. Make-up: George Newell.

PATRICK DEMARCHELIER
CINDY CRAWFORD, 1990
On the streets of New York
Cindy Crawford wears (right)
silver-sequined swimsuit by Liza
Bruce and (opposite) a silver
ruched bikini also by Liza Bruce, a
fringed silver leather cowboy jacket
from Johnsons and a silver stetson
from Harvey Nichols.

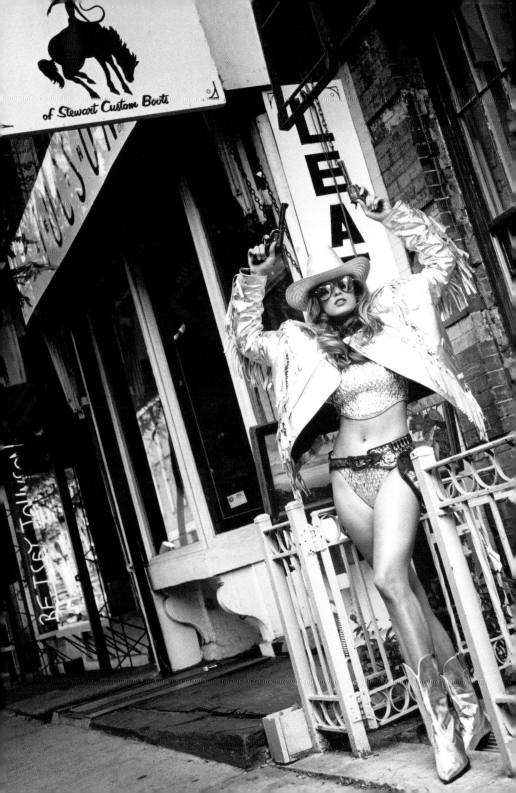

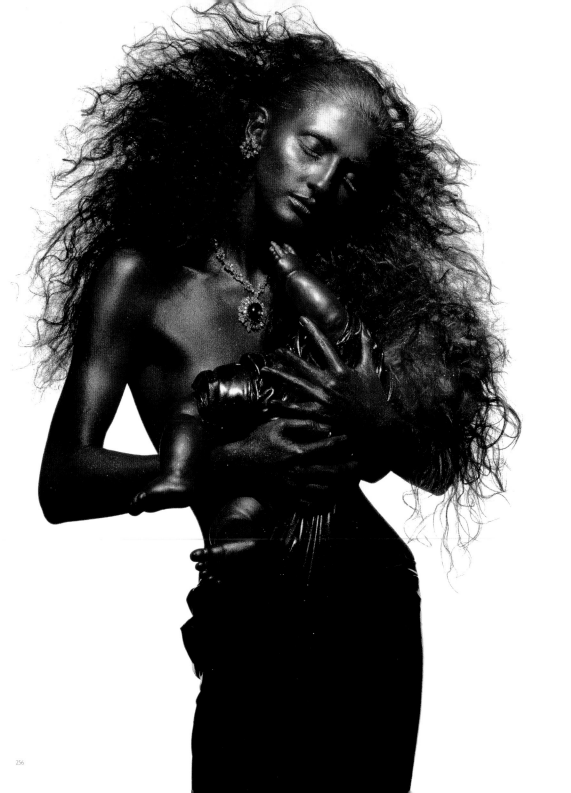

opposite
TYEN
'MODERN MADONNA', 1990
This was commissioned for a
Christmas feature but never ran.

right
TYEN
PARIS COLLECTIONS, 1991
Fashion editor: Harriet Jagger. Hair:
Klaus Roethlisberger. Make-up: Kim.

BRUCE WEBER
LISETTE, 1991
A variant from a series of photographs – documentary,
fashion and informal portraits – taken against the broad
landscapes of Montana, where Weber has a ranch. The
portfolio 'Big Country' included 65 prints, in black and white
and colour, and extended over 30 pages of *Vogue*'s January
issue. Had the magazine published no other Bruce Weber
pictures, it would have been left here with a distillation of
his most recognisable theme – a heroic beauty captured in
those who never imagined that they possessed it. Former
Vogue writer Mimi Spencer has written of these pictures:
'The clothes were incidental to the plot, but I remember
being fascinated by the characters. It felt as though I was
meeting a roomful of people at a party.' Fashion editor:
Lucinda Chambers. Hair: Tom Priano.

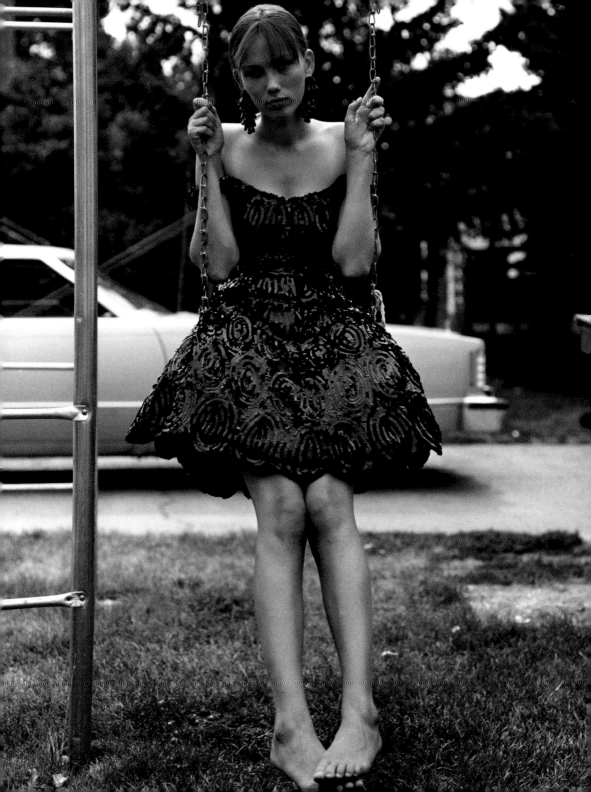

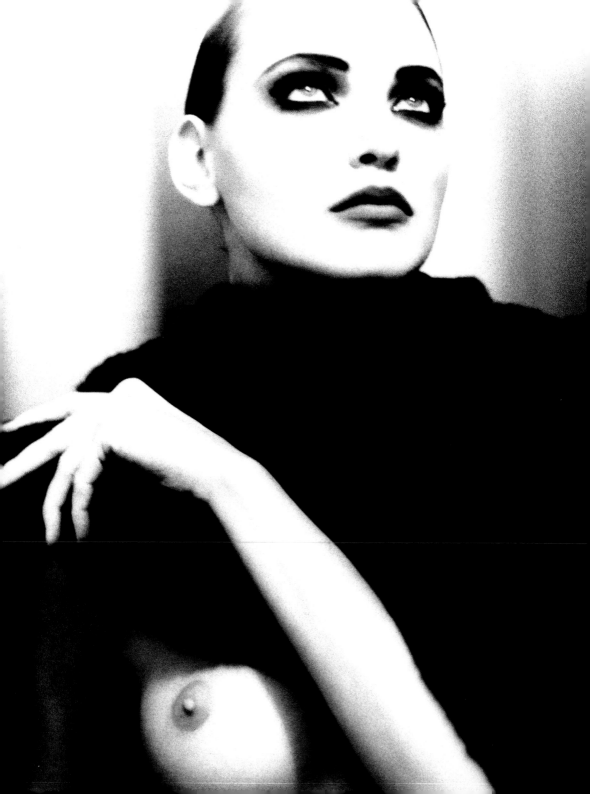

ELLEN VON UNWERTH
NADJA AUERMANN, 1991
Two out-takes (unused shots). Auermann,
described as having the longest legs in the western
world, first wanted to be a tightrope walker or,
failing that, Chancellor of Germany. 'My pictures,'
von Unwerth told Vogue, 'come from playing
around, not standing behind the camera shouting
orders.' Fashion editor: Lucinda Chambers.
Hair: Julien d'Ys. Make-up: Laurie Starrett.

following pages
ELLEN VON UNWERTH
TATJANA PATITZ, 1991
These photographs were taken on the Cap San
Diego in dock at Hamburg. Tatjana Patitz wears
slate-grey wool jacket and skirt by Gianfranco
Ferre with a wide-brimmed hat by Frederick Fox.
Fashion editor: Sarajane Hoare. Hair: Ward
Stegerhoek. Make-up: Laurie Starrett.

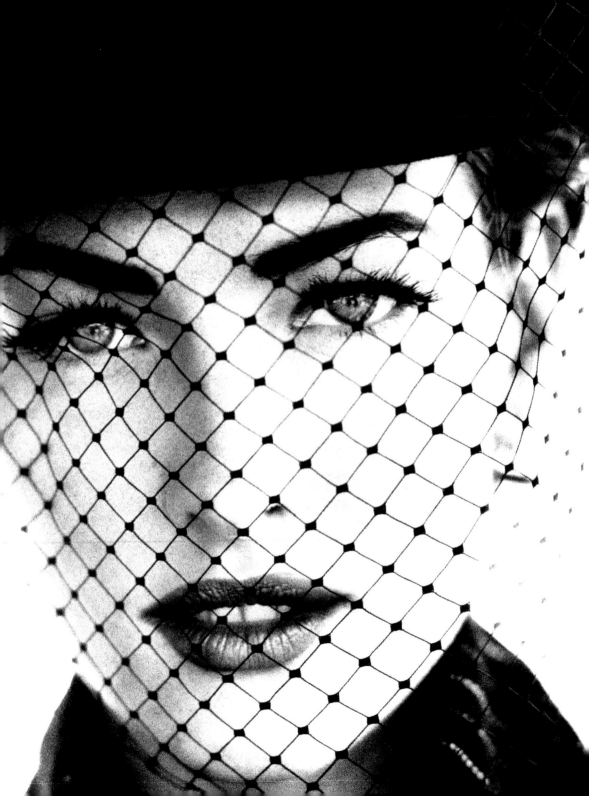

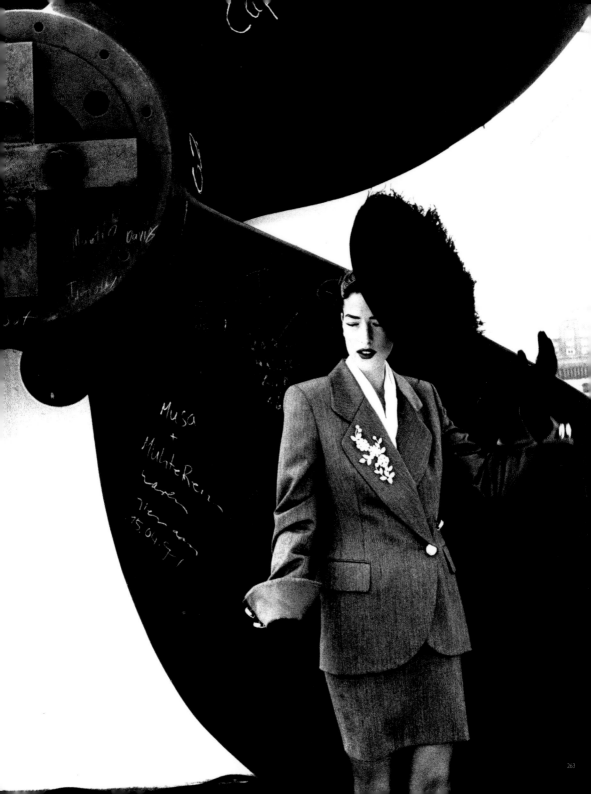

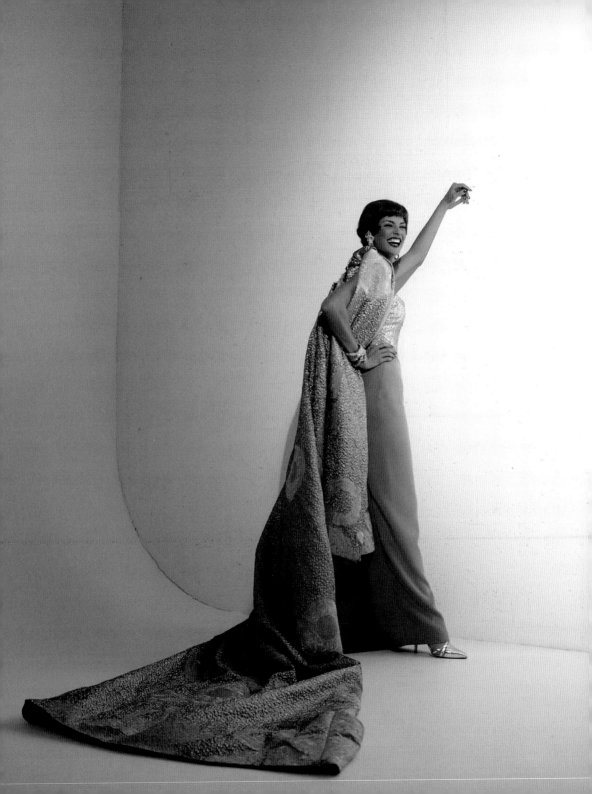

PATRICK DEMARCHELIER
LINDA EVANGELISTA, 1991
'We don't wake up for less than
$10,000 a day.' This is The Quote,
the defining moment of
supermodel-dom, the 'Let-them-
eat-cake' for the twentieth century,
as one commentator has put it.
'I feel like those words,' Linda
Evangelista reportedly said, 'are
going to be engraved on my
tombstone.' She has apologised
repeatedly for her hubris, though
she does not, according to
American *Vogue* in 2001, 'regret
anything any more'. Nor should
she. At least she has made it
into the *New Penguin Dictionary
of Modern Quotations* (2000).
Twice. The other entry, uttered
to *The Daily Telegraph*: 'No one is
born with perfect eyebrows.'
The September 2001 issue of
American *Vogue* devoted 28 pages
and the cover to her triumphant
return to modelling, her first
assignment in three years. These
two pictures are from the Couture
Collections, Paris, in the year she
uttered her epitaph. The strapless
gown, bodice and embroidered
stole (*opposite*) are by Gianfranco
Ferré for Dior, and the backless
dress (*right*) is by Versace.
Fashion editor: Sarajane Hoare.
Hair: Sam McKnight.
Make-up: Mary Greenwell.

CORINNE DAY
ROSEMARY FERGUSON AND CECILIA CHANCELLOR, 1993

Analysing the eclectic look of the London girl for an essay 'Fashion's New Spirit', Lisa Armstrong of *Vogue* noted that Corinne Day's subjects included, in magazine parlance, 'real' people, such as 'Tesco checkout girl-turned-model Rosemary Ferguson (*above*) and Sarah Murray, whose CV covers stints in a chip shop and at a Go-Kart track'. Day, who had shot Kate Moss before, was chosen by *Vogue* to portray this New Spirit – discerned on the streets of London and at the previous season's New York fashion shows. Marc Jacobs (for Perry Ellis) was a leading exponent of the new movement, later termed 'Grunge'. *Vogue* was prescient in its choice of photographer. Day's brief, recalls *Vogue*'s editor, Alexandra Shulman, was 'to do what she did so well – to depict fashion without artifice… The way Corinne looks at women is the way a girl appreciates a girl's looks; not the way women judge other women. There is a warmth and an intimacy there.' Her diaristic style, distilled from the realism of American photographers such as Nan Goldin and Larry Clark, celebrated by *Vogue* and denounced by the press, was defiantly 'anti-glamour'. Her prints were likened to stills from a gritty documentary or freeze-frames from a home movie. Whatever they were, they tried hard not to be fashion photographs, attempting to be natural and without 'style'. Few, though, saw beyond the frequently grimy locations to the innocent beauty in her pictures or their humour. The photograph (*opposite*) was taken at Moss's old school. 'One of the dinner ladies came up to me,' remembered Day, 'and said, "you haven't changed much." I'm ten years older than Kate…' Another, getting the right girl, remarked, 'She looks all right when she's done up…' The jacket, vest and skirt are by Jasper Conran. Fashion editor: Lucinda Chambers. Hair: James Brown. Make-up: Linda Cantello.

CORINNE DAY
LINDA EVANGELISTA, 1993
For this fashion story, 'To Hug and to Hold', Day brought her distinctive style to the queen of supermodels, who was well aware that the staying power of a supermodel was measured by seasonal changes of haircut and colour, and a willingness to embrace new photographic trends. 'I turned this down at first,' Day recalled, 'as I'd only worked with Kate [Moss], and I hadn't done much in the studio. Also, I couldn't really relate to Linda; one minute she'd be some sort of exotic character, the next a film star, and I was into the opposite. But Linda was just as unsure of me. She was really very sweet.' Fashion editor: Jayne Pickering. Hair: James Brown. Make-up: Linda Cantello.

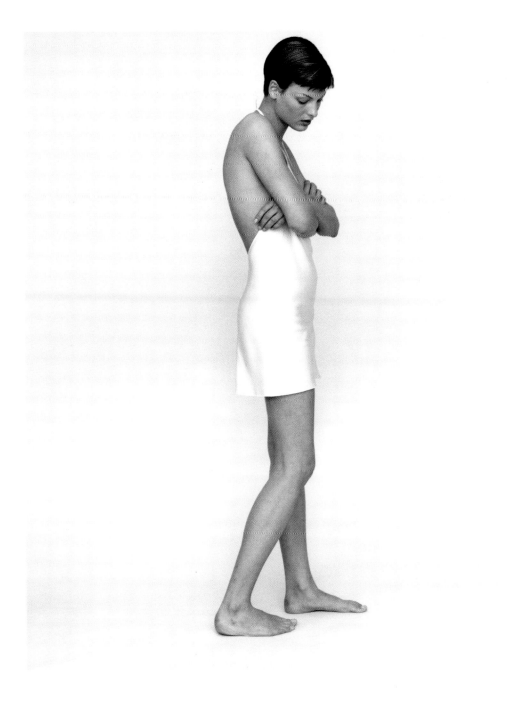

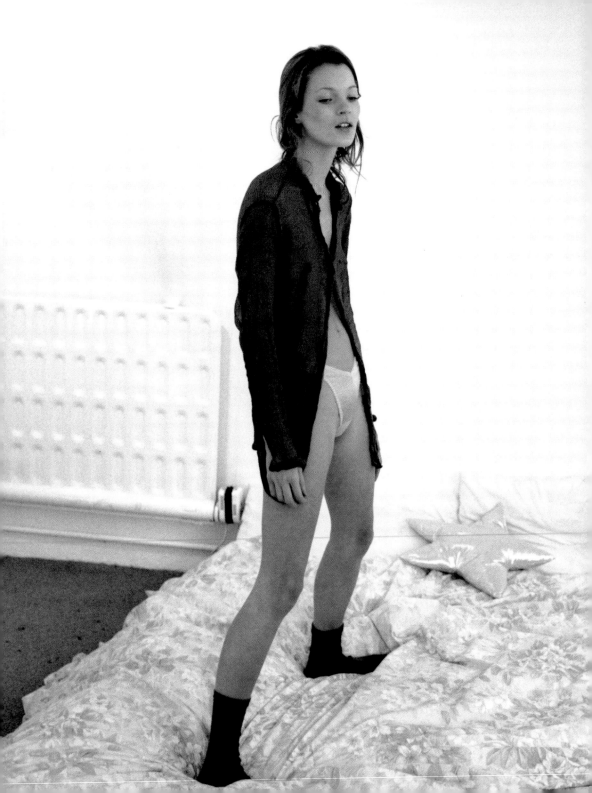

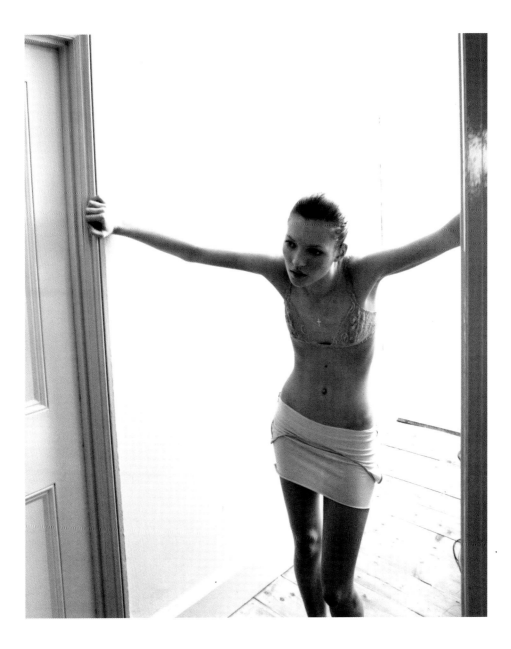

CORINNE DAY
KATE MOSS, 1993

Photographed in daylight, a thin and slightly awkward 19-year-old, this was Kate Moss portrayed by her friend Corinne Day. The published prints, of which these are black-and-white out-takes, were typically downbeat. Moss's hair was barely groomed, her make-up minimal and the setting – the west London flat she shared with her then boyfriend photographer Mario Sorrenti – far removed from the exotic locations popularly associated with the *Vogue* fashion shoot. When the pictures were published, the press greeted them with a tidal wave of disapproval. 'American tan tights falling down Kate's legs – we were poking fun at fashion,' Day said at the time, adding wistfully. 'Halfway through the shoot, I realised that it wasn't fun for her any more and that she had become a "model". She hadn't realised before how beautiful she was…'

Of their first meeting, Day later recalled for *Vogue*, 'I looked at her and said "You're going to be so famous." I loved her attitude. She was really just this cocky kid from Croydon. She wasn't like a model. She was naive in some ways, but very streetwise in others.' The 15-year-old, whom Day first saw some 15 years ago and whom Sarah Doukas of Storm modelling agency saw first across a sea of faces in a JFK flight queue, has in that time changed the perception of fashion and beauty across the globe and became famous, as Day predicted, fast. She wears a petrol-blue muslin shirt (*opposite*) with high-cut briefs by Gossard. Lace bra by Janet Reger (*above*) with aqua vest dress, worn as skirt, by Liza Bruce. Fashion editor: Cathy Kasterine. Hair: James Brown. Make-up: Miranda Joyce.

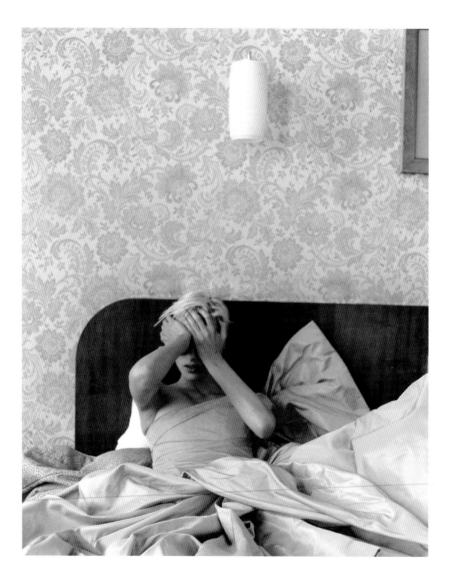

above, opposite and following pages

DAVID SIMS
EMMA BALFOUR, 1994

David Sims first worked on British youth and style magazines, including *The Face* and *i-D*, but had his sights set on the world of the high-fashion glossy magazine. Without rejecting the conventional artifice of such magazines, Sims brought to them a part of the real world outside. 'Everything,' he has said of his work, 'was an attempt to put into a magazine something that would stimulate people to look beyond their expectations of a fashion picture.' Sims was successful almost immediately yet, throughout the 1990s, remained outside the mainstream of fashion photography. What marked him out from his contemporaries was less a determination to remove himself from any association with 'glamour' than an effort to reinterpret it in ways his generation could assimilate. In this he had much in common with Louis Faurer, Bob Richardson and Saul Leiter, progenitors of narrative fashion photography who, some 30 to 40 years previously, had paved the way for this 'anti-fashion' stance. Fashion editor: Jayne Pickering. Hair: Guido. Make-up: Dick Page.

NICK KNIGHT
LINDA EVANGELISTA, 1995

Nick Knight is one of a handful of British photographers of his generation to have established an international reputation in the world of fashion. Since 1993, few native talents have enjoyed such success. Fewer still have manipulated images for mainstream magazines quite as he has, or seen their darkroom processes so widely imitated. His shoots can be slow, painstaking and labour intensive; but it is in postproduction that the fastidiousness for which he is well known becomes almost obsessive. While a catalogue for Jil Sander reportedly took five days to photograph, the results took two months to print to Knight's satisfaction. Such campaigns – for Sander, Alexander McQueen, Christian Dior and Yohji Yamamoto among others – have been award winning and influential. A Nick Knight picture of Naomi Campbell in a red Yamamoto coat, for example, has become as much an icon for the late 1980s as was Horst's 'Mainbocher Corset' for the prewar years. Now in his early forties, Knight is something of a father figure to a generation of magazine photographers who, like him, came to prominence through 1980s style magazines. For a while, as well as taking pictures, he was picture editor of i-D magazine, from where he was able to encourage younger talents such as Juergen Teller and Craig McDean. To his credit – and unlike some of his distinguished predecessors in Vogue – Knight has never been ashamed of, or embarrassed by, his association with the fashion world. Rather, he has acknowledged that it has allowed him to embrace new technology and to explore, especially with computer manipulation and digital photography, new ideas and visions which challenge traditional notions of photographic 'truth'. Photographed in the window of Harvey Nichols department store, London, in a variant of a published image, Linda Evangelista wears a flesh-coloured rubber T-shirt by Stephen Fuller. Fashion editor: Lucinda Chambers. Hair: Julien d'Ys. Make-up: Linda Cantello.

following pages
NICK KNIGHT
AMBER VALLETTA, 1994

Amber Valletta wears (*left*) a duchesse satin suit with exaggerated lapels, and (*right*) a silk crepe tuxedo with wide-leg satin pants by Martine Sitbon, and felt trilby by Stephen Jones. Fashion editor: Lucinda Chambers. Hair: Guido. Make-up: Linda Cantello.

pages 280–1
NICK KNIGHT
SHALOM HARLOW, 1995

Two pictures from the Couture Collections. The photograph of Lacroix's pink dress with a low-cut back (*left*) was replaced by an illustration of it by François Berthoud. The nude study (*right*) was originally published in black and white. Fashion editor: Lucinda Chambers. Hair: Sam McKnight. Make-up: Dick Page.

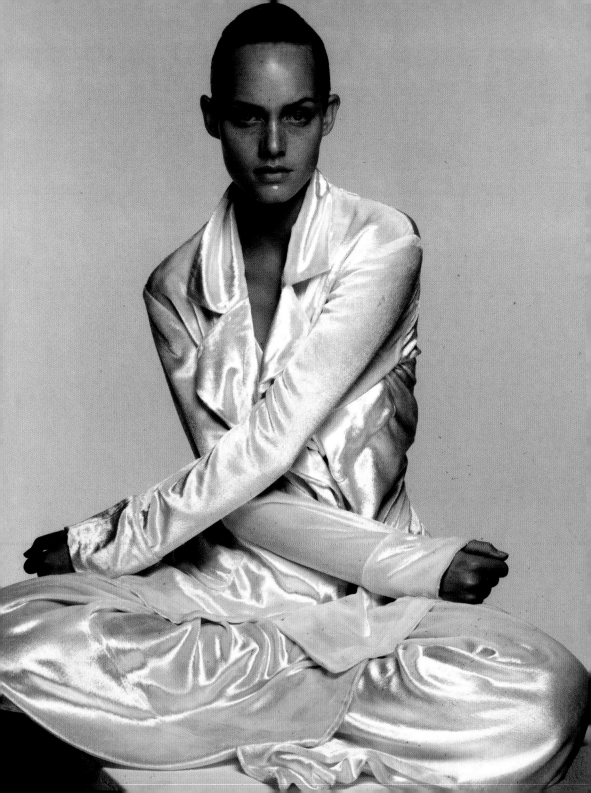

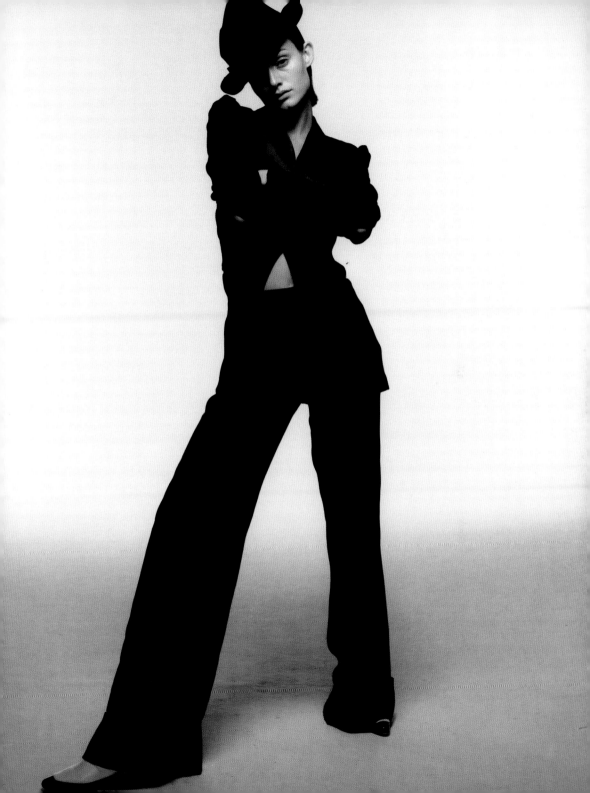

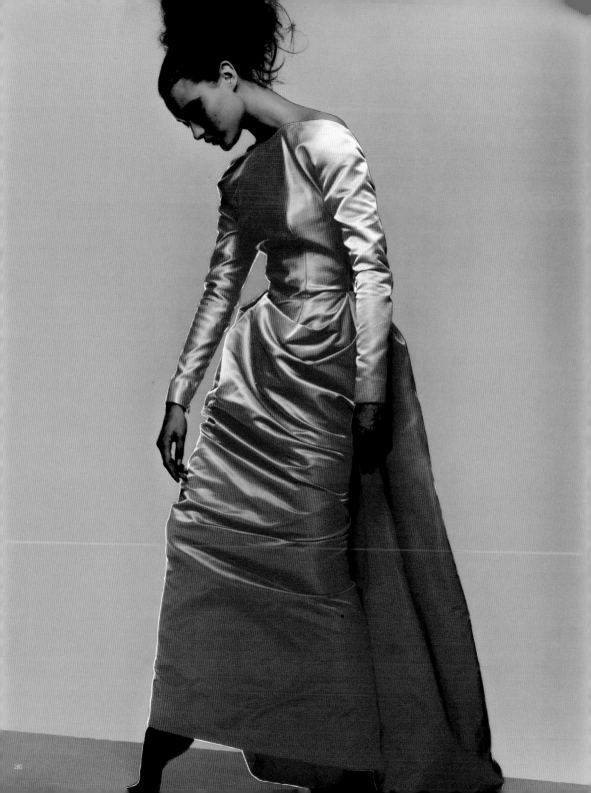

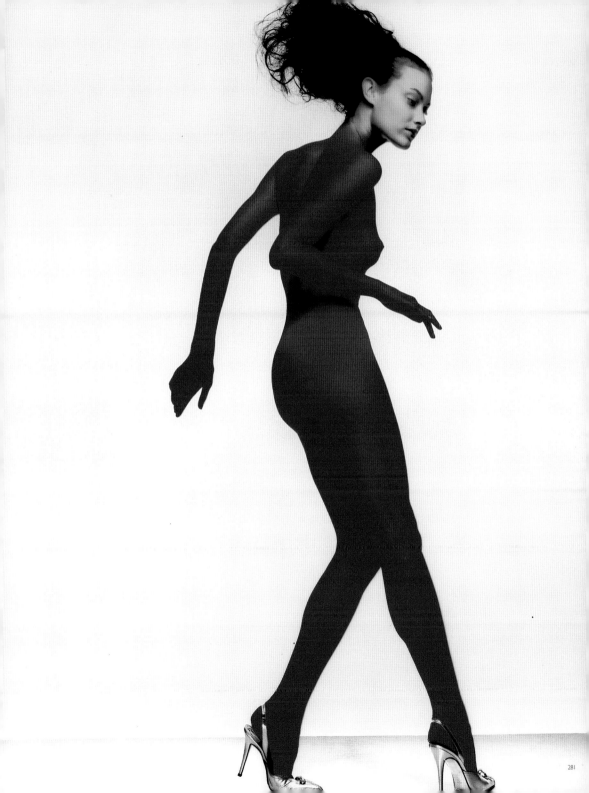

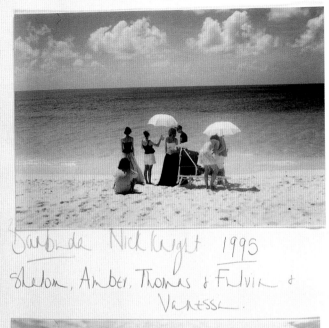

Barbados Nick Knight 1995
Shalom, Amber, Thomas & Fulvia &
Vanessa.

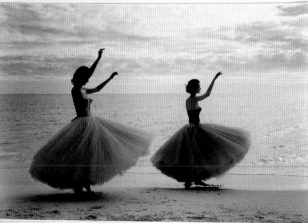

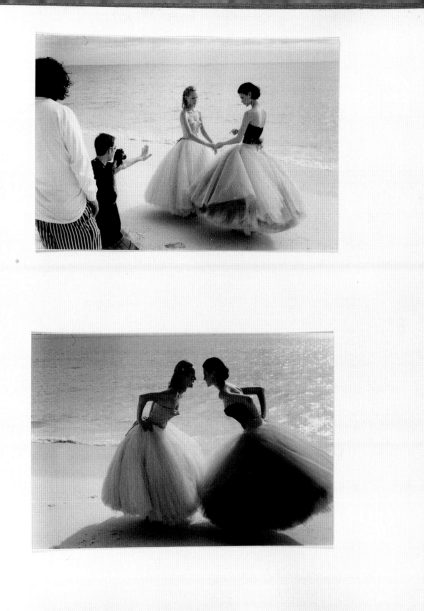

LUCINDA CHAMBERS
NICK KNIGHT ON LOCATION, 1995

Pages from the scrapbook of Lucinda Chambers, *Vogue*'s fashion director, taken on location on the Caribbean island Barbuda. Shalom Harlow and Amber Valletta, dancing to Blondie's *Rapture*, wear pale dove-grey and peach dresses with duchesse satin bodices by Isabell Kristensen. The writer James Servin was interested to discover that real-life friends Shalom and Amber were also

found that 'both had lived three former lives, all as men, and may have crossed paths in an Indian incarnation.' "We had horrible, tortured deaths," Amber says.' Shalom was bridesmaid at Amber's wedding. 'They imagine,' continued Servin, 'that one day, perhaps in their twilight years, they'll return to the tropical setting of *Vogue*'s pages. "We've talked about it," Amber says. "Already, we're like old ladies the way we walk down the street, arm in arm," says Shalom.'

JUERGEN TELLER
SHALOM HARLOW, 1996

Though born and trained in Germany, the photographer Juergen Teller first achieved success in London. His impact on fashion photography has become increasingly pronounced since then. 'I want you to be able to see,' Teller once explained, 'not a piece of clothing but a characterisation that's interesting and inspiring; that people can then translate themselves. I'm not interested in pieces of clothing… the world is a much more fragile place nowadays. You can feel it in the sort of fashion photography that we do and in the type of interest that we have. Maybe that in turn makes it more interesting to people who would not normally be interested in fashion.' His studies, often taken in an informal 'snapshot' style, reveal a sense of dislocation and alienation. This has frequently led him to abandon the usual contrivance of the fashion photographer; with point-and-shoot cameras, his pictures are sometimes the result of nothing more than a happy accident. However, as is demonstrated by this cover try (a photograph styled as a potential cover) and those on the following pages, he has brought this confrontational approach to a studio setting. Like all great photography, his pictures appear to be executed for his own amusement. 'Every picture I take – even a commercial picture – has to please me,' he says. If they work for others, so much the better. Fashion editor: Tiina Laakkonen. Hair: Guido. Make-up: Miranda Joyce.

following pages
JUERGEN TELLER
CLAUDIA SCHIFFER, 1995

Two prints from a potential cover shoot. By March 2000, *Forbes* magazine estimated Schiffer was the richest model in the world, with a total wealth of some £30 million. Her face has appeared on the covers of over 700 magazines. Fashion editor: Tiina Laakkonen. Hair: Guido. Make-up: Miranda Joyce.

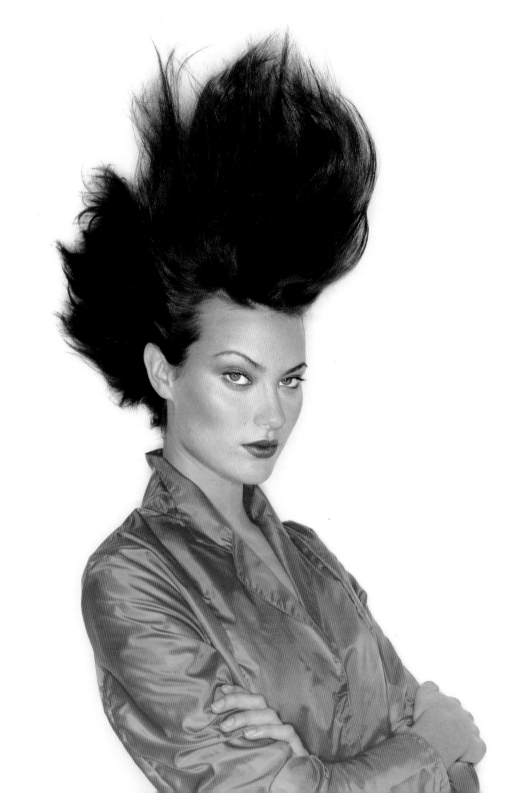

JUERGEN TELLER
STEPHANIE SEYMOUR, 1995

'I woke up,' said Stephanie Seymour of one day
around 1993, 'and decided it was time.' Time, that
was, to dump her wild-girl image, born of
appearances in *Playboy* and in a promo for Guns N'
Roses, band of her boyfriend Axl Rose. By 1995, she
had married the wealthy polo-playing publishing
magnate Peter Brant, and switched nights of
partying for days of riding in Connecticut where,
Australian *Vogue* reported, 'she wears Azzedine
Alaïa almost every day.' She astutely ploughed much
of her earnings from a 10-year association with
lingerie chain Victoria's Secret into art. Along with
work by Warhol, Basquiat and Hirst, she owns one
of Jeff Koons's giant flower sculptures *Puppy* (as
seen outside the Guggenheim, Bilbao). As a 33-year-
old grandmother (courtesy of one of her five
stepchildren) she still models. Her feature-film debut
was as the artist Helen Frankenhalter in Ed Harris's
biopic *Pollock* (2001). Teller has recently completed
a book of portraits of Seymour. Fashion editor: Tiina
Laakkonen. Hair: Guido. Make-up: Miranda Joyce.

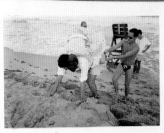

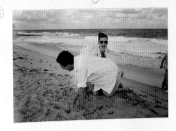

strong man Mario
with Meghan in Palm Beach

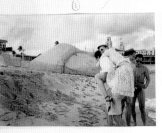

Mario
Testino
Palm Beach
November
1994

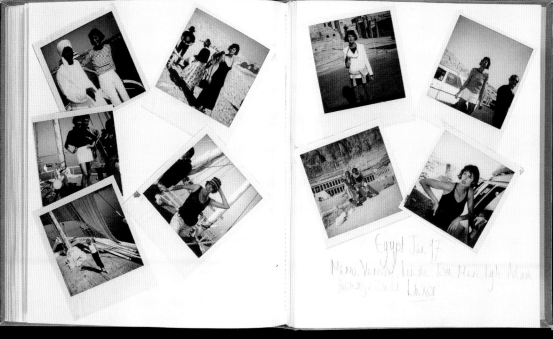

Egypt Jan 97
Mario, Vanity, Su de Tom, Marie Syle Adam honey Sue Luxor

LUCINDA CHAMBERS
MARIO TESTINO ON LOCATION,
1994 AND 1997

These pages of snapshots by *Vogue* fashion director Lucinda Chambers show (*opposite*) a Vogue shoot in progress in Palm Beach with models Meghan Douglas and Yasmeen Ghauri and (*above*) another with Linda Evangelista in the Valley of the Kings, Luxor, Egypt. Mario Testino represents an unapologetic return to fashion at its most opulent. His photographs owe a debt to the tableaux of Cecil Beaton with whom he shares a delight in the pretence, the drapes, the roses and the sheer hauteur of a rarefied world. To those who have strived to drag fashion out of the salons and on to the streets, his extraordinary and sustained success must be alarming. His 'name is dropped so often in fashion circles,' wrote one commentator, 'that it's surprising it hasn't shattered.' But the nonchalance of much of his work and his apparently effortless touch is honed of great experience and determination.

Though his earliest work for British *Vogue* dates from the early 1980s, it was probably his portraits of Diana, Princess of Wales, for *Vanity Fair* in 1997 – her last set of sanctioned photographs – that put him on the map. Born in Lima and trained as a lawyer, the multilingual Testino came to London in the 1970s. 'I liked London,' he told *Stern.* 'This mixture of cosmopolitan city and anarchy was just what I'd always been looking for…' Though he can be informal if he chooses, he is just the sort of fashion photographer people have in mind if ever they talk about fashion photographers; the descendant perhaps of *Funny Face*'s Dick Avery – faultlessly polite, inexhaustibly flattering, utterly self-deprecating and single-minded in his pursuit of excellence. In 2002 he held a successful exhibition at the National Portrait Gallery, London.

DAVID SIMS
CHRISTY TURLINGTON, 1995
Variants from a published sitting. Leather jacket by
Calvin Klein (*left*) with satin hotpants by Clements
Ribeiro and knee-length boots by Prada. White
scoopneck top (*opposite*) by Yves Saint Laurent Rive
Gauche with plastic laminated cotton skirt by
Katharine Hamnett and patent-leather boots by
Claire Norwood. Fashion editor: Tiina Laakkonen.
Hair: Guido. Make-up: Miranda Joyce.

NEIL KIRK
JANINE GIDDINGS, 1995
Two prints from an unpublished
shoot in Los Angeles. Fashion
editor: Kate Phelan. Hair: David
Gardener. Make-up: Diane Kendal.

DAVID SIMS
CHRISTINA KRUSE AND
STELLA TENNANT, 1995
In 1995 Kruse was, according to *Vogue*,
'the latest in a long line of icy
Germanic blondes,' who 'upped her
coolness factor during the last round
of shows – at Gucci she was one of
only a few models able to navigate the
runway in a pair of the label's perilous
steel heels.' Fashion editor: Tiina
Laakkonen (herself an icy blonde).
Hair: Guido. Make-up: Miranda Joyce.

PAOLO ROVERSI
MARTINE HOUGHTON, 1995
Two out-takes (unused shots) from 'Wild and Wonderful'. 'Mainstream fashion,' ran the introduction, 'is all about pared-down classics,
but there's still room for invention.' Fashion editor: Lucinda Chambers. Hair: Guido. Make-up: Mary Greenwell.

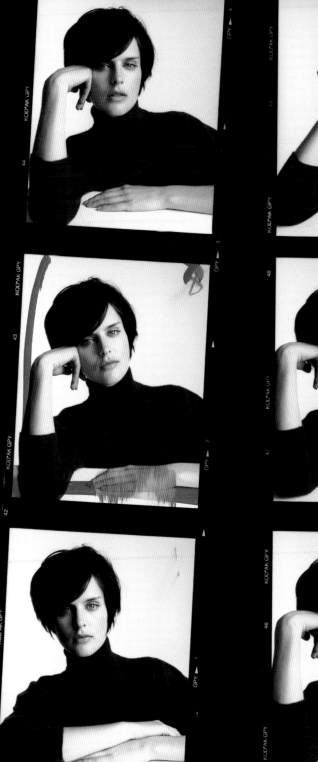

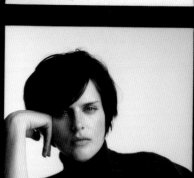

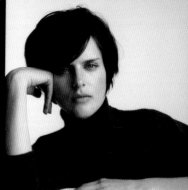

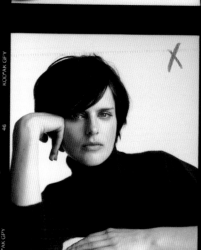

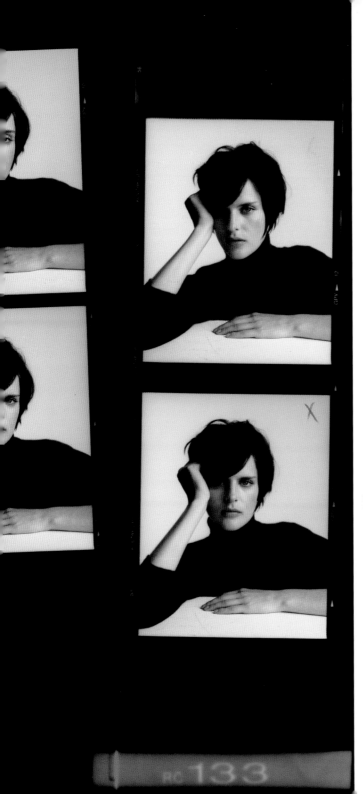

REGAN CAMERON
STELLA TENNANT, 1996
A contact sheet from an unpublished cover sitting.
The granddaughter of the Duke and Duchess of
Devonshire, Stella Tennant was discovered on a
casting for Steven Meisel held by Isabella Blow,
former *Vogue* associate editor and talent spotter.
Despite her ranginess (she's around six feet tall) and
her self-possession, in those days she seemed unlikely
to succeed, other than fleetingly as a curiosity – she
had, for example, recently pierced her own nose, on
a railway platform. But she also possessed a languid
elegance and an unsmiling demeanour not seen in an
English model since Barbara Goalen and Anne
Gunning in the 1950s, and this she used to her
advantage. It took a little time to come together,
even when the nose ring went. On location in
England for American *Vogue*, photographer Arthur
Elgort was heard to mutter, '*Pretty, Stella, pretty,*'
attempting to soften her hauteur. But, exploiting her
not-over-classical looks, she has, observed *Vogue*,
'challenged the conventions of what makes a great
model'. 'When we first saw Stella,' Loulou de la
Falaise, muse to Saint Laurent told *Vogue*, 'we thought
she was strange but *fabulous* and *new*.' After a break
from modelling, she returned recently, as languid as
ever and still unfazed by it all. Her grandmother, the
Duchess of Devonshire (born Deborah Mitford),
is similarly matter of fact. After watching her
granddaughter in a Chanel show, her only
observation, *Vogue* reported, was: 'So good at
lambing.' Fashion editor: Kate Phelan.

TIM WALKER
'SPIRITED', 1997

Pages from the day book of Tim Walker, showing contact prints of his *mise en scène* and the meticulous preparation that precedes it. Walker's idiosyncratic, neo-romantic slices of country life, like these taken on location in Ireland, have provided *Vogue* with whimsical images that evoke its past. For Italian *Vogue* especially, Walker has reworked traditional, yet fast-disappearing, aspects of British country life, such as the hunt, the country-house weekend, the shooting lunch. Before taking up photography, he spent some months working in *Vogue*'s archives. It is tempting to speculate that, during his painstaking cataloguing of the magazine's holding of Cecil Beaton negatives, something of Beaton's style may have rubbed off. For this shoot the model waving a sparkler and wearing a paper crown is Rhea Durham. Fashion editor: Charlotte Pilcher. Hair: Ken O'Rourke. Make-up: Lesley Chilkes.

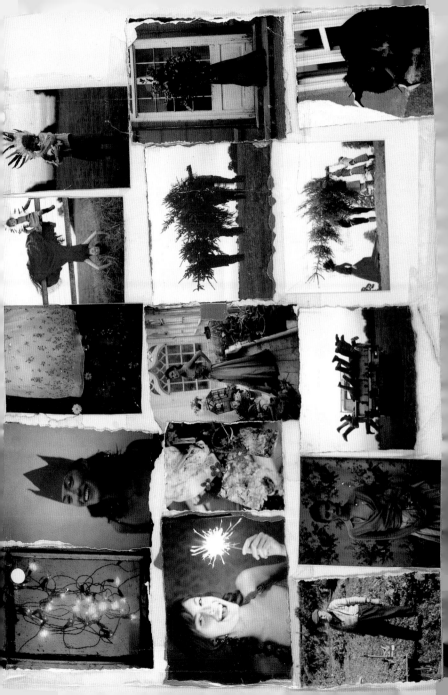

opposite

MARIO TESTINO
AMY WESSON, 1996
Fashion editor: Lucinda Chambers. Hair:
Marc Lopez. Make-up: Tom Pecheux.

above

MARIO TESTINO
SHALOM HARLOW, 1995
A *Vogue* cover try. Shalom Harlow wears
an organza halterneck dress by Prada.
Fashion editor: Lucinda Chambers.
Hair: Tracey Gray. Make-up: Tom Pecheux.

CRAIG McDEAN
GUINEVERE VAN SEENUS, 1996
A former assistant to Nick Knight, McDean
was taken on, said Knight, 'because of the way
he looked. He was more like David Bowie
than Bowie. Magenta hair. But he turned out
to be one of the best assistants I ever had.'
Though he once warned *The New Yorker*, 'Don't
call me a fashion photographer,' McDean took
off in his career at the American fashion
magazines *Harper's Bazaar* and *W*. His style, a
hybrid of English sensibility and international
modernism, and his exceptional sense of
colour, has led to his being labelled a 'luxury
realist'. Past successes include campaigns for
Martine Sitbon (one taken in a *faux*-sylvan
setting was especially admired). This is a variant
from a published sitting. Cashmere polo
sweater, by Prada. Earrings, by Paloma Picasso.
Fashion editor: Kate Phelan. Hair: Eugene
Souleiman. Make-up: Pat McGrath. At this time,
McDean undertook hardly any shoots without
this hair and make-up team.

following pages
CRAIG McDEAN
CARMEN HAWK AND
KATE MOSS, 1996
Alternative takes on published pictures.
Deconstructed satin dress, by Christian Lacroix
(*left*). Fashion editor: Lucinda Chambers. Beige
suede dress with lilac slip, by John Galliano (*right*).
Fashion editor: Kate Phelan. For both pictures, hair:
Eugene Souleiman, make-up: Pat McGrath.

ROBERT ERDMANN
ANNIE MORTON, 1996
Robert Erdmann, a fashion editor-turned-photographer, has had a long
association with British *Vogue*. Chain-mail slip dress, by Versace (*above*) and
leather sandals, by Manolo Blahnik. Brocade evening coat, by Sportmax (*opposite*),
cream beaded dress, by Giorgio Armani, and gold leather sandals, by Manolo
Blahnik. Fashion editor: Kate Phelan. Hair: Sam McKnight. Make-up: Lisa Eldridge.

JUERGEN TELLER
IRIS PALMER AND
JAYNE WINDSOR, 1997
Photographed in the Hackney
Empire, London. Pale blue slip
dress (this page), by Stella
McCartney. Black asymmetrical
dress (opposite), by Rifat Ozbek.
Fashion editor: Tiina Laakkonen.
Hair: Sam McKnight.
Make-up: Miranda Joyce.

CARTER SMITH
STELLA TENNANT, 1997
Stella Tennant, wearing John Galliano,
in Central Park, New York City.
Fashion editor: Kate Phelan.

TOM MUNRO
ANGELA LINDVALL, 1997
The life story of Angela Lindvall,
Vogue noted, 'reads like a John
Steinbeck novel: born into a large
family in Lee's Summit, Missouri;
spends her spare time playing
the guitar; recently drove her
family cross-country to Florida.'
Organza asymmetrical dress by
Antonio Berardi. Fashion editor:
Kate Phelan. Hair: Ward.
Make-up: Lisa Butler.

TERRY RICHARDSON
GEORGINA COOPER, 1998
Terry Richardson's first camera was a
snapshot one given to him by his mother.
He exposed several frames and showed
the results to his father, who, it was
reported, picked over the prints and told
his son: 'These are terrible – you'll never
be an artist.' His father is fashion
photographer Bob Richardson, and
clearly a hard act to follow. For several
years now, *Vogue* has showcased Terry
Richardson's fluid, realist style, described
by Robin Derrick, creative director of
British *Vogue*, as 'broken glamour': his
models suck on ice lollies, drink in pubs
and dance wildly, catch their dresses in
car doors, shout, pull the tablecloth from
under the plates, slide down banisters.
Like those who have attempted
spontaneity in fashion photography
before, Richardson shares a commitment
to dynamic impact over formal
photographic qualities – and mostly it
works. Kate Phelan, fashion editor at
Vogue, says of him that it is not his
purpose to 'make fashion history – and
he's not interested in pretence either. He
photographs what he sees, and edits his
film for the moment; not for the perfect
image.' One commentator reported the
following exchange between father and
son, as recalled by Terry: 'I said, "You told
me I couldn't take pictures." And he said,
"Well, now you can. I helped you put a
fire under your ass…"' Two variants from
one of his earliest fashion stories for
Vogue. Polka-dot chiffon dress by Rifat
Ozbek with St Tropez knickers by Agent
Provocateur (*left*). Dress by Christa Davis
(*opposite*). Fashion editor: Kate Phelan.
Hair: Rolando Beauchamp.
Make-up: Francisco Valera.

TERRY RICHARDSON
HELLE, 1998
Out-takes from the Couture. Black jet
beaded fishnet cardigan with black
heron feathers (below), by Jean Paul
Gaultier. Pearl-grey silk tulle and chiffon
dress embroidered with sequins
(opposite), by Valentino. Fashion editor:
Kate Phelan. Hair: Rolando Beauchamp.
Make-up: Francisco Valera.

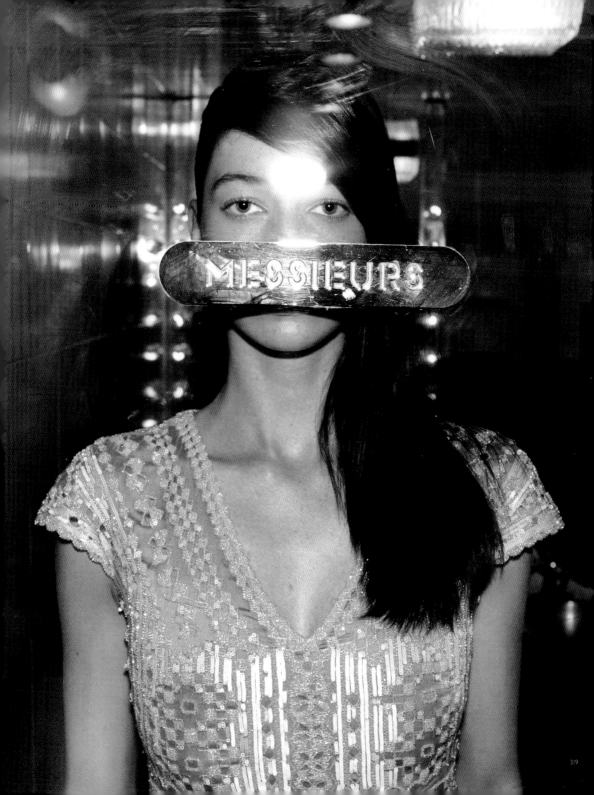

above
NICK KNIGHT
KYLIE BAX, 1998
An out-take from 'Energy', a fashion story on the versatility and
elasticity of 'techno-fabrics'. Fashion editor: Lucinda Chambers.
Hair: Sam McKnight. Make-up: Sharon Dowsett.

opposite
NICK KNIGHT
MAGGIE RIZER, 1999
A picture for *Vogue*'s silver-covered Millennium issue, the first
occasion the magazine was published without a cover image
since its diamond-jubilee issue of 1976. Though the double
exposure was unintentional, it seems apposite for 'Give me
Space', a futuristic fashion story, and the beginning of the
twenty-first century. Maggie Rizer wears a streamlined silver
leather top and leather trousers by Alexander McQueen for
Givenchy, and boots by Jean-Charles de Castelbajac. BBC
Costume and Wigs lent the silver, padded backpack, just
discernible. The disc is a large Perspex bubble hat by Julien
Macdonald, which, *Vogue* conceded, was 'not essential for
everyday use', but was sure to come into its own 'for future
trips to the moon'. Fashion editor: Lucinda Chambers.
Hair: Sam McKnight. Make-up: Sharon Dowsett.

NICK KNIGHT
JENY HOWARTH AND
SARAH MORRISON, 1999
For *Vogue's* Millennium issue, Nick Knight
undertook the most ambitious and most
expensive fashion shoot in the magazine's
history. Over several weeks, in London, Paris
and New York, he photographed four
generations of models, as a chronicle of the
profession. The results were distilled into a
portfolio of 41 published pictures. The earliest
generation was represented by Carmen, and
Dorian Leigh, who both first worked in the
1940s, an era when models were known as
'mannequins'. The most recent group – the big
names of today – included Gisele, Angela
Lindvall, Maggie Rizer. Between these
generations were names still resonant of
the glamour of their era: Twiggy, Iman,
Marisa Berenson, Penelope Tree. Logistical
problems and limited space meant that these
two pictures never made it into the magazine.
Knight has championed Sarah Morrison
(*opposite*) as a model for *Vogue*, and has also
photographed her for the cover image of
Saturday Night, the single by Suede.

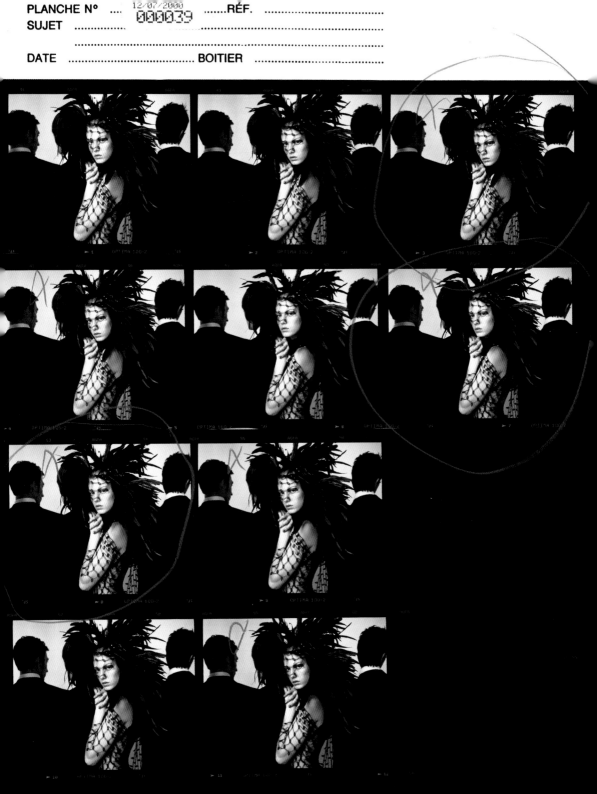

PLANCHE N° RÉF.
SUJET ..
..
DATE BOITIER

27/09/99
000039

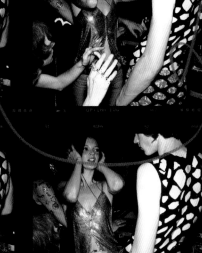
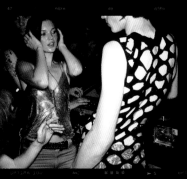

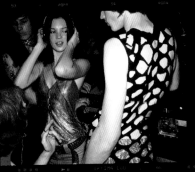
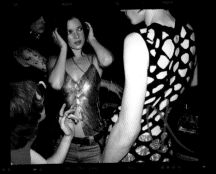
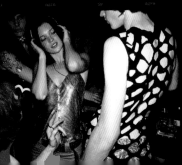
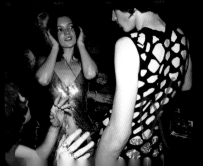

left

MARIO TESTINO
KATE MOSS, 1999
At the end of each day, wherever in the world
he finds himself, Testino edits the the contact
sheets from his previous assignment, soliciting
opinions from anyone who happens to be
around. This is a marked-up contact sheet from
his 24-page contribution to *Vogue*'s 'Millennium'
issue. Kate Moss wears a chain-mail camisole by
Paco Rabanne.

opposite

MARIO TESTINO
ANGELA LINDVALL, 2000
Another contact sheet, part of Testino's
contribution to *Vogue*'s end-of-year 'Gold' issue.
Angela Lindvall wears a net 'Eiffel Tower' dress by
Jean Paul Gaultier. Hair: Marc Lopez. Make-up:
Tom Pecheux. Nails: Brenda Abrial. Fashion editor
for both pictures: Lucinda Chambers.

327

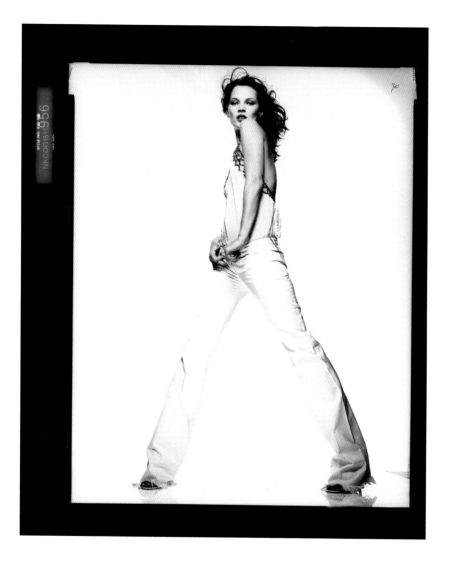

NICK KNIGHT
KATE MOSS, 2000 AND 1999

The herald of 'reality'; assassin of the supermodel and high-fashion artifice; the
face of 'Obsession' and countless other brands; style prophetess; devotee of
real diamonds and second-hand couture; unjustly vilified scapegoat to
campaigners for anorexia awareness; one half, with Johnny Depp, of a high-
cheekboned transatlantic couple; ordinary, gawky suburban girl; totem of
contemporary culture to young British artist Gary Hume, and sitter for Lucian
Freud – Kate Moss is, simply, a phenomenon, the unrivalled icon of her
generation, which, as she told the writer Plum Sykes, is 'I don't know... Weird'.
Clothes (above), by Stella McCartney for Chloé, and (opposite) by Ralph
Lauren. Fashion editor: Kate Phelan. Hair: Sam McKnight. Nails: Marian
Newman. Make-up: Val Garland (above); Sharon Dowsett (opposite).

RAYMOND MEIER
VIVIEN SOLARI, 2000
Cruise wear by Missoni (*opposite*), and Gucci (*above*).
Fashion editor: Tiina Laakkonen. Hair: Eugene Souleiman.
Make-up: Fulvia Farolfi.

TOM MUNRO
GISELE BUNDCHEN, 2000

In 2000 Gisele appeared simultaneously on the
January covers of British and American *Vogues*, *W* and
Harper's Bazaar. She also appeared on British *Vogue's*
October cover in a Union Jack bikini with a naked co-
star, the singer Robbie Williams, whom she unnerved
during the shoot, *Vogue* reported, by showing no
particular interest in him. '"Does she fancy me?"
Robbie asks plaintively to anyone who will listen.' The
Brazilian supermodel has also made an impression on
the creative director of British *Vogue* by 'performing a
little dance. I remember once arriving in Paris for a
shoot,' recalled Robin Derrick in an interview in *GQ*.
'It was crack of dawn and I was feeling awful, really
miserable. But there was Gisele just dancing
and singing. She is incredibly vivacious; she just lifts
everyone. She's professional, she's always on time, and
she's very chic.' Moreover, Gisele has inspired Cathy
Horyn of *The New York Times* to coin a word: 'She has
that instinctive thing where you just go… schwing!'
This is a cover try for another 2000 issue of *Vogue*,
but one that did not make it. White cotton Lycra top
and leather pants by Loewe. Fashion editor:
Kate Phelan. Hair: Ward. Make-up: Frank B.

following pages
TOM MUNRO
MALGOSIA BELA AND
ANA CLAUDIA, 2000

Halterneck swimsuit (*left*), by Louis Vuitton. Bikini
(*right*), by Ralph Lauren. Fashion editor: Kate Phelan.
Hair: Michael Boadi. Make-up: Frank B.

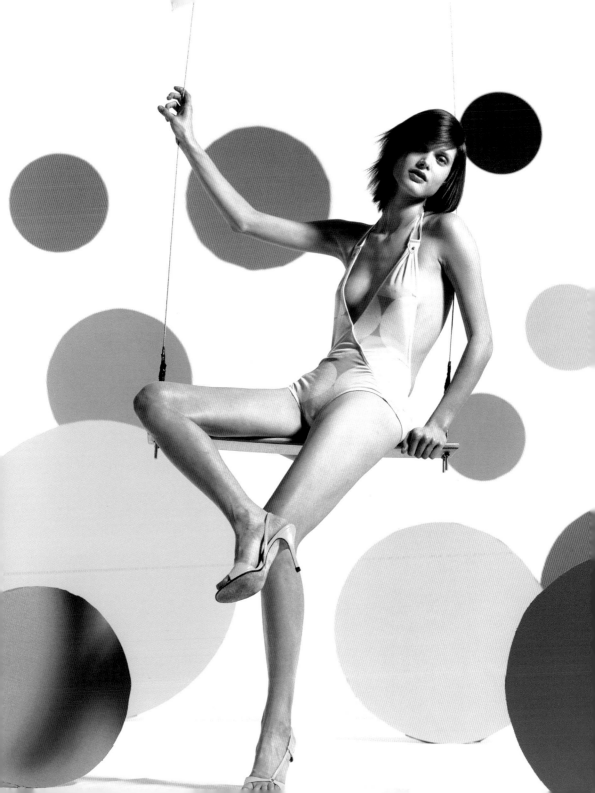

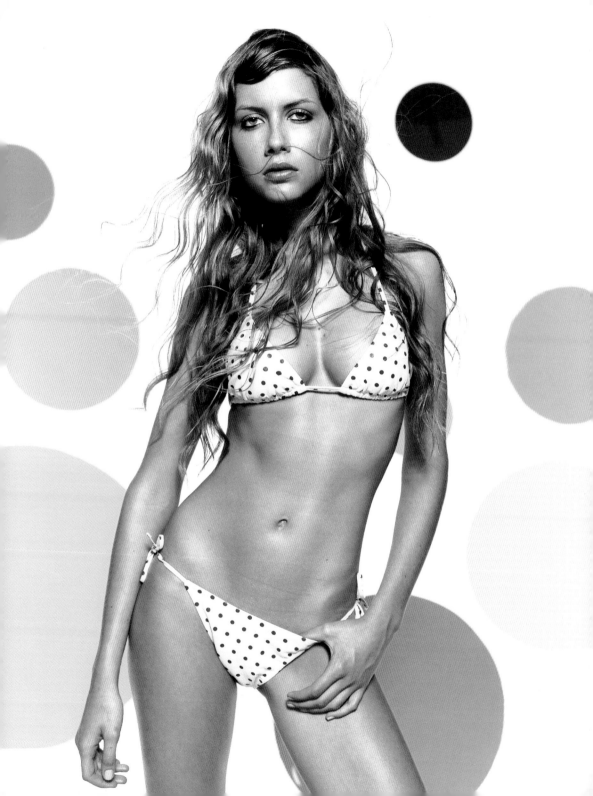

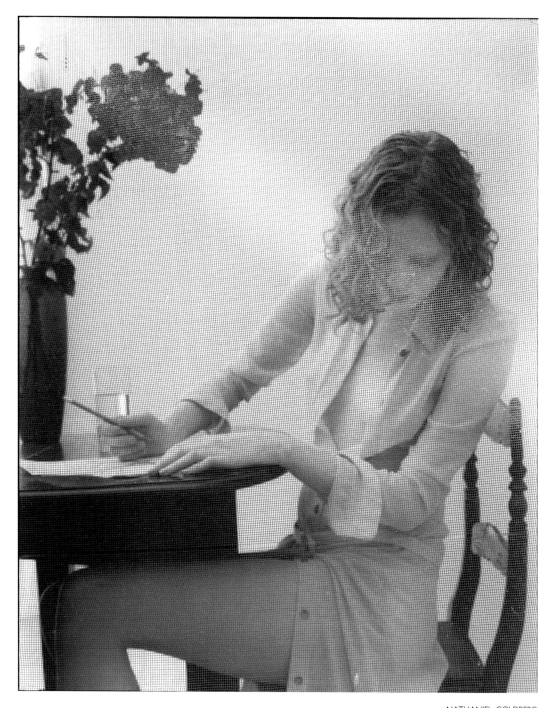

NATHANIEL GOLDBERG
KAREN ELSON, 2000
Silk-chiffon shirt dress (*above*), by Calvin Klein, and cotton and silk halterneck
top (*opposite*), by Louis Vuitton. Fashion editor: Kate Phelan. Hair: James
Brown. Make-up: Lucia Pieroni. Set design: George Xenos.

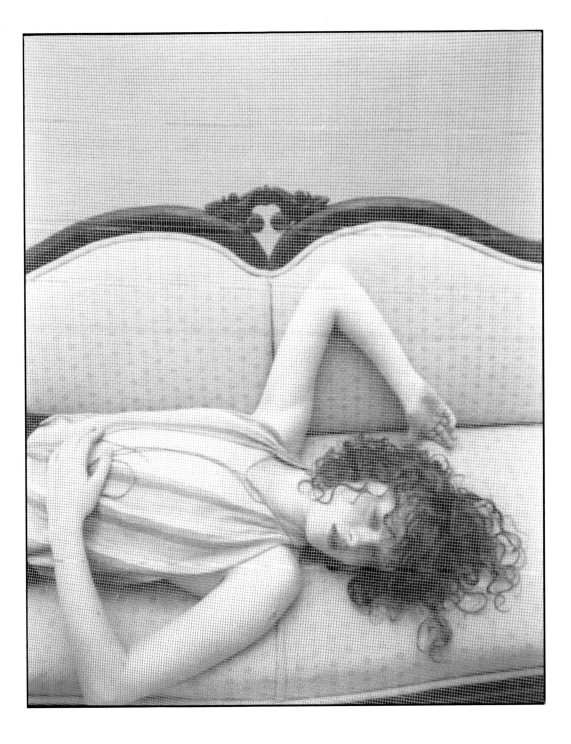

VANINA SORRENTI
SOPHIE DAHL, 2000
Sophie Dahl's image on billboard posters for Yves Saint Laurent's perfume 'Opium', naked and provocatively posed, stopped traffic and prompted at least 750 passers-by to complain to Britain's Advertising Standards Authority. As a model, Dahl was undoubtedly large; yet, with her flame-red hair, Dresden-porcelain complexion and voluptuous curves, she has proved unequivocally that size is not all. Interviewing her for *Vogue*, Christa D'Souza maintained that, 'although she is still very much an anomaly in the world of modelling – a kind of Alice in Wonderland-cum-music-hall siren… she is far from the caricature I expected. In essence she is too downright beautiful, with her delicate cheekbones and and surprisingly regular features, to be considered a curiosity any more.' Fashion editor: Lucinda Chambers. Hair: Johnny Sapong. Make-up: Lisa Eldridge. Set design: Michael Howells.

CORINNE DAY
ERIKA WALL, 2000
Out-takes from 'Scent Crazy', taken on location on
a farm in Shropshire. Fashion editor: Kate Phelan.
Hair: Neil Moody. Make-up: Lisa Eldridge.

CARTER SMITH
'CARAVAN OF LOVE', 2001
Among the models on location outside New York
are Elizabeth Jagger (*centre*) and Jenny Valtheurer
(*in yellow top*). Fashion editor: Lucinda Chambers.
Hair: Jimmy Paul. Make-up: Gucci Westman.

NICK KNIGHT
FANNI BOSTROM, 2001
Clothes, by Yves Saint Laurent.
Fashion editor: Kate Phelan.
Hair, styling: Sam McKnight,
colour: Nicola Clark.

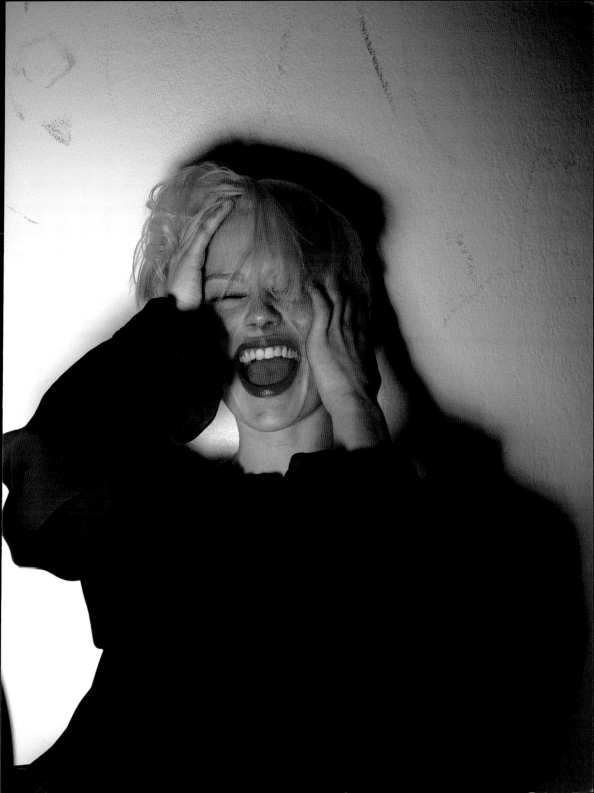

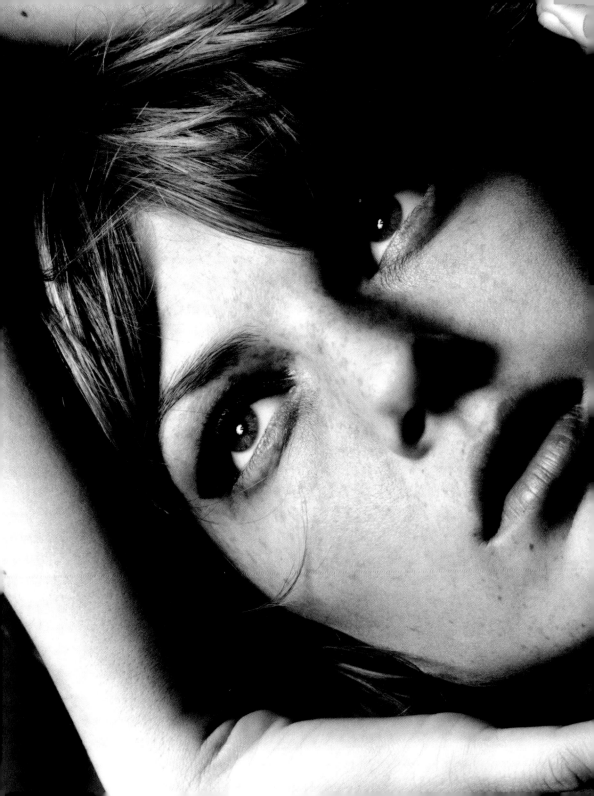

THOMAS SCHENK
ANGELA LINDVALL, 2001
Clothes, by Gucci. Fashion editor:
Evyan Metzner, daughter of the
photographer Sheila Metzner.
Hair: Ward Make-up: Christy Coleman.

ACKNOWLEDGMENTS

Robin Derrick conceived this book in summer 2000 and researched it with his co-author Robin Muir over the following 18 months. They wish to extend their grateful thanks to Lisa Hodgkins of the Condé Nast Library, London, who during that period allowed them daily to overturn the archive she so assiduously oversees. They pay tribute here to her patience and inexhaustible good humour.

The authors would like to thank for their encouragement Alexandra Shulman, editor of British Vogue, who readily agreed to write a foreword to the book, and Nicholas Coleridge, Jonathan Newhouse and Stephen Quinn (The Condé Nast Publications Ltd). They owe a special debt of gratitude to Harriet Wilson, Emma Mancroft and Lucy Carrington (The Condé Nast Publications Ltd), who played crucial roles in the early stages of work on the book and throughout. They would also like to thank Julian Alexander of Lucas Alexander Whitely, and Teresa Marlow, their former colleague at British Vogue, now managing editor of House & Garden, for editing their texts with such grace and at short notice.

In the preparation of the book, the authors have been greatly assisted by many people on both sides of the Atlantic: Linda Rice, Leigh Montville and Michael Stier (Condé Nast Publications Inc); Janine Button and Suzy Koo (Condé Nast Library, London); Susan Train (Paris Bureau, American Vogue). From British Vogue: Lucinda Chambers (fashion director); Kate Phelan (senior fashion editor); Madeleine Christie (fashion editor); Charlotte Pilcher (contributing fashion editor); Nick Cox (senior fashion assistant); and Francesca Martin (fashion bookings editor). Allan Finamore (Metro Imaging). Terry Davis and Bob Wiskin (Grade One Photographic).

Special thanks are due to Robin Derrick's colleagues in the art department of British Vogue: Marissa Bourke (art director); Rebecca Smith (designer); Kate Law; Aimée Farrell.

They would like to thank the following, too: Carole Callow (Lee Miller Archive); Fiona Cowan, Leigh Yule and Jake Parkinson (Norman Parkinson Archive); Corinne Day; Anna Harvey; William Klein; Nick and Charlotte Knight and Philippa Oakley-Hill (Nick Knight studio); Juergen Teller and Katy Baggot; Huw Gwyther (Mario Testino studio); Tim Walker and Joe Lacey; Charlie Kelly; Antony Penrose; Brian Dowling; Mark Sanders and Pam Makin.

The authors would also like to thank Julia Charles (Little, Brown) and Alice Rawsthorn (director, the Design Museum, London).

Lastly, both authors would like to record their gratitude to all the photographers – those credited and those not – whose work is included in this book, the art directors who commissioned it and the editors who killed it. All of them have enlivened the pages of Vogue and many continue to do so.

Jacket and endpaper photographs by Robin Derrick.